The Complete Book of

Drawing

The Complete Book of
Drawing

The history, materials, techniques, theory and
practice of drawing

José M. Parramón

Phaidon Press Ltd
140 Kensington Church Street
London W8 4BN

Copyright © 1987 José M. Parramón Vilasaló
Copyright © Parramón Ediciones, S.A.

Cover design © copyright 1993 Phaidon Press Limited

First published in Great Britain 1993

ISBN 0 7148 2839 4

A CIP catalogue record for this book is available from
the British Library.

Printed in Spain

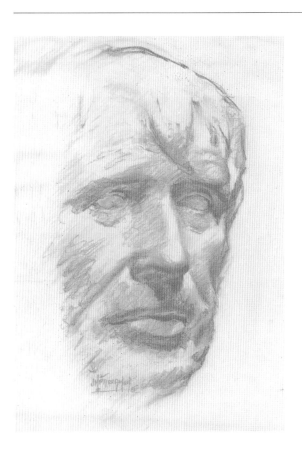

Contents

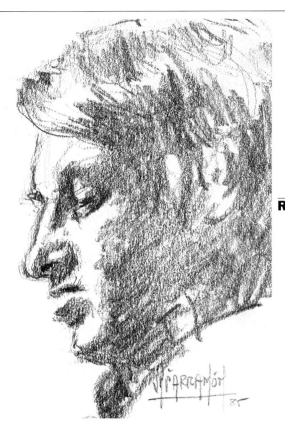

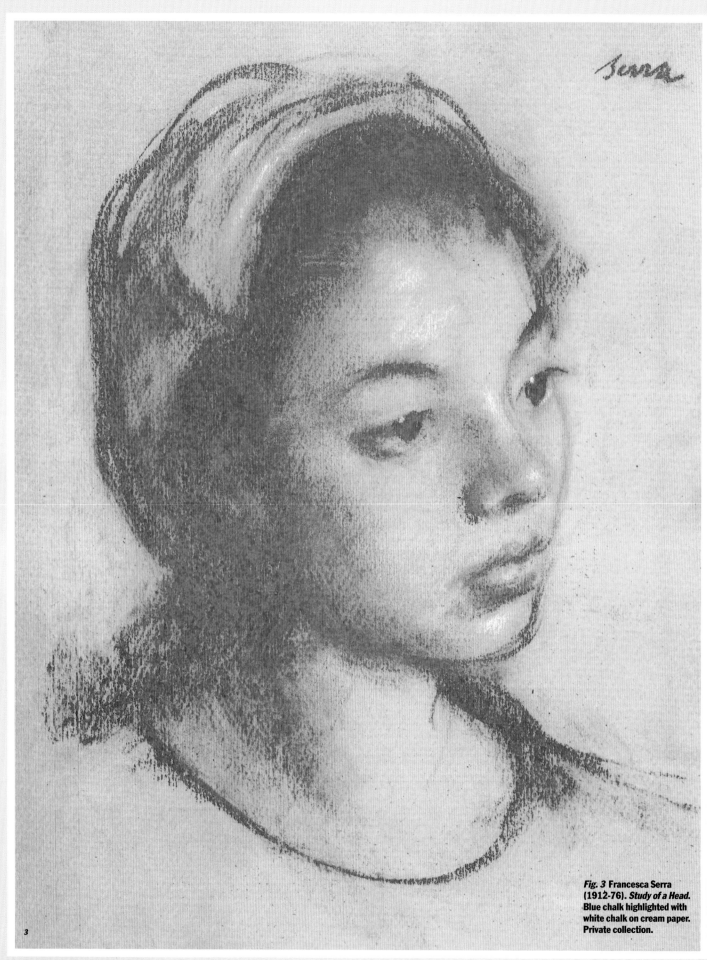

Fig. 3 Francesca Serra (1912-76). *Study of a Head.* Blue chalk highlighted with white chalk on cream paper. Private collection.

Introduction

Before beginning a painting, the great masters of the past drew and then painted several preliminary versions. This is still done nowadays. The Old Masters also began their works with *painted drawings*. First they gave the canvas or the piece of wood a coat of glue and plaster. Some artists dyed or repainted this mixture: Titian and Velázquez with reddish sienna, Rubens with silver-grey. They would then paint on top of that coat with one or two colours and white. Rubens, for example, after adding a coat of silver-grey tone, would draw in the model with a dark ochre, and later enhance light areas with white. Eventually, taking this painted drawing as a starting point, Rubens would complete the painting using all the colours of his palette.

John Sloan, a founding member of the Ash Can School (famous for its paintings of sordid slums in New York), wrote a book detailing his ideas on art. He stated, 'The great painters used to separate shape and colour. Firstly, they used to paint shapes with neutral colours by drawing them. Then, they added colour.' Sloan also stated that:

Painting is drawing.

Indeed, when we paint, we are drawing. When painting a tree, the artist must first draw – with paint – its length and thickness, its illuminated and shadowed areas. Many other artists have remarked, as Ingres did, 'We paint the same as we draw.'

The purpose of this book is to teach the art of drawing, both as an end in itself and as part of the process of painting.

The book begins with a summary of the history of artistic drawing. To illuminate this summary are reproductions of works by Leonardo, Michelangelo, Raphael, Rubens, Watteau, and other master draftsmen. Various media are discussed, such as coloured pencils, oil crayons, oil pastels, chalk pastels, and even watercolour. You may wonder why so many media are included in a book about drawing. They are here because they can be used for both painting *and* drawing; thus they provide an important link between the two art forms.

In discussing drawing materials, I have tried to remain impartial regarding brands and manufacturers. After each presentation, I have commented on the use and techniques of the various materials. Keep in mind that the basic principles of perspective, proportions, light and shade, value contrasts, composition, form and space can be applied to both drawing and painting. However, in this book we have chosen drawings as examples.

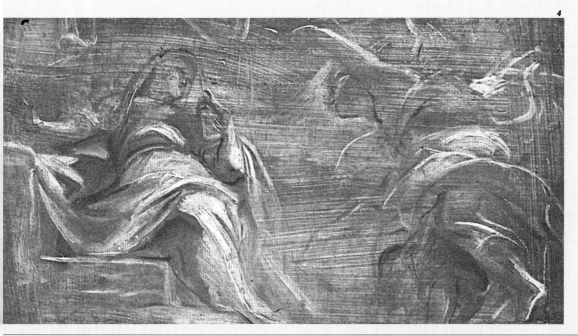

4

Fig. 4 **Peter Paul Rubens (1577-1640).** *The Annunciation.* **Ashmolean Museum, Oxford. Rubens began this first stage of the panel by painting in a layer of silver-grey colour, then drawing the model with touches of ochre, and finally working the light areas with white paint.**

Finally, I have stressed throughout the book the necessity of drawing as much as possible, of finding models and subjects everywhere, and knowing there are tools and techniques to achieve real masterpieces. Practice – steadfast work at your drawing – is the most important factor in learning to draw. Matisse proclaimed, 'We must work as workmen. He who has done something worthwhile has worked in this way.' Working also means thinking; 'having the picture in our mind' (Monet), or walking along a street 'keeping our mind busy, observing men's and women's faces on cloudy days' (Leonardo). Making good use of your time is also important: 'Everybody is amazed at how much I paint. But the point is that instead of wandering to and fro, like so many other artists I know do, I shut myself in my studio' (Delacroix). Geneviève Laporte, one of the women in Picasso's life, wrote a book called *Picasso's Secret Love*, in which she presents Picasso's ideas and attitudes while he was with her. 'We used to talk about the young artists: "Young artists think it is enough to do what I used to do at their age: chatting, drinking, smoking, going to cafés ... and wait for fame and success to arrive." He sent out a puff of smoke and half-closing his eyes he said: "That's not true. You have to *work*."'

José M. Parramón

5

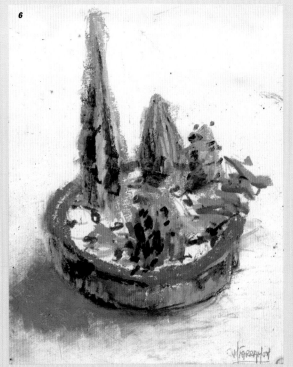

6

Figs. 5 and 6 The art of drawing offers many possibilities, not only because of the variety of themes, for example portraits, landscapes, and still life; but also because of the different media, for example, charcoal, Conté, pastels, and coloured pencil. In the drawings shown here, you can see examples of this diversity: the black and white rendering of the head of a young girl drawn in lead pencil of an HB grade on fine-grain paper, and the cactus drawing made with oil crayons.

(Opposite) Maurice Quentin de La Tour (1704-88). *Self-Portrait.* Louvre, Paris.

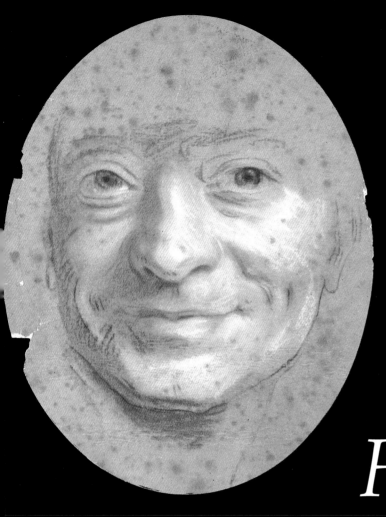

History of the art of drawing

'The least essay written by a painter will advance the theory of the art better than a million volumes.'

Sir Joshua Reynolds (1723-92)

20,000 years B.C.

At the beginning of this century, the German ethnologist Leo Frobenius noticed that 'to hunt a deer, the aboriginals of a tribe drew the effigy of the animal on a rock, then threw their arrows at it, and only after that did they set off to capture it'.

Frobenius and most ethnologists agree that this behaviour was not an isolated practice. More than 20,000 years ago men drew animals on the walls of the caves they lived in. The purpose of these drawings was to request the gods' help when fishing and hunting.

Those men were the first artists acknowledged as such. They drew large figures. They preferred hard rock walls where they engraved the animals' profiles with flint chisels. They outlined the animals with coal, and coloured the surface with earthen pigments of various shades: black, brown, yellow, and, rarely, purple. They used blood, fat, and vegetable resins to bind the colours.

Those people were nomadic and basically naturalistic, therefore their paintings were completely realistic. It was not until the Neolithic period, thousands of years later, that men learned to cultivate land, build dwellings, domesticate animals, establish economic systems, and set up villages and towns. The Neolithic period also brought the use of geometry and shapes, and saw a rejection of much of the naturalism of earlier man. Neolithic art consisted mainly of abstract embellishments on utensils, vessels, tools, and weapons. It was not until 3,200 B.C. that the relay was taken up again. It was then that the history of ancient Egypt began.

Egypt: art of the pharaohs and eternal life

In ancient Egypt, the king, or pharaoh, was regarded as a god. Both pharaoh and subjects believed in immortality. Thus, Egyptian art was always directed by the pharaoh and was meant for the life that was to continue beyond death. All ancient Egyptian paintings, whether they were murals or on papyrus, can be found in tombs. They all depict what the dead person and his life and surroundings were like. This kind of message picture was sketched first on limestone boards called ostraca. From those, the artist would carry out the final work on a wall or a wooden board which had previously been covered with a coat of stucco made of white lime.

Egyptian artists used fine brushes made with rushes crushed at one end and red colour

made of iron oxide agglutinated with gum arabic and egg white. Having drawn the outline, they coloured the shapes in plain colours, without regard for light and shade effects.

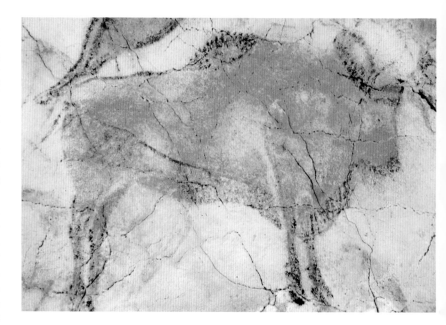

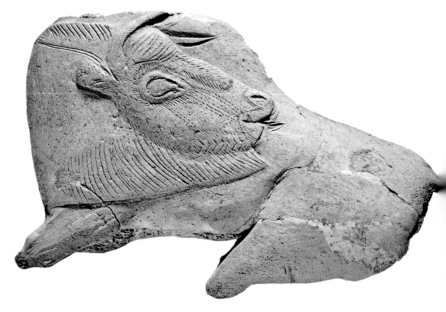

Fig. 8 Bison. Altamira Caves, Spain.

Fig. 9 Bison Carved on a Reindeer's Horn. Madelaine's Grotto, Museum of St Germain-en-Laye, France. 13,000 years ago men were already capable of drawing the contours and forms of animals with great style.

Egypt: art of the pharaohs and eternal life

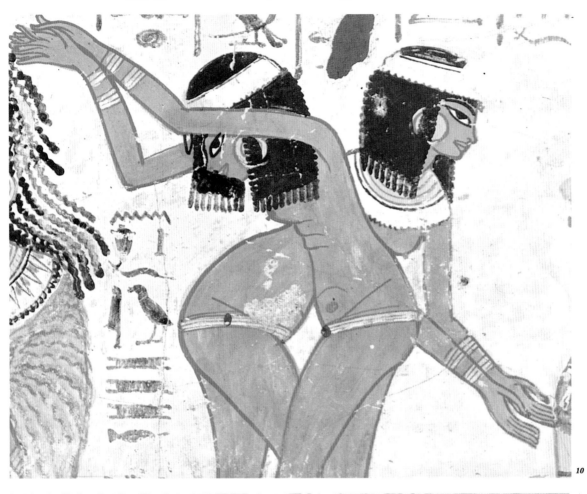

Fig. 10 New Empire, mural painting of the School of Thebes, *Egyptian Dancers*. British Museum, London. Egyptian art is subject to a series of traditional forms: in the human figure, faces are inexpressive, the features are impersonal and the head and legs are in profile. The image is exceptional in showing the dancer's torso also from the side, not the front. From the beginnings of Egyptian art, female bodies are painted ochre-yellow and the male bodies red. Curiously, these artistic conventions do not happen in animal drawings, which are more lifelike, painted in a variety of colours.

10

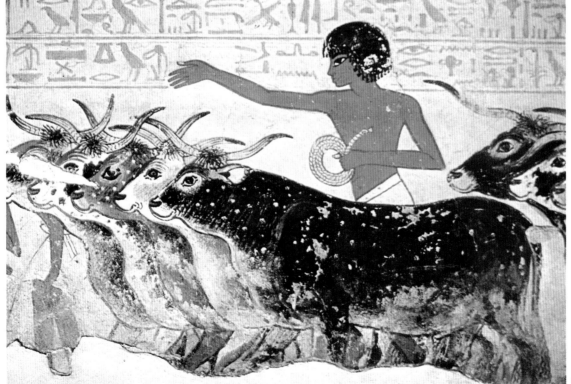

Fig. 11 *Inspection of the Cattle*. Detail of Nebamon's tomb. School of Thebes. British Museum, London.

11

The Greeks (776 B.C.)

In 776 B.C., when the first Olympic Games took place, the Greeks began to record and write their history. The chroniclers of that period – Pausanias, Plutarch, Herodotus and Aristotle among the Greeks, and Pliny and others among the Romans – tell us about the great Greek artists and draftsmen. They mention Polygnotus as one of the great masters who painted murals and started up a school. They also refer to the prominent sculptor Phidias, who was the first disciple of Polygnotus and who copied the figures of his master to create his own sculptures for the Parthenon. They tell about Zeuxis, who painted with such realism that on one occasion birds came up to peck at the grapes he had painted. They write of the artist Apelles, renowned for his great skill, who was chosen by Alexander the Great as his only portraitist. The Roman historian Pliny, in Volume 35 of his *Natural History*, records that Parrhasius's disciples learned to draw using silver or lead tips on parchment or wooden boards covered with bone dust. This technique, metalpoint, is exactly the same one described by Cennino Cennini and used by Pisanello in Italy a thousand years later.

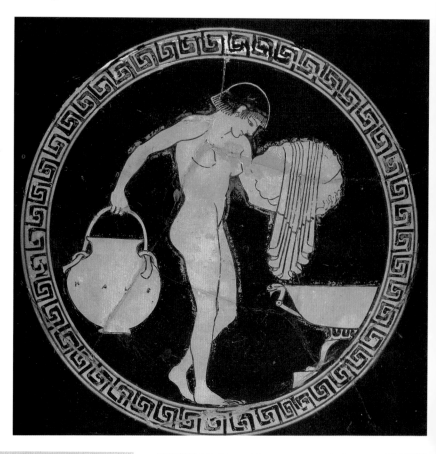

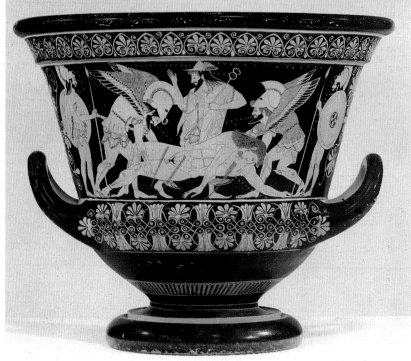

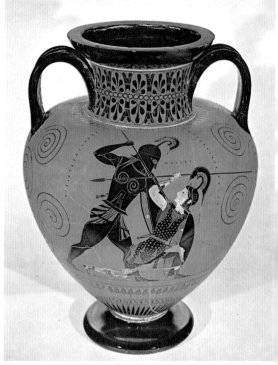

13 14

Fig. 12 Attributed to Onesimos. *Girl Preparing to Take a Bath,* 480 B.C. Royal Museum of Art and History, Brussels.

Fig. 13 Euphronius, painter, and Euxitheos, ceramist. *Dream and Death Lifting the Body of King Sarpedon.* Metropolitan Museum of Art, New York.

Fig. 14 Exekias, painter and ceramist. *Achilles Killing Penthesileia* (Queen of the Amazons). British Museum, London.

Unfortunately, there are no existing studies, pictures or murals drawn and painted by the great masters of ancient Greece. However, Greek pottery and Roman painting – copied from Greek painting – does confirm the existence and high quality of the works mentioned by Greek and Roman historians.

In fact, the figures, subjects, and scenes found in Greek pottery were very often based on those depicted in wall paintings, as many artists were both painters and potters. The quality of the images, particularly those drawn on certain funeral vases called lekythoi, shows that the art of drawing flourished in ancient Greece.

On the other hand, it is widely accepted that the majority of Roman paintings found at Pompeii, Herculaneum and other places are copies, albeit bad copies, of Greek paintings. For example, the mosaic found at Pompeii of the Battle of Issus, in which Alexander the Great is shown fighting Darius of Persia, may be a copy of a famous painting by Apelles' disciple Philoxenus from the 4th century B.C.

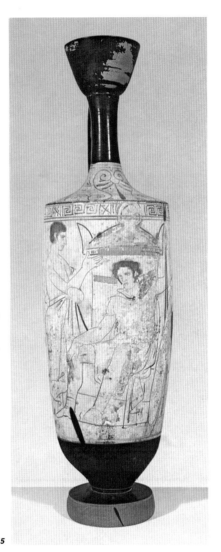

15

16

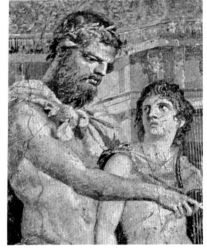

17

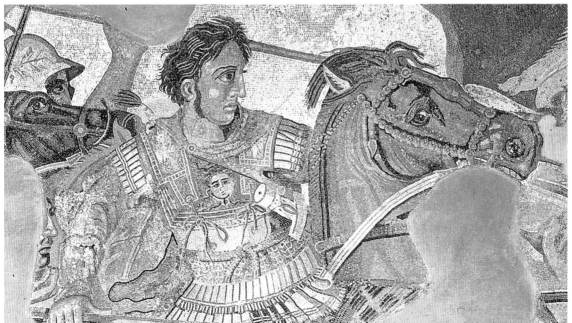

18

Fig. 15 Painter of Penthesileia. *The Judgment of Paris.* Ceramic. A vessel for keeping cosmetics, 460 B.C. Metropolitan Museum of Art, New York.

Fig. 16 Reed painter; a *lekythos*, or funerary vessel. National Museum, Athens.

Fig. 17 Quiron Instructs Young Achilles. A mural found in Herculaneum; possibly a copy of an original by Apelles. National Museum, Naples.

Fig. 18 Mosaic copy of a painting by Apelles and his pupil Philoxenos, *The Battle of Issus.* Mosaic found in the House of the Faun, Pompeii. National Museum, Naples.

Rome

From its very beginning, Roman art was a reflection of Greek art. It began in the 6th century B.C. in Etruria, in the centre of Italy. It reached maturity in the 3rd century B.C., when Rome ruled over central Italy and had spread its influence to Greek towns in the south of Italy. The treasures of Greek art were then taken home, where Romans became passionate collectors.

The development that drawing and painting had achieved in Rome can be seen in the ornamentation of houses and buildings at Pompeii and Herculaneum. Both cities were buried during the eruption of Vesuvius in A.D. 79. The wall paintings from Pompeii show Roman art with basically ornamental themes and style, and frescoes copied from Greek wall paintings.

Besides themes, style, and clothing, there is something that proves Roman painting was highly influenced by Greece: The Greek and Roman chroniclers mention more than 50 Greek painters and draftsmen. The only Roman artist mentioned by Roman historians is Fabius Pictor. One important reason for the lack of recognition Roman artists received is that art was seen primarily as a way of glorifying the lives and deeds of the emperors and was not generally favoured for its own sake. In Augustus's days there are more than 80 statues with his effigy just in the city of Rome itself: Augustus the young child, Augustus the valiant warrior, Augustus the benevolent patrician, Augustus the mighty emperor.

19

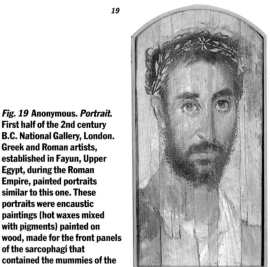

Fig. 19 Anonymous. *Portrait.* First half of the 2nd century B.C. National Gallery, London. Greek and Roman artists, established in Fayun, Upper Egypt, during the Roman Empire, painted portraits similar to this one. These portraits were encaustic paintings (hot waxes mixed with pigments) painted on wood, made for the front panels of the sarcophagi that contained the mummies of the portrayed.

Figs. 20 and 21 Wall painting from the House of Livia, in the Palatine, Rome. (Below) Wall painting from the House of the Vetii, Pompeii. In Roman painting proper, there were four different styles. The first is called the *encrustation* style, which shows the complex ornamentation of the mouldings, doors, windows and pilasters. The second style, called *architectonic*, reproduces the effects of perspective and depth (see foreground in the figure above) and mixed, at times, with natural subjects. The third style, the *ornamental*, is mainly decorative. And the fourth, the *illusionist* style (left), is a mixture of the other three, with effects of perspective and depth, encrusted mouldings, frames and, as seen in the central area, a copy of a Greek painting.

21

Indian and Islamic art

Indian art from the 3rd century B.C. was mainly Buddhist art. It was also the art of sculpture. Until A.D. 800, Hindu architects and sculptors built temples and shrines with plenty of sculptures. Many of these temples were carved in rock cliffs.

Among these buildings, nearly thirty caves carved in Ajanta, in central India, must be mentioned. Besides sculptures and bas-reliefs, there is a series of wall paintings considered among the greatest masterpieces ever made by man. The outstanding quality of these frescoes made them into models not only for artists who painted murals many years after, but even for manuscript illustrators.

In the Middle Ages, artists in India drew on palm leaves, which necessitated a long and narrow format. They marked the surface with metalpoint, a primitive pencil. Then they scattered dark blue dust on the surface and blew it off in order to get the drawing. In the 14th century, paper was introduced in India. It came from Persia and helped in the making of drawings and miniatures which, from then on, were to be painted with watercolours and opaque colours (gouache).

In 622 Mohammed left Mecca and went to Yathrib (now Medina), Saudi Arabia, and founded a new religion: Islam. A hundred years later the Islamic world was an empire that covered a vast territory, from Tibet to the Atlantic Ocean, and included all the peoples and nations of the southern coast of the Mediterranean.

The Koran, the holy book of Islam, does not ban the representation of images in art. However, the ancient Muslim theologians pontificated that drawing people implied a sinful arrogation of the divine power of creation and doing so was banned in religious books and buildings. Islamic artists then developed all sorts of decorative embellishments until the Koran was revised and no reason could be found for the previous ban.

In the 14th century, Tamerlane, heading the Mongolians, went as far as Turkey and India and established the first Timurid school of miniaturists in Persia. Persia then became the artistic centre of Islamic art. Among others the schools of Herat and Mughal of Akbar were established at this time; and artists such as Bihzad, Aqa Riza, and Riza i'Abbasi were working during this fertile period. Riza i'Abbasi was the most prominent Islamic draftsman and painter, and also the founder of the Abbasi school.

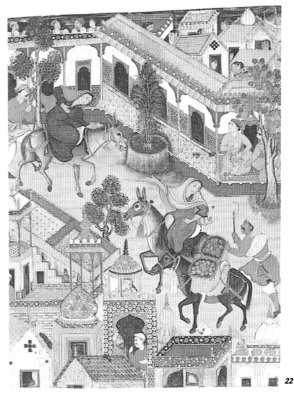

Fig. 22 Mughal School of Akbar. *Zanbur, the Spy.* Metropolitan Museum of Art, New York. The original of this page of the manuscript measures 74 x 57.2 cm (29$^{1}/_{2}$ in x 22$^{1}/_{2}$ in). It was painted with watercolours, opaque colours, and gold on cotton cloth mounted on paper. It belongs to a series of 14 volumes, each one including a hundred illustrations similar to this one. Note that the high perspective point gives a good illumination of the facts of the scene. The laborious ornamentation of houses and mansions is characteristic of Islamic art.

Fig. 23 Anonymous. *Balkis, Queen of Sheba* (fragment). British Museum, London. The subject, the Queen of Sheba and her love affair with Solomon, has been represented by such well-known artists as Raphael, Veronese, and Claude Lorrain.

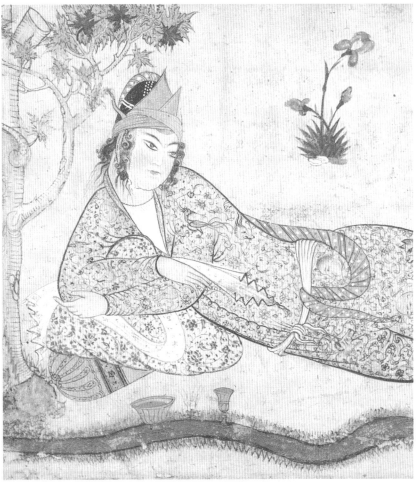

Far East: China and Japan

The Chinese use the same materials for both writing and painting; that is, silk or paper, ink, and a brush. 'All colours are possible in ink,' the Chinese say, although when painting, they also use watercolours.

This has been true for centuries. However, there have always been two classic styles of expression in Chinese art: the linear and the tonal. The linear is based on sketches made with a brush. Outlines and inner lines are drawn on white backgrounds, and images are painted with plain colours without any shading or relief. The tonal style is based on shades of colour rather than on lines. This style, developed in the Han age (206 B.C. – A.D. 221), helped solve the needs of landscape painting and, as a consequence, gave rise to the invention of paper and the further development of brushes.

Calligraphy and drawing became closely related during the Han period. Artists used to say a painting is a poem without words. Poems and sentences were written on the same scrolls as landscapes, the favourite subject in Chinese art. These landscapes were composed of tints, contrasts, and subtle tonal gradations that suggest mood and pictorial depth.

Among the best representatives of the linear style were Yen Li-pen (7th century) and Fan K'uan (12th century). Good examples of the tonal tendency were Wang Wei (8th century) and Mu Ch'i (13th century).

In Japanese art, the traditional media were watercolours and gouache. At first, Japanese art was a reflection of Buddhism and Chinese art. But by the 10th century new subjects were introduced, and a pure Japanese style appeared. It was the so-called Yamato-e style. During the Kamakura period, subjects became more dramatic. With the advent of Zen, priests, and particularly a monk called Sesshu, introduced simple subjects and the use of monochromatic wash. Those styles were cultivated by the Kano school derived from the Sumi-e and the Tosa schools, which monopolized the national Yamato-e style.

In 1683, Hishikawa Moronobu printed an engraving with a non-religious subject. The idea was successful, and in the 18th and 19th centuries, plates with Japanese engravings reached Paris, where they influenced the Impressionist painters and spread all over the world. This new way of expression was followed by many Japanese artists, most notably Harunobu, Utamaro, and Hokusai.

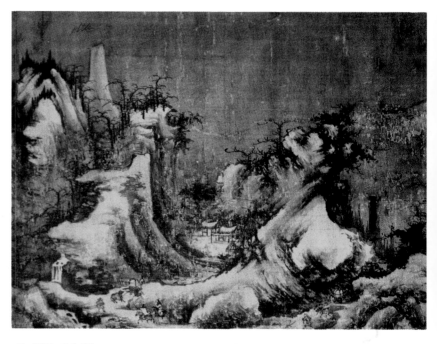

Fig. 24 Kuo Hsi. *Chinese Wintry Landscape* (detail). 11th century. Museum of Art, Toledo, Ohio. Traditional example of a Chinese landscape showing the characteristic tonal subtleties, blendings, light and shade effects, and spatial illusion.

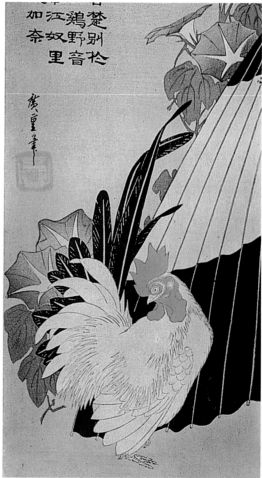

Fig. 25 Ando Hiroshige (1797-1858). *Flowers and Birds.* Hermitage, St Petersburg.

Fig. 26 Katsushika Hokusai
(1760-1849). *Birds in
Flight.* Uffizi, Florence.
Hokusai lived for 89 years.
He is credited with about
30,000 works, including
paintings, engravings, and
drawings. His most famous
collection is the *mangwa*
(meaning 'copious
drawings'), consisting of 15
volumes that represent the
character of people in
action, from the elegant
bourgeois to the most
humble worker, their tools
and clothes, and the streets
and houses of everyday life.
His work influenced artists
from the West, especially
the Impressionists Degas,
van Gogh and Toulouse-
Lautrec. In this drawing on
white Japanese paper,
painted with a wash of
Indian ink and ochre-yellow
watercolour, Hokusai shows
us his extraordinary
imagination and memory,
as well as his clever
handling of composition.

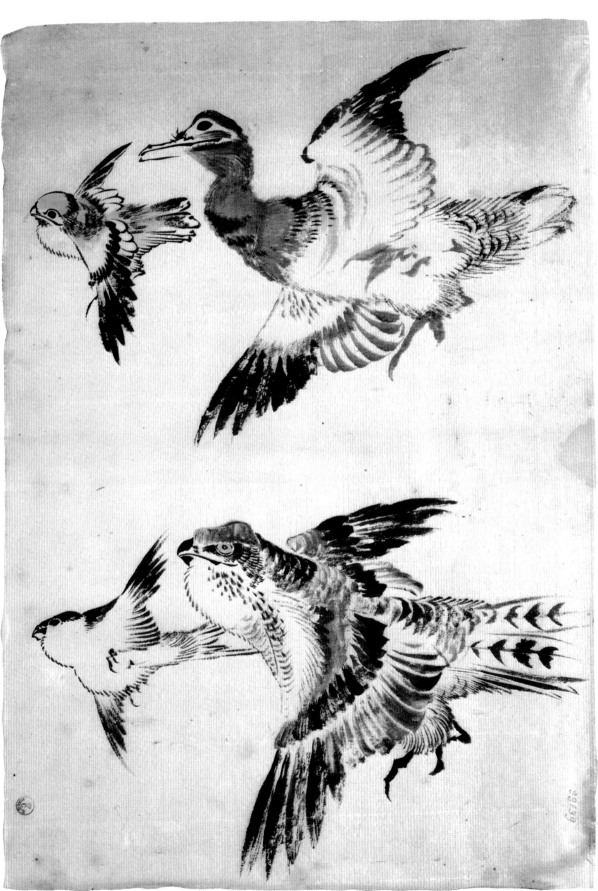

Medieval art in Europe

In the 4th century, Rome ruled over two vast territories: the western Roman Empire and the eastern Roman Empire. In the latter, Rome had to create a new centre of power because of the recurrent wars and the pressures exerted by the barbarians. Thus, the Roman Emperor Constantine the Great chose the former Byzantium to found Constantinople, the capital of the new Byzantine Empire.

More than a hundred years later, the barbarians sacked Rome. The Roman Catholic Church was the only institution that managed to escape the cataclysm. Helped by Eastern and Western rulers, the Church condemned classical art and promoted Christian art as a means of spreading the religion.

In Byzantium, art became theological. The images of Jesus, the Virgin and the saints appear in mosaics, though not in paintings, and are shown richly dressed to imitate the hieratic and authoritarian ritual of the court. Then, in the year 726, the Iconoclast movement began its attempt to suppress the sensuousness of the classical period. All figurative representations were forbidden and sculptures and paintings of images were destroyed. 'Churches remained entirely white, and those who dared sculpt or paint were severely punished,' wrote the sculptor Ghiberti in the 15th century. After this period, a renaissance of art began in Byzantium, which, in drawing and painting, produced parchments and miniatures in the ancient classical style such as the *Psalter of Paris*.

In the meantime, the West had been invaded by the barbarians. The historian Arnold Hauser wrote about this age of decay, 'During the sixth and seventh centuries no one in the West was able to draw a human figure.' After this dark period, we find Charlemagne, head of the Carolingian Empire founded in the 9th century. Before the year 800 there was already a famous Irish school of miniaturists, among whose works is the *Book of Kells*. Charlemagne attracted artists of this school, as well as Italian and English artists. He also stimulated a cultural renaissance of a religious kind and established the *scriptoria* at Fulda, Luxeuil, and Tours. The study of prosody and grammar was given emphasis as well. As a result of these changes, Romanesque art appeared. However, when the Holy Roman Empire lost its strength as a state, and the power of lords, barons, and courts was acknowledged, feudalism emerged. Feudalism divided Europe into hundreds of small states, each one closed to the rest and isolated from the world. In the long run, this hindered the development of art and culture.

In the 12th century, the Gothic period in art began. Life came back to cities, and art experienced a new awakening. In Italy, Giotto became a successful artist in the 13th century. In France, Villard de Honnecourt compiled hundreds of sketches in a 'lodge book', or sketchbook, as we would say today. He collected plans of buildings, figure studies, animal studies, and war machines.

In 1159 paper began to be produced in Spain, and by the 14th century throughout Europe. During the 1390s the artist and educator Cennino Cennini wrote his famous book *Il Libro dell'Arte*. There, he dealt with the techniques of artistic drawing and enumerated the tools and materials needed, from the metalpoint (primitive pencil) to coloured papers.

In the 15th century, when drawing began to be considered an art in itself, Pisanello became a prominent figure of the international Gothic style. Many of his sketches and drawings are included in the Vallardi Codex, one of the best collections of drawings of that period. There we can find studies of animals, clothes, and antiques, and sketches of paintings, including nudes, drawn with a metalpoint on white drawing paper tinted with pale colours. The Renaissance had come at last, and the art of drawing had established itself once and for all.

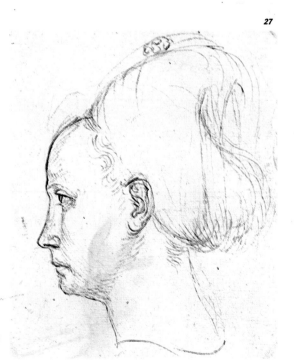

27

28

Figs. 27 and 28 Pisanello (1395-1455). *Woman's Head, Study.* Louvre, Paris. (Left) *Head of a Woman turned to the Left in Profile.* Pellegrini Chapel of Saint Anastasia, Verona. This detail of a woman's head, done in ink with a pen over black chalk, was a preliminary study for a fresco.

Fig. 29 Martini (1284-1344). *Blessing of Christ with the Angels.* Papal Palace, Avignon. Charcoal underpainting for a fresco mural.

Fig. 30 Anonymous Irish illustrator (A.D. 800). *Book of Kells* (initial). Trinity College Library, Dublin. The *Book of Kells*, 33 x 25 cm (15 x 10 in), is tempera painted on parchment. It is the most important manuscript of the Irish school, noted for the originality and beauty of its miniatures.

Fig. 31 Monaco (1370/2-1425). *Mary's Meeting with Elisabeth.* Dahlen Museum, Berlin. Lorenzo Monaco, also called Lorenzo the Monk, was a 'modern' artist of the time. He introduced the International Gothic style into Florence, by changing the golden backgrounds and flat figures of traditional Gothic art to more realistic details. The backgrounds become landscapes, and figures have depth, an idea that was later adopted by Ghiberti, Martini, and Pisanello. The originality of Lorenzo Monaco is evident in this pen and ink and tempera drawing on parchment.

Fig. 32 Anonymous. *Joshua Receiving the Emissaries.* Vatican Museum, Rome. The biblical character Joshua is represented here, by a Byzantine artist of the 10th century, in a *volume* (parchment scroll) drawn in pen and ink and wash.

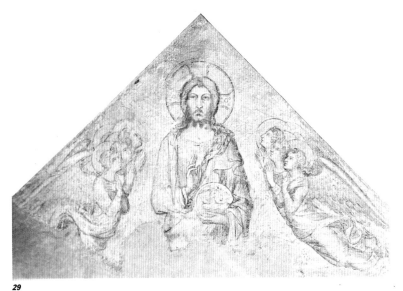

29

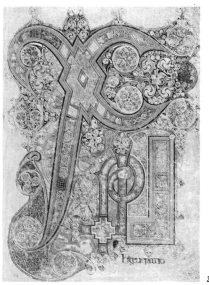

30

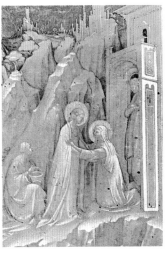

31

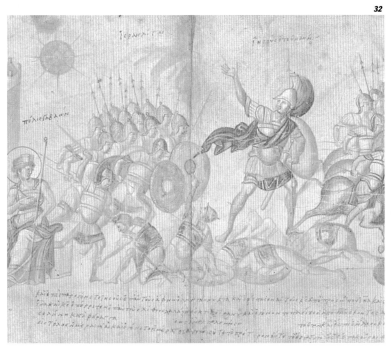

32

Making paper

Around the year A.D. 105, the Chinese Minister of Agriculture developed the process of manufacturing paper. This invention did not reach the West until the year 751, when the Chinese were defeated by the Arabs in the Battle of Talas (in Russia near the Chinese border). Some experts in paper manufacturing were captured and, later, paper factories were set up in the Middle East and Northern Africa.

Eventually, paper making was brought to Europe, first to the Iberian Peninsula: Córdoba (1040), Játiva, and Catalonia (1150). Later, factories were built in Italy (1276), France (1348), Germany (1390), and elsewhere. By 1390, when the artist and educator Cennino Cennini wrote his well-known book *Il Libro dell'Arte*, in which he describes the techniques of artistic drawing complete with the tools and materials needed, he included coloured papers. Around 1740, James Whatman in England made the first watercolour paper; one hundred years later, Etienne Canson in France developed a new method of sizing paper, which resulted in Canson drawing paper, a well-known high-quality paper still available today.

33

34

Fig. 33 The raw materials used to make paper are wood, vegetable fibres, old paper, and cotton rags. These materials, first sorted, cut up, and sized, become what is called stuff, which is the basis of paper making, and consists mainly of cellulose.

Fig. 34 To make a sheet of paper, use a frame with a wire mesh. The amount of stuff necessary for one sheet is spread over the mesh.

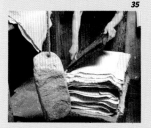

35

36

Fig. 35 Once the water has drained from the sheet and it begins to stiffen, it is removed and covered with a piece of felt on top and a piece of fine smooth cloth underneath.

Fig. 36 Next, a number of sheets complete with their pieces of felt and cloth are put in a press so that any remaining water will be pressed out. As a final step, the sheets are dried and prepared for either a rough or smooth surface.

The Renaissance: the Quattrocentro

The pioneers of the Renaissance were three artists from Florence: the painter Masaccio, the sculptor Donatello, and the architect Brunelleschi. They knew each other's work and together they created a new type of art. After them, in about a century's time, the greatest masters of drawing and painting ever known appeared: Botticelli, Leonardo da Vinci, Michelangelo, Raphael, Titian, and Correggio.

When talking about the 15th century, or Quattrocento, there is a family name that stands out: Bellini. The father, Jacopo, produced two books of sketches which inspired his sons Gentile and Giovanni. Giovanni followed his father's guidelines and became the most prominent master of his generation. Other artists who lived and worked at the time were Botticelli (probably a disciple of Fra Filippo Lippi), Paolo Uccello, Piero della Francesca (who improved the theories of perspective

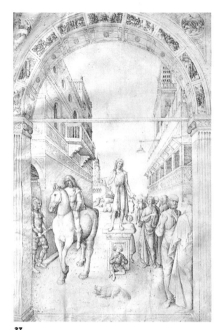

37

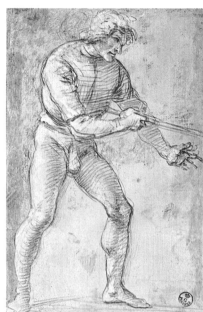

38

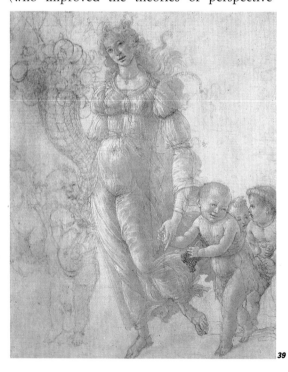

39

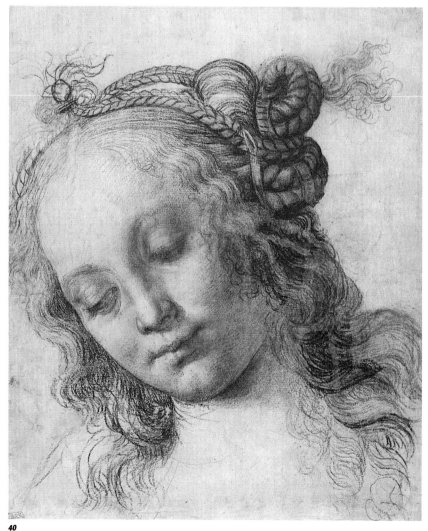

40

Fig. 37 Jacopo Bellini (1400-70). *A Saint Preaching in a Town.* Ink and wash on parchment. Louvre, Paris.

Fig. 38 Filippino Lippi (1457-1504). *Study for a Figure in Action.* Charcoal or sanguine, highlighted with white chalk on pink-tinted paper. Uffizi, Florence.

Fig. 39 Sandro Botticelli (1445-1510). *Abundance, or Autumn.* Black chalk, sepia watercolour, sepia ink and white chalk highlights on pink-tinted paper. British Museum, London.

Fig. 40 Andrea del Verrocchio (1435-88). *Woman's Head with a Complicated Hairstyle.* Black charcoal highlighted with opaque white (tempera/gouache). Metropolitan Museum, New York.

developed by Brunelleschi) and Verrocchio (master of Leonardo). There are other masters in the Quattrocento who should be mentioned: Antonello da Messina who was influenced by the Flemish master Jan van Eyck; Rogier van der Weyden, also Flemish; Hans Memling, from Germany; François Fouquet from France; Jaume Huguet from Catalonia; and Gentile da Fabriano, Andrea Mantegna, Domenico Ghirlandaio, and Perugino from Italy.

By the time of the Renaissance, drawing was already a compulsory subject for the artist. It can be said that to paint well, one must draw better. Artists were already using the means present-day artists have, that is, white and coloured papers, metalpoints, charcoal, sanguine, brushes, watercolour, and gouache.

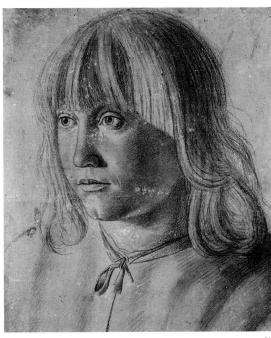

Fig. 41 **Antonello da Messina (1430-79).** *Portrait of a Boy.* **Charcoal on sepia-tinted paper. Albertina Museum, Vienna.**

Fig. 42 **Lorenzo di Credi (1459-1537).** *Head of a Youth with Long Hair.* **Drawing made with metalpoint on yellow-tinted paper. Albertina Museum, Vienna.**

41

Metalpoint

According to Pliny in 400 B.C., the pupils of the Greek painter Parrhasius already drew with a metalpoint, a handle with a tip on one end. This tip was made of lead, silver, or gold. Its marks were black but on a prepared ground left an impression similar to our present-day lead pencil, though a bit lighter. Parrhasius's pupils drew on parchment or wooden boards prepared with bone dust and gum arabic.

Cennino Cennini, author of *Il Libro dell'Arte* (1390), mentions the metalpoint, also called a stylus, and describes the preparation of the surface with chalk dust and saliva. This procedure was commonplace and was used in the 15th and 16th centuries by most Dutch, Italian and German artists.

If you want to try this technique, a plumber can provide you with a 10 cm (4 in) pencil-shaped piece of lead or solder. Sharpen this tip with a pencil sharpener and you will be able to draw, preferably on *couché* (laid) paper, with the same tool used 500 years ago by Giotto, Botticelli, Leonardo da Vinci, Michelangelo, Raphael, and Dürer.

43

Leonardo da Vinci

Leonardo da Vinci was a genius; he was not simply an artist, but also excelled as a sculptor, an architect, a town planner, a physicist, a botanist, a biologist, an artillery designer, a mechanic, an anatomist, a geologist, a writer, and a poet. Before aeroplanes were invented, he thought of the parachute; he also proposed a theory of gravity two hundred years before Newton's law. He was one of the foremost pioneers in the field of comparative anatomy. He is known to have developed more than thirty inventions, among them, the steam pump, the howitzer, the hand grenade, and the darkroom.

But Leonardo was mainly a painter and a draftsman. In his *Treatise on Painting* (which has been translated into most languages), he provided timeless observations on drawing, such as his assertion in the chapter entitled 'Drawing: Outlines and Reliefs': 'The closer the outlines of a figure are to our eyes, the sharper and lighter they appear.'

Leonardo drew anything that motivated his imagination and intelligence: plans and sketches of his inventions, studies of figures both still and in motion, intricate botanical illustrations, landscape and figure sketches, studies of poses and facial expressions, caricatures, and self-portraits. He drew for the sake of drawing and made use of all materials and techniques known at that time. It is also well known that he loved preparing new colours, developing new binding media, new solvents, and varnishes.

Leonardo drew on papers tinged with blue, green, ochre, yellow, cream or pink, using crayon or pen with inks of various colours. He also combined media, for example, crayon, charcoal and metalpoint. He paid great attention to tones, chiaroscuro, and sfumato, which he did with his fingers. He improved upon the 'hard and dry style' (as the great art historian Vasari called it) of the Quattrocento. His interpretation of contrast, space and atmosphere looks very modern, and he never fell into affectation.

Leonardo, though he belonged to the generation before Michelangelo and Raphael, was truly one of the three great creators of the High Renaissance.

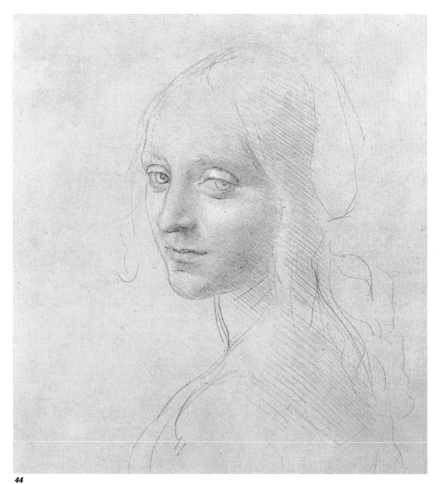

44

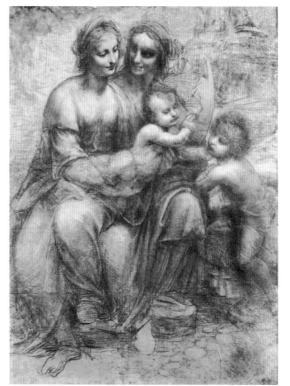

46

Fig. 44 Leonardo da Vinci (1452-1519). Study for Virgin of the Rocks. National Library, Turin.

Fig. 45 *Virgin of the Rocks* (detail). Louvre, Paris. The structure of the face and its subtle value gradation make this an example of a perfectly finished drawing.

Fig. 46 Leonardo da Vinci. *The Virgin and Child with Saint Anne.* National Gallery, London.

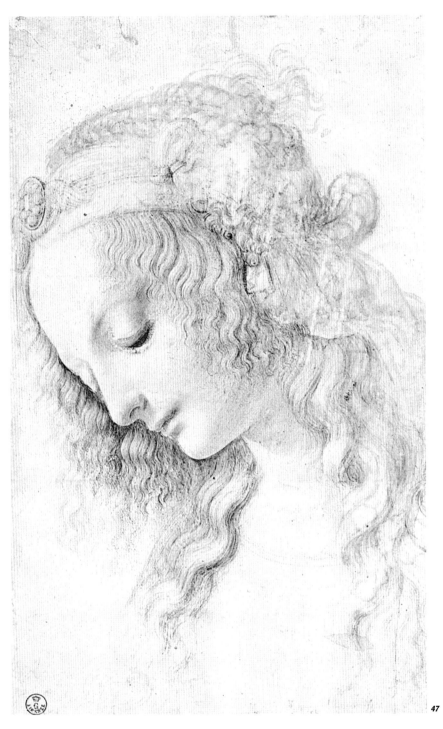

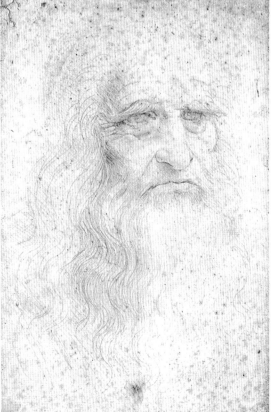

48

47

49

Fig. 47 Leonardo da Vinci. *Woman's Head*. Uffizi, Florence.

Fig. 48 Leonardo da Vinci. *Madonna and Child with a Cat*. Ink on paper. British Museum, London.

Fig. 49 Leonardo da Vinci. *Self-portrait*. Sanguine. Metropolitan Museum of Art, New York.

Michelangelo

One of the great challenges for 15th-century sculptors was making the pyramidal composition of the dead Jesus stretched almost horizontally in the lap of his mother Mary. Michelangelo Buonarroti managed to accomplish it when he was only 24. The *Pietà* in Saint Peter's, Rome, is the most sublime composition of the death of Jesus Christ. Thirteen years later, at the age of 37, he finished the ceiling of the Sistine Chapel, the greatest wall painting of all time, 'with three hundred square metres and 343 figures' (Papini). Michelangelo was also an architect and was in charge of the work at Saint Peter's Basilica in Rome, the design of its dome being his personal masterpiece.

Like many Renaissance artists, Michelangelo was a poet. He was a prolific draftsman as well. About five hundred of his drawings, most of them studies of figures for wall paintings or pictures, have been preserved. Some of these drawings are only sketches, but others are entirely finished. Some of them are made with charcoal, others with crayon. They were done on ochre or cream paper with highlights in white chalk.

Before he died, Michelangelo had the opportunity to read his own biography. Written by the art historian Vasari, it stated that he was the greatest of all sculptors, painters, and draftsmen and one of the best architects and poets. It is a curious fact that while he was painting the Sistine ceiling, Michelangelo abhorred his recognition as a painter since he regarded himself primarily as a sculptor. To his friend Giovanni da Pistoia he said: 'Giovanni, defend my dead painting and my honour as an artist for ... I am no painter.'

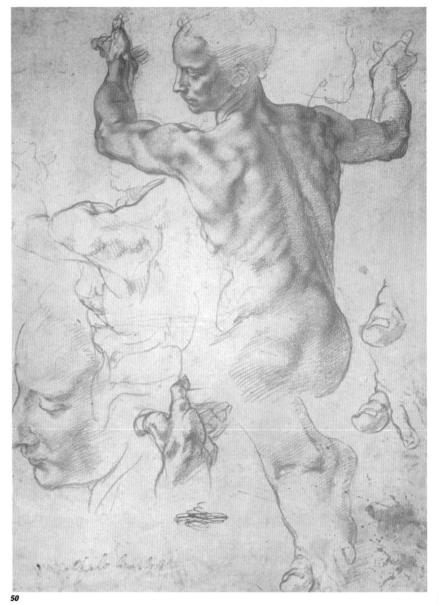

50

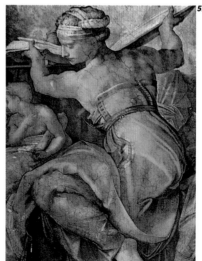

51

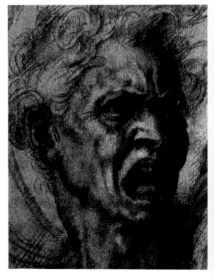

Fig. 50 Michelangelo (1475-1564). *Studies for the Libyan Sibyl* (detail). Sanguine on yellow paper. Metropolitan Museum of Art, New York.

Fig. 51 *The Libyan Sibyl.* Fresco on a wall of the Sistine Chapel. Vatican, Rome.

Fig. 52 *Soul of a Convicted Person.* Charcoal. Uffizi, Florence.

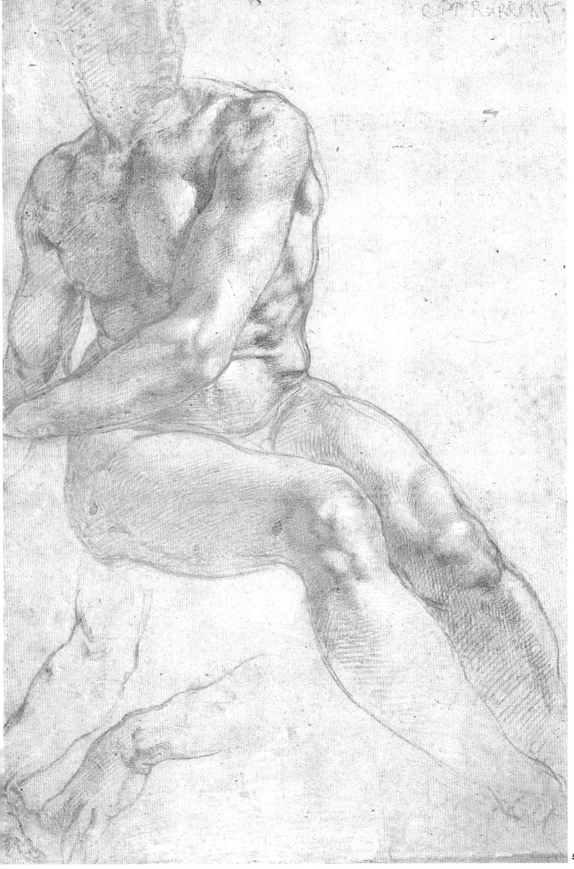

Fig. 53 Michelangelo. *Naked Man Seated*. Sanguine drawing highlighted with white chalk. Albertina, Vienna. The study of the Sibyl (opposite page) and this one of a man sitting are two excellent examples of the artistic abilities of Michelangelo in every aspect of drawing: the perfect construction of the form, proportions, and dimensions; the subtle gradations of tone, the precision of the highlighted areas, and a perfect resolution of the shaded area setting off the chiaroscuro effects, the light on the shade. There is also a masterful lesson in anatomy to be found here. Anatomy was a subject unknown in those times; Michelangelo studied it for himself by going to the morgue at Holy Ghost Hospital in Florence, where he would work secretly by the light of an oil lamp. In those times, the dissection of a corpse, even for scientific study, was completely forbidden and punished with a prison term.

53

Raphael

Raphael was born in Urbino, Italy, on 6 April 1483. His mother died when he was 8 and his father when Raphael was 11. We do not know much about him until he was 17, when we find him working in Perugino's workshop. He then signed his first contract to paint *The Coronation of the Blessed Nicholas of Tolentino*. At 19 he painted *The Coronation of the Holy Virgin* and at 21, *The Marriage of the Virgin*, which was admired by all his contemporaries, even Perugino.

Pope Julius II called on Raphael when the artist was 25 (1508) to decorate the walls of the *Stanze*, the rooms at the Vatican, with wall paintings. Perugino, Bramantino and Sodoma were already working on these rooms. The Pope entrusted the first room, the *Stanza della Segnatura*, to Raphael. But no sooner did he see the first sketches than the Pope gave all the rooms to him, 'dismissing the rest and their stories', according to Vasari. By then Michelangelo was thirty-three and had already begun the ceiling of the Sistine Chapel. Michelangelo and Raphael were the only artists employed by the Vatican. Six years later, Raphael succeeded Bramante as the architect of Saint Peter's. Raphael was clever; he organized a workshop with many good disciples to help him with his assignments from the Pope, kings and princes who asked for pictures, wall paintings, and tapestries. To carry out these assignments he used his own studies, sketches and drawings. What a pity that he died at 37.

Fig. 54 Raphael (1483-1520). *Study of Naked Men.* Preliminary drawing. Metalpoint and sanguine on white paper. Albertina, Vienna. Raphael's level of craftsmanship and aesthetic quality make him a master of classical drawing.

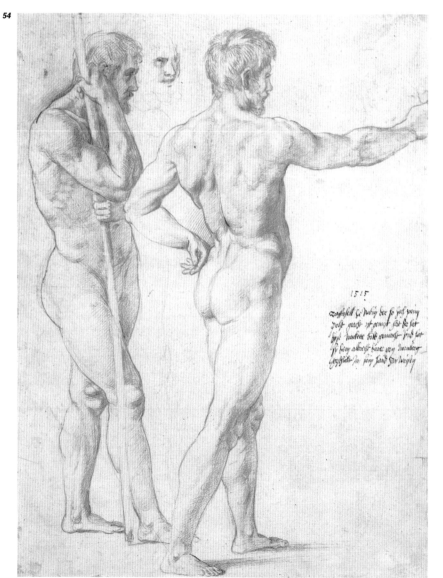

54

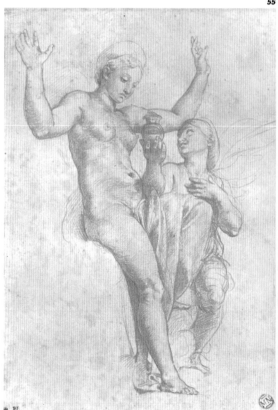

55

Figs. 55 and 56 Study for Venus and Psyche. Sanguine. Louvre, Paris. (Left) School of Raphael. *Venus and Psyche.* Farnesina, Rome.

56

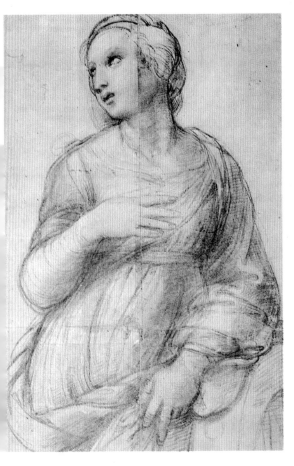

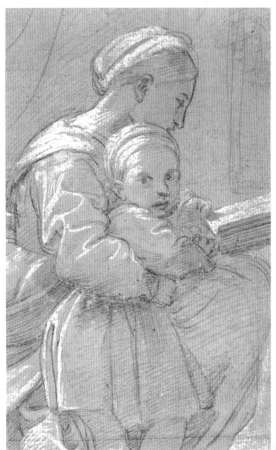

Figs. 57 and 58 Study for Saint Catherine of Alexandria. Charcoal drawing and white chalk on white paper. Louvre, Paris. (Below) *Saint Catherine of Alexandra*. National Gallery, London.

Fig. 59 Woman Reading to a Child. Metalpoint and white chalk on grey-tinted paper. Devonshire Collection, Chatsworth, England.

Fig. 60 Cartoon for the School of Athens. Sienna watercolour. Ambrosian Art Gallery, Milan.

58

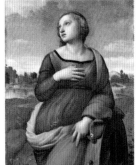

59

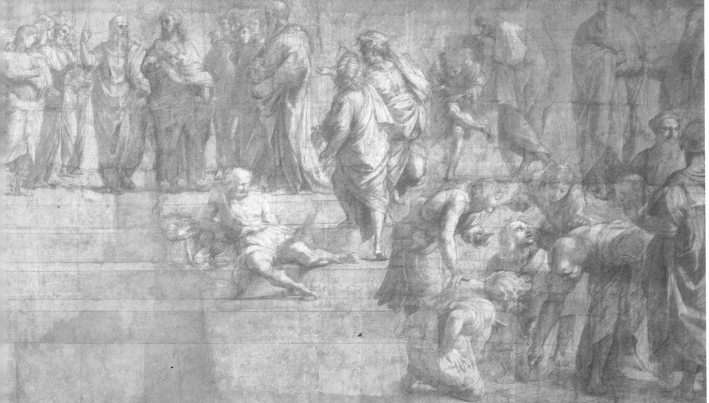

60

The Cinquecento: Florence and Rome

Lorenzo the Magnificent was known as a prince and a banker but also as a poet, philosopher, and a patron of the arts. His death in Florence in 1492, followed by the exile of his family, the Medicis, and Savonarola's dictatorship, displaced Florence as the cultural centre of Italy. It was replaced by Rome, where the patronage of Pope Julius II and the fame of the Vatican sculptures and paintings was spreading among Italian artists.

The Renaissance had begun in Florence. After Brunelleschi, Masaccio, and Donatello, the Florentines recognized Leonardo and Verrocchio as great artists. Leonardo, who studied at Verrocchio's workshop, produced such a great work in The Baptism that his master gave up painting. Andrea del Sarto, Pontormo, Rosso, and Bronzino were also Florentines. Together with Tintoretto (Venice) and Parmigianino (Parma), they started the Mannerist movement, which flourished between the Renaissance and the Baroque periods.

Rome was at that time (1500-25) the leading capital of the Renaissance. Michelangelo

and Raphael were carrying out the most representative sculptures and paintings of the age. Pope Julius II was a wholehearted lover of art. Many prominent Florentine artists in addition to Michelangelo and Raphael, and some others from Venice and Parma, met in Rome and spent time there drawing, painting, and sculpting. Even Leonardo lived in Rome between 1513 and 1516. They were all great draftsmen who valued drawing as an independent art.

Fig. 63 Jacopo Carrucci Pontormo (1494-1557). Detail of *Three Men Walking, Study*. Sanguine. Museum of Fine Arts, Lille, France.

Fig. 64 Correggio (*c.* 1490-1534). *Eve*. Sanguine and white chalk. Louvre, Paris.

Fig. 65 Parmigianino (1503-40). *Study of a Caryatid*. Preliminary drawing of metalpoint, sanguine and white chalk on cream paper. Albertina, Vienna.

Fig. 62 Barocci (*c.*1535-1612). *Study of the Head of an Old Man*. Black chalk, sanguine and white chalk on grey-green tinted paper. Hermitage, St Petersburg.

Fig. 61 Del Sarto (1486-1530). *Head of an Old Man*. Charcoal. Uffizi, Florence.

61

62

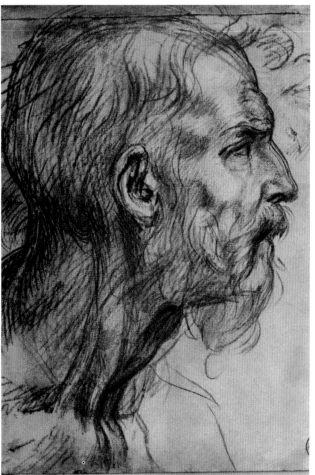

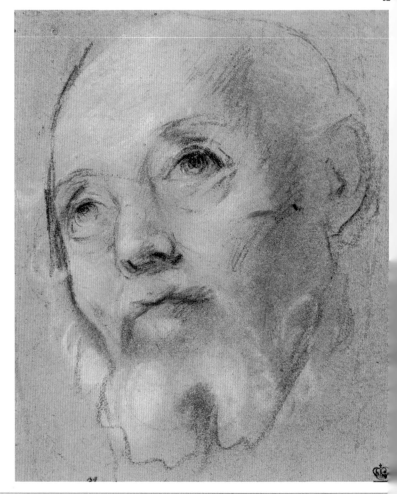

63

64

65

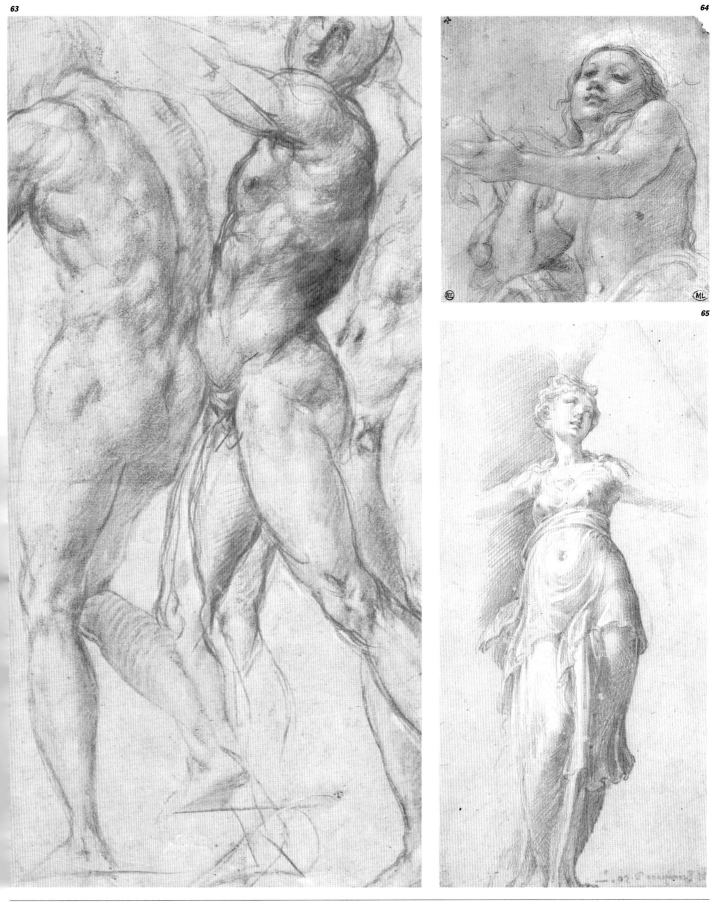

The Cinquecento: Venice

Titian, the great Venetian artist, painted his pictures without any preliminary sketches. He did not worry about constructing his forms linearly but created shapes by means of colour stains in a style that almost anticipated Impressionism.

Among Titian's colleagues in Venice were Lotto, Veronese and Sebastiano del Piombo, who collaborated with Titian in the completion of several works left unfinished by Giorgione. Most of these Venetian artists drew with charcoal, black chalk, or Italian stone, a material quite similar to our carbon pencil, though softer. The fact that these artists favoured these materials rather than metalpoint is understandable because Venetian painting emphasized colour which, when translated to drawing, implies a more thorough and expressive pencil stroke.

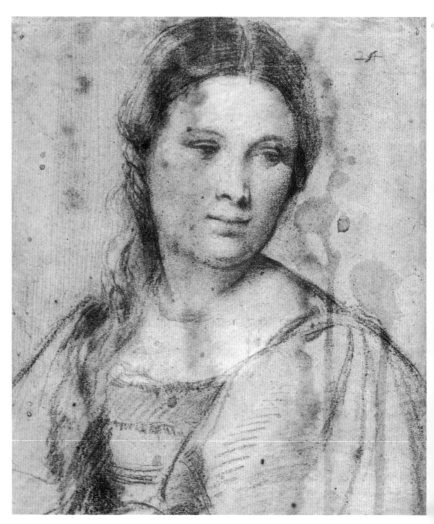

67

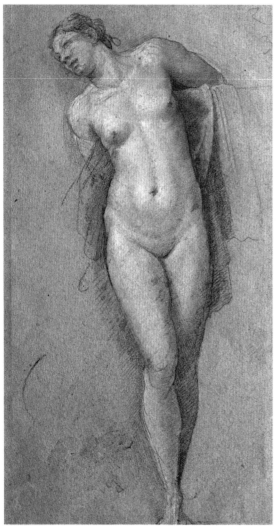

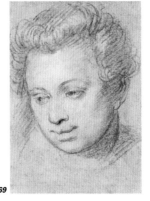

68

69

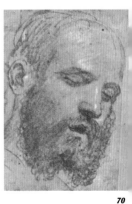

70

Fig. 66 Titian (1490-1576). *Portrait of a Young Woman.* Charcoal and white chalk on ochre-grey tinted paper. Uffizi, Florence.

Fig. 67 Del Piombo (1485-1547). *Naked Woman Standing.* Charcoal and white chalk on blue-tinted paper. Louvre, Paris.

Fig. 68 Tintoretto (1518-94). *Study of the Roman Bust of Emperor Vitellius.* Black chalk and white chalk. Staatliche Museum, Munich.

Fig. 69 Veronese (1528-88). *Head of a Woman.* Black chalk and white chalk on blue paper. Art Institute of Chicago.

Fig. 70 Lotto (1480-1556). *Head of a Bearded Man.* Black chalk and white chalk on dyed *verdaccio.* János Scholz, New York.

The Renaissance in Europe: Dürer

Albrecht Dürer was an outstanding engraver and draftsman with a tremendous talent for assimilating new ideas. A German, Dürer travelled constantly, introducing Italian ways and ideas to northern Europe, listening to everybody and teaching what he knew. During his journeys to Italy he was apprenticed with Bellini, Titian, Leonardo, and Mantegna. He lectured on the art of woodcut illustration, and thanks to his efforts, this art form spread all over Europe.

Dürer's work consists of many woodcuts, engravings, drawings, watercolours (an unusual medium at that time, which Dürer pioneered), and oil paintings, as well as treatises on medicine, fortifications, and artistic theory.

Woodcuts and etching

At the beginning of the 16th century, Albrecht Dürer was the supreme master of wood and cooper engraving in Europe. Wood cutting (xylography) is done in a thick wooden block. On its even and polished surface the artist engraves an image with a chisel and a gouge, cutting away the parts meant to be white in the final picture, so that the parts meant to be in black stand out on the surface. After this, the surface is inked. A sheet of paper is placed against the block and rubbed with a burnisher. Thus we get the first proof.

An etching is engraved on a copper plate which has been coated with an acid-proof resin. The plate is engraved with a burin which removes the resin and leaves the metal exposed. Then the plate is soaked in nitric acid, which dissolves the metal in the exposed parts. After removing the rest of the resin, the plate is inked so that the ink fills the grooves. Finally, a proof is printed by pressing a sheet of paper against the plate with the help of a hand printing press.

71

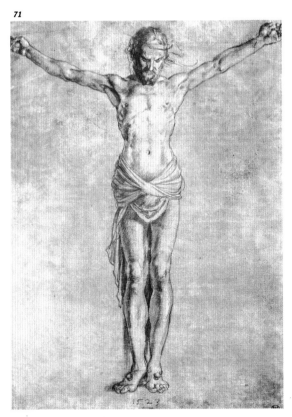

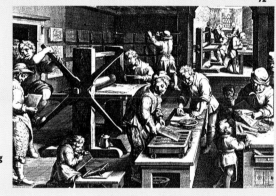

72

Fig. 72 Van der Straet, known as Stradamus (1530-1605). Printing with copper plates from the 16th century. Etching from *Nova reperta et alia.*

73

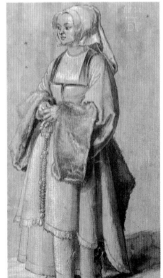

Fig. 71 Dürer (1471-1528). *Christ on the Cross.* Lead metalpoint and white chalk on cream paper. Louvre, Paris.

Fig. 73 Dürer. *Girl Dressed as a Dutch Woman.* Sepia watercolour and white tempera (gouache). National Gallery of Art, Washington.

Fig. 74 Dürer. *The Four Horsemen of the Apocalypse* (detail). Engraving in xylography.

74

The Renaissance in Europe

Culturally speaking, one of the most significant achievements of Italy was the artistic conquest of Europe. Except for a few exceptional artists, such as those in the workshop of the Flemish painter Pieter Brueghel, the influence of Italy was ever-present during the 15th and 16th centuries in the workshops of European artists. The new theories about perspective (Uccello and Piero), the rediscovery of anatomy by means of dissection drawings (Leonardo and Michelangelo), the latest techniques of *sfumato* and chiaroscuro (Leonardo), as well as the Renaissance subjects with man as the centre, fascinated Dürer, inspired Holbein, suggested new subjects to Gossaert (also called Mabuse), and compelled most artists to travel to Italy in order to grasp the essence of the Renaissance. Unfortunately for art, the Renaissance came to an end around the beginning of the 16th century, when the Protestant Reformation began. In 1527, the army of Charles V conquered and sacked Rome, causing the bankers to flee and the artists to disperse. Around that time artists abandoned the quiet classicism of Renaissance art in search of a more intellectual style that came to be known as Mannerism.

Fig. 75 Holbein, the Younger (1497-1543). *Portrait of Anna Meyer.* Coloured chalks. Kunstmuseum, Basel.

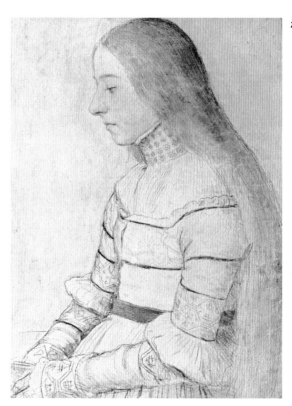

Fig. 76 Baldung, also called Grien (1484-1545). *Saturn.* Charcoal. Albertina, Vienna.

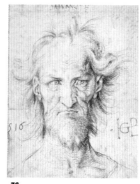

76

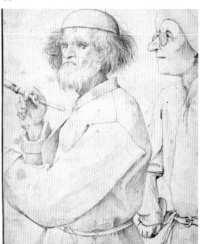

78

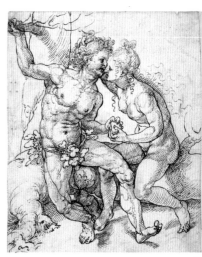

79

Fig. 78 Brueghel, the Elder (1525-69). *The Painter and the Critic.* Bister ink. Albertina, Vienna.

Fig. 79 Gossaert, also called Mabuse (c. 1478-1532). *The Fall of Man.* Dark sepia ink. Albertina, Vienna.

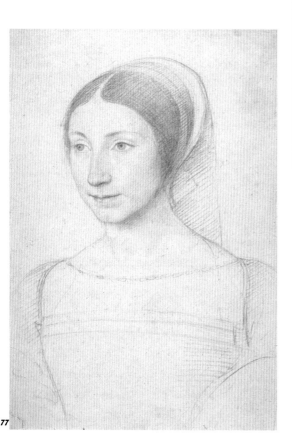

Fig. 77 Clouet (1485/90-1541). *A Lady.* Charcoal and sanguine. British Museum, London.

77

The Baroque period: the drawing academies

When Luther began the Protestant Reformation in Wittenberg, in 1517, the Roman Catholic Church answered with a bigoted attitude towards customs and art. After the Counter-Reformation, the Church became more tolerant and tried to develop a more imposing look to reassert its authority. Icons were renewed. More emphasis was put on the representation of supernatural concepts such as the triumph of faith, the papacy, saints, the Immaculate Conception, heaven and glory. On the other hand, kings and princes were so keen on splendour that they promoted huge projects and sumptuous decorations. Thus arose the Baroque style: a visual, dynamic type of art characterized by extravagant forms and gesticulating figures. It is said that Correggio and his imitators and even Michelangelo in his *Last Judgment* had already begun the Baroque period. However, the ones who really determined the new style were the Carracci family and Caravaggio. The Carraccis were a Bolognese family of three artists: Ludovico, the eldest, the first artist to systematize the teaching of life drawing, and his cousins, Annibale and Agostino. The three of them founded an academy in Bologna. This academy became the School of Bologna, frequented by artists such as Domenichino, Reni, Albani... Drawing and classical painting were taught there following the great masters of the Renaissance, and avoiding the artificial realism of Mannerism. Annibale was the greatest of the Carraccis. He had many followers and painted, among other things, the ceiling of the Farnese Gallery, Rome, considered among the best frescoes of the 16th century. Academies of drawing proliferated throughout the 16th and 17th centuries not only in Italy but all over Europe.

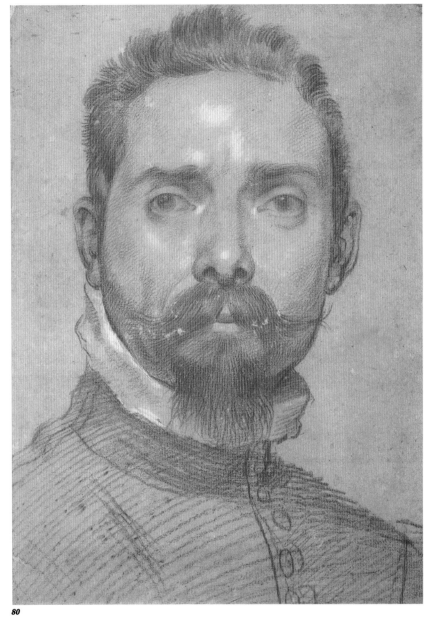

80

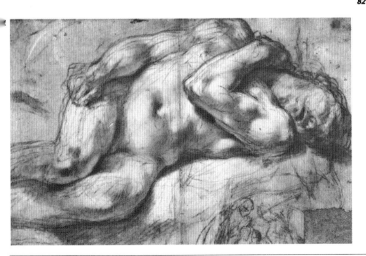

82

Fig. 80 Annibale Carracci (1560-1609). *Portrait of a Member of the Mascheroni Family*. Sanguine and white chalk on sepia-tinted paper.

Fig. 81 Agostino Carracci (1557-1602). *Dead Man Lying Down*. Sanguine and white chalk. János Scholz, New York.

Fig. 82 Ludovico Carracci (1555-1619). *Head of a Woman Looking to the Left*. Charcoal and white chalk on beige paper. Metropolitan Museum of Art, New York.

The Baroque period: *Caravaggio*

When the Carraccis had already established the Baroque as a theatrical and sentimental, though careful and harmonious, style, the revolutionary style of Caravaggio appeared, though Baroque too in his way. It was said that he had come to this world 'to destroy the art of painting' (Poussin), though other artists like Rubens admired him and copied his paintings. Caravaggio was the founder of the naturalistic style, which was followed by all the great masters of the century: Ribera and Velázquez in Spain, La Tour and the Le Nain brothers in France, Rubens in Flanders, and Rembrandt in the Netherlands. Unfortunately, we do not know of any drawings by Caravaggio. However, we do know that he used to begin his paintings without sketching first, painting and drawing all at once, as Titian and Velázquez were known to do.

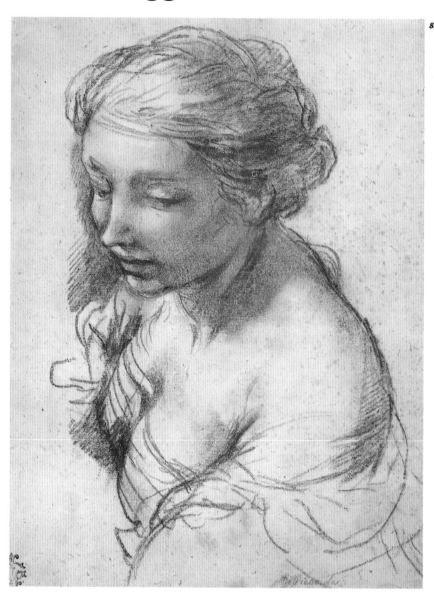

Fig. 83 Pietro da Cortona (Berrettini) (1596-1669). *Study of a Young Woman.* Black chalk, sanguine and white chalk on grey paper. Albertina, Vienna.

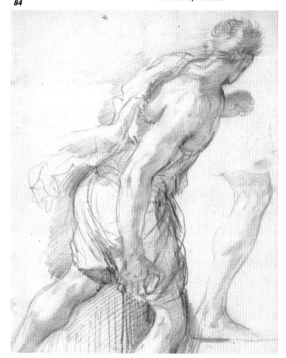

Fig. 84 Mola (1612-66). *Figure Running with a Stone in his Hand.* Charcoal and sanguine. British Museum, London.

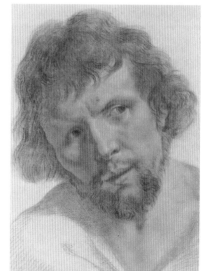

Fig. 85 Le Guide (1575-1642). *Head of a Youth.* Black chalk and sanguine. Hermitage, St Petersburg.

Fig. 86 Poussin (1593/4-1665). *Landscape with River.* Ink and bister wash. Albertina, Vienna.

Rubens

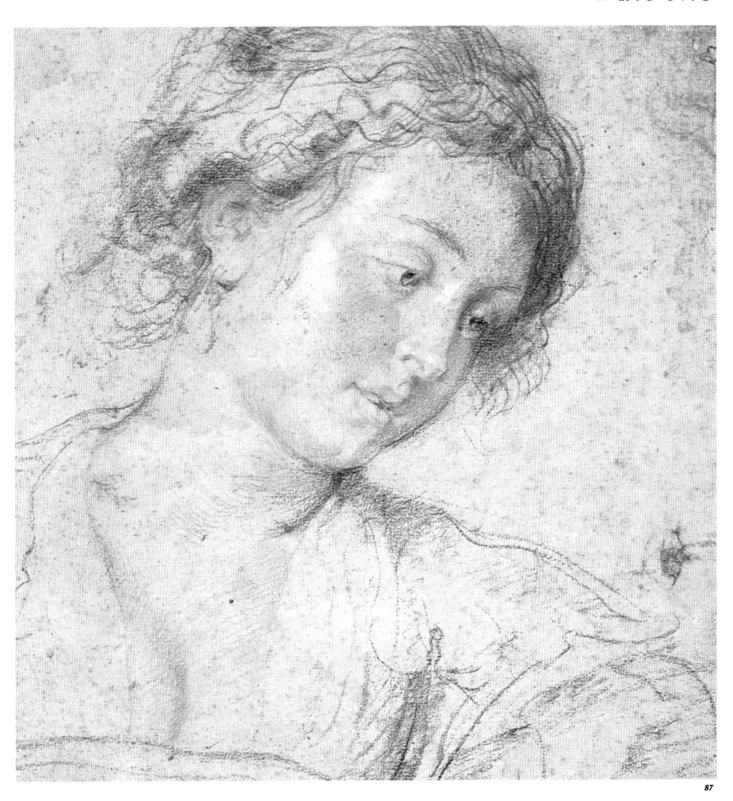

87

Fig. 87 Rubens (1577-1640). ***Young Woman with Crossed Hands*** (detail). Black chalk, charcoal, sanguine, and white chalk on cream paper. Boimans-Van Beuningen Museum, Rotterdam. Rubens's biographers say that he drew with an extraordinary rapidity and a confident and expressive line. These qualities are evident in this drawing: the contours of the hair are spontaneous and the features are drawn *alla prima*. Note the subtle gradations of the eyes, nose, and mouth, with just the right values and contours. Note also the range of colour achieved using only black chalk, red sanguine, white chalk and a cream-coloured background.

Rubens

In 1621, Peter Paul Rubens sent a letter to William Trumbull, a man closely connected with the English court, acknowledging the return of a picture painted for the English ambassador to Holland. In that letter Rubens also promised to paint another picture 'entirely himself' and added, in answer to the ambassador's complaints, that he had never been told whether the picture was supposed to be Rubens's work alone or simply delegated to his apprentices.

Indeed, many of the pictures attributed to Rubens were painted by his followers and pupils. Rubens was a very busy man. In addition to his work as an artist, he was also a diplomat in the service of the governors of Flanders, and took on assignments given by kings and princes. To meet all these obligations and still be able to paint more than 2,500 paintings during his lifetime, Rubens organized his work and workshop employing followers and pupils such as van Dyck, Jordaens, Snyders, van Unden, and Wildens. The whole team worked from drawings and watercolour sketches by Rubens. Sometimes Rubens did not participate in the final resolution of these paintings. Only when the patron demanded greater accuracy did Rubens take part in painting the head, hands, or arms of the most visible figures. No wonder then that Rubens's artistic capacity is judged nowadays both by his drawings and sketches and by the finished works. His biographers recount that he drew amazingly fast, with clear, long, and expressive lines. He preferred cream-coloured paper and charcoal or black stone. To emphasize light and brightness, he used white chalk, or sanguine if the colour of flesh was required.

Fig. 88 Rubens. *The Fall of the Convicted Man.* Charcoal. British Museum, London.

Fig. 89 Rubens. *Lion.* Black, yellow, and white chalk on grey-sienna paper. Louvre, Paris.

Fig. 90 Rubens. *Male Figure Bending Down.* Sienna and white chalk on beige paper.

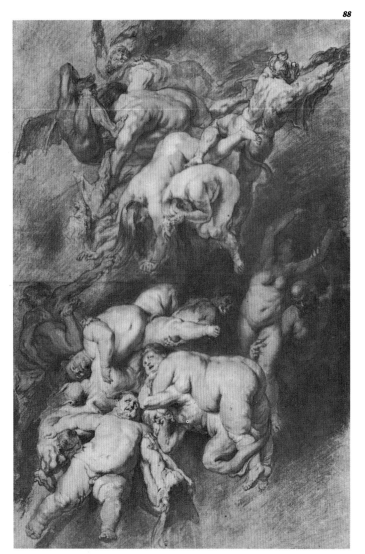

88

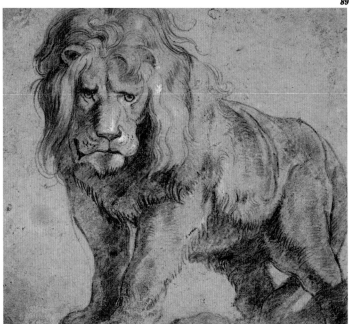

89

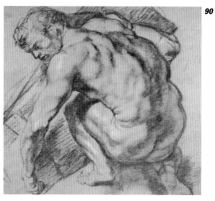

90

Rembrandt

Rembrandt is another example of a master painter and draftsman. In 1851, the painter Delacroix dared to foretell that one day Rembrandt's art would be regarded as superior to Raphael's. In response, Ingres called Delacroix a heretic. However, Delacroix's prophecy has been fulfilled. Today, Rembrandt is regarded as one of the great masters of the art of painting and drawing, as good as Raphael, if not better.

About 600 paintings are attributed to Rembrandt, along with 300 etchings combined with drypoint, and about 2,000 drawings, many of which were executed in sanguine and wash. In addition to Rubens, other contemporaries of Rembrandt were Jordaens, van Dyck, and Teniers in Flanders; Ribera, Zurbarán, Velázquez and Murillo in Spain; and the Le Nain family, Poussin, La Tour and Claude Lorrain in France.

93

91

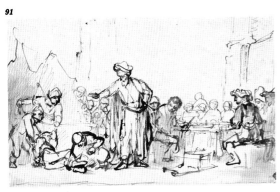

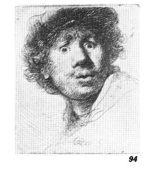

94

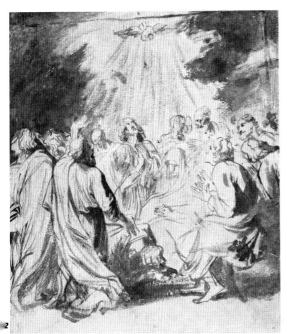

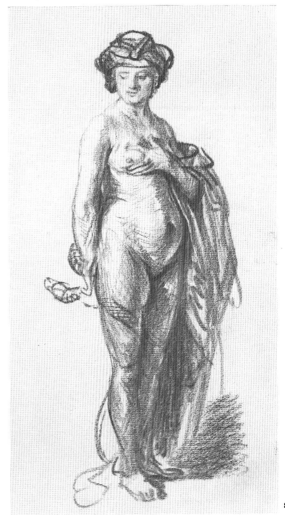

Fig. 91 Rembrandt (1606-69). *Biblical Scene.* Bister and watercolour wash. Albertina, Vienna.

Fig. 92 Van Dyck (1599-1641). *Pentecost.* Sienna ink. Hermitage, St Petersburg.

Fig. 93 Rembrandt. *The Omval at the River Amstel.* Etching. British Museum, London.

Fig. 94 Rembrandt. *Self-portrait Expressing Terror.* Rijksmuseum, Amsterdam.

Fig. 95 Rembrandt. *Cleopatra.* Sanguine on cream paper. Villiers David, London.

95

The 18th century in Italy and England

In the 18th century, many Italian artists, such as Ricci, Canaletto, Guardi, Piranesi, Carlevari, and Panini, used to draw *vedutas* (views of Venice and the ruins of ancient Rome), which were reproduced as etchings printed in sepia and black. These *vedutas* were to be sold to foreign visitors, particularly English tourists who wanted a souvenir of their visit to ancient Rome. While looking at those sheets printed in black, someone had

Fig. 96 Canaletto (1697-1768). *Country House and Tower on the Edge of a Small Lake.* Sienna and ochre wash and ink. Hermitage, St Petersburg.

the idea of colouring them with transparent watercolours. Paul Sandby, 'the father of watercolour', according to English experts, developed this work into a fine art. By the end of the 18th century, artists such as Cozens, Pars, Towne, Gritin and Turner made watercolour the English national art. In Italy, Giambattista Tiepolo, known for his wall paintings and frescoes, left hundreds of wash drawings as sketches for his decorative art.

96

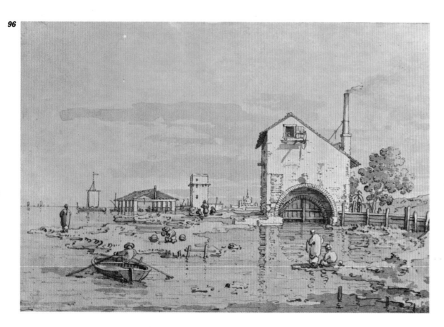

97

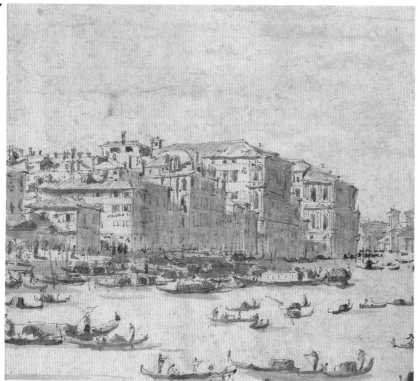

98

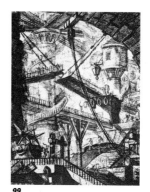

99

Fig. 97 Guardi (1712-93). *Houses on the Grand Canal, Venice.* Sienna wash and ink. Albertina, Vienna.

Fig. 98 Tiepolo (1696-1770). *Saint Jerome in the Desert Hearing Angels.* Sienna wash and ink. National Gallery of Art, Washington.

Fig. 99 Piranesi (1720-78). *Prisons.* Engraving. Beid Colnaghi, London.

France: the Rococo period

During the Renaissance, Italy was the artistic centre of the world, and during the Baroque period Flanders had that distinction. After that, France determined styles and tendencies in art. The new French style was called Rococo. It inherited from the Baroque its luxury, sensuousness, and ornamentation. This new style changed elegant ornamentation into fine arrangements and substituted a more intimate and delicate representation for the expressive force and dynamism of the Baroque.

Fig. 100 Watteau (1684-1721). *Three Studies of the Head of a Black Youth.* Charcoal, sanguine, and white chalk on cream paper. Louvre, Paris.

Famous artists of the Rococo period were Watteau, Boucher, and Fragonard. Watteau was regarded as a painter of *fêtes galantes*. He was an admirer and a follower of Rubens. A great draftsman, Watteau kept thick sketchbooks filled with hundreds of drawings of figures, heads, hands, and clothes, which he used for his paintings. Boucher was a pupil of Watteau and excelled as a decorator, a draftsman, and a painter of charmingly irreverent intimate and mythological scenes.

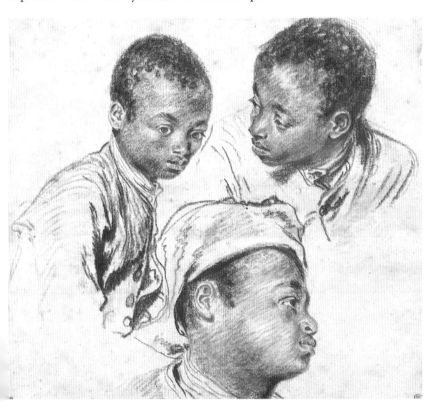

101

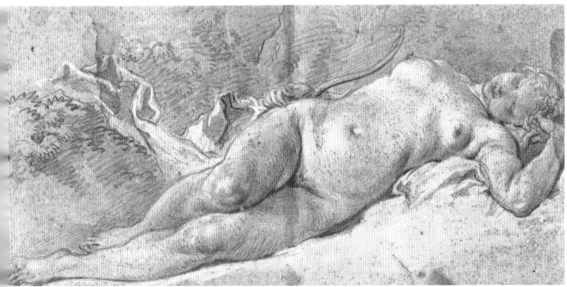

Fig. 101 Fragonard (1732-1806). *Angelica Appears Before Sacripante.* Charcoal with touches of ochre, grey, and sienna watercolours. Museum of Art, Princeton University.

Fig. 102 François Boucher (1703-70). *Diana Sleeping.* Sienna chalk and white chalk on beige paper. School of Fine Arts, Paris.

102

The 18th century in England and Spain

Fig. 103 Francisco de Goya y Lucientes (1746-1828). *The Disasters of War: With or Without Reason*. Etching. National Chalcography, Madrid. Goya is an exceptional Spanish artist. In addition to his well-known paintings, he made hundreds of drawings and engravings on social subjects and as protests against war. These pictures are admired the world over for their drawing quality and powerful imagery.

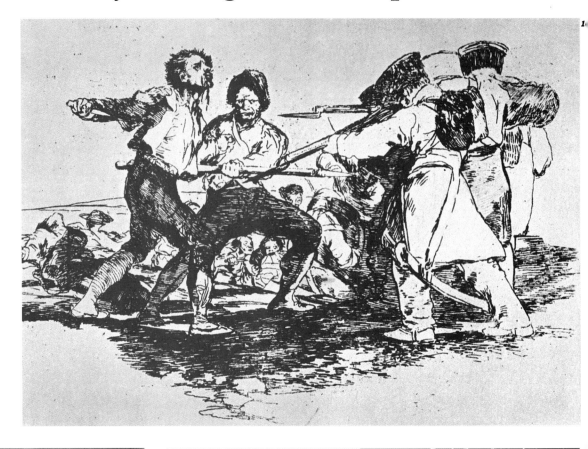

Fig. 104 Gainsborough (1727-88). *Study of a Woman*. Possibly for the painting *The Stream at Richmond*. Charcoal and sienna chalk with white gouache on buff paper. British Museum, London.

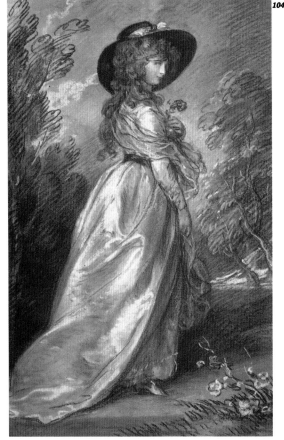

Fig. 105 Cozens (*c.* 1717-86). *Composition for a Landscape*. Indian ink. British Museum, London.

Fig. 106 Ingres (1780-1867). Study for the painting *Turkish Bath*. Lead pencil. Louvre, Paris.

Fig. 107 Prud'hon (1758-1823). *Venus*. Charcoal and white chalk on blue paper. National Gallery of Art, Washington D.C.

Fig. 108 Corot (1796-1875). *Landscape*. Charcoal. British Museum, London.

Neoclassicism

On 14 July 1789, the Bastille was stormed and the French Revolution erupted. Jacques-Louis David, the painter of the Revolution, established the grounds for a new classical style, a reflection of the ancient Roman republic. This new style was called Neoclassicism. Its outstanding representative is Jean-Auguste-Dominique Ingres, a proponent of classicism and an exceptional draftsman. Ingres is known for his sketches and portraits in lead pencil, as well as his paintings. He was also known for his sayings, such as, 'you paint the same as you draw', 'the details are tell-tales one has to keep under control', or 'the good draftsman must keep an eye on everything'. During his lifetime, Ingres was a controversial painter because of his academic style. His dogmatism and sensitivity to criticism often led to a conflict with critics. His most passionate enemies were Géricault and Delacroix.

The German Anton Mengs was also a prominent artist of that time. He was one of the best-known artists of the Neoclassical period, a child prodigy who could make great pastel portraits at 13 and who was appointed chief painter of the Dresden court at 17. In France, Prud'hon, who already hinted at Romanticism, and Corot, who began as a classicist and whose last pictures placed him close to Impressionism, were also important.

106

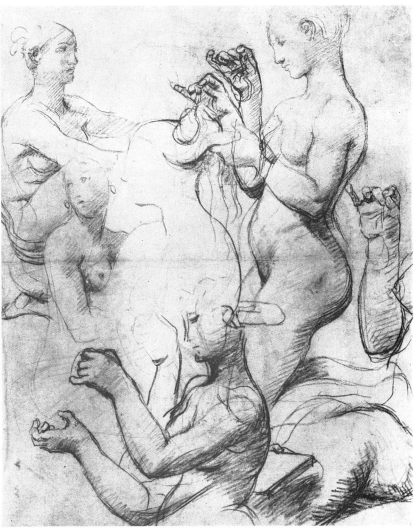

107

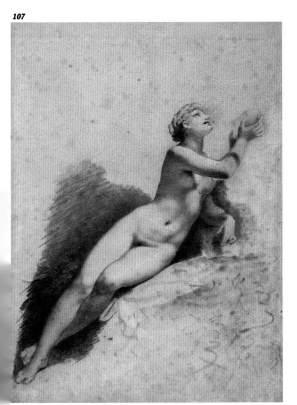

108

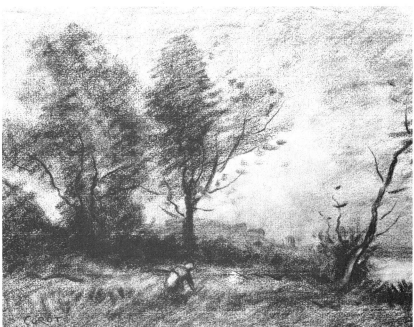

Romanticism and realism

Romanticism is a passionate reflection of the imaginative and individualistic spirit of the 19th century. Realism, on the other hand, rejects the great historical subjects and the dramatic contents of Romanticism to develop a style whose intention is to reproduce nature faithfully. Delacroix was an important spokesman of Romanticism. A great colourist, he was a master of sketches and drawings. Théodore Géricault in France, and Henry Fuseli and William Blake in England were other prominent Romantic painters.

Daumier, Rousseau, Courbet, and Millet in France, and Fortuny in Spain were the foremost Realist artists of this period. Turner, Corot, Boudin, and the American Winslow Homer began as Romantics and went on to pioneer Impressionism. It is notable that all the artists of this period were excellent draftsmen, particularly Delacroix, with his thick sketchbook filled with hundreds of drawings; Blake, who was an illustrator of books and of his own poetry; Daumier, a painter of social themes; Fortuny, a great watercolourist; Corot, with his studies of nature; and Homer, an illustrator and watercolourist.

Fig. 109 Delacroix (1798-1863). *Study of a Female Nude for the Death of Sardanapalus.* Pastel. Louvre, Paris.

Fig. 110 Courbet (1819-77). *Self-Portrait, Man with Pipe.* Charcoal. Wadsworth Atheneum, Hartford, Connecticut.

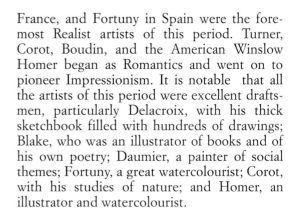

109

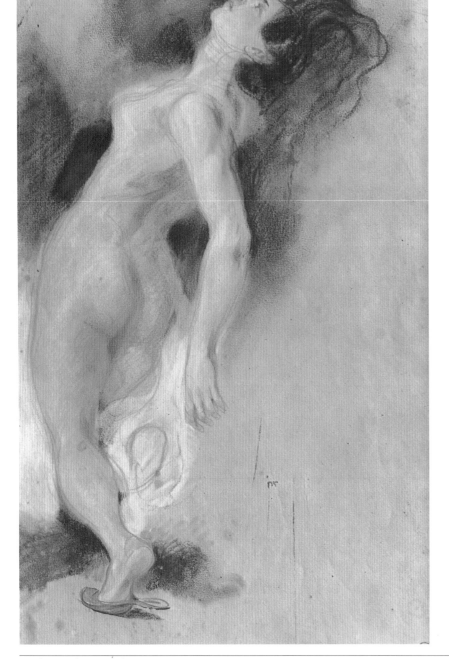

Impressionism

Monet, Manet, Pissarro, Renoir, Degas, Sisley, Cézanne, Boudin, Morisot... In the 19th century, during the sixties and seventies, the great jury of the Salon de Paris refused the pictures of these artists. In trying to find outlets for their works, they organized the so-called Salon des Refusés (the Exhibition of the Rejected). The exhibition was a complete failure. In the *Figaro* newspaper an account of the exhibition read: 'five or six lunatics – one of them a woman – a group of poor devils tempted by a foolish ambition, have joined together to exhibit their pictures ... a terrible spectacle of human vanity bordering on madness'. The title of one of the pictures exhibited was *Impression, Soleil Levant* (*Impression, Sunrise*) by Claude Monet, which

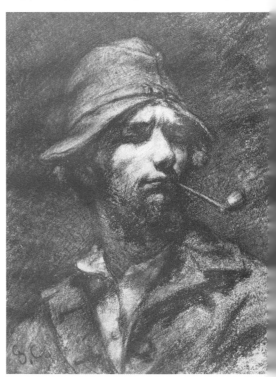

Impressionism

inspired the critic M. Leroi to ridicule the members of the group by calling them Impressionists. The word *Impressionism* was included by these artists in their group exhibition of 1874.

Impressionism meant a real revolution: it entailed a radical change in the colours of the artist's palette, in composition, in subject matter, and in technique. It also changed the environment of the painter from the academic studio to the outdoors.

All Impressionists relied on drawing: Degas, with his extraordinary pastels, is perhaps the master draftsman of all time; Toulouse Lautrec is known for his sketches in coloured pencils or chalk; and van Gogh showed the same expressiveness in his pencil and ink drawings that he did in his paintings. The drawings of Impressionists are fine examples of a style that became a prelude to modern art.

Figs. 111 and 112. Manet (1832-83). *Portrait of Madame Jules Guillemet.* Charcoal. Hermitage, St Petersburg. This drawing served as a preliminary sketch for the finished painting shown in Fig. 112.

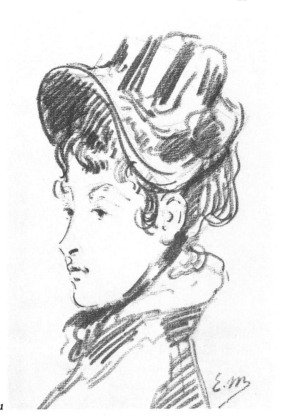
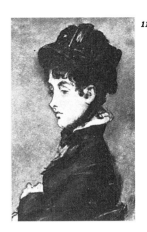
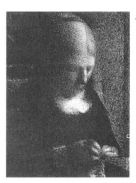
111
112
113

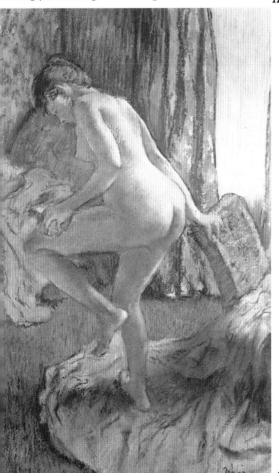
114

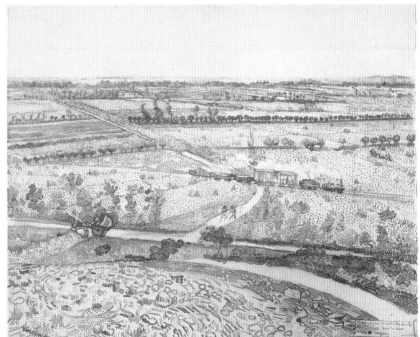
115

Fig. 113 Seurat (1859-91). *Woman Embroidering.* Conté crayon. Metropolitan Museum of Art, New York.

Fig. 114 Degas (1834-1917). *After the Bath.* Pastel. Durand Ruel Collection, Paris.

Fig. 115 Van Gogh (1853-90). *La Grau Seen from Montmajour.* Pencil, red pen, pen, brown and black ink on Whatman paper. Rijksmuseum, Amsterdam.

Drawings by modern masters

It is impossible to summarize in a few lines the vast number of drawings, noted artists and styles of art that exist in the 20th century. But the following comprise the major artistic movements that have developed in the last hundred years: Post-Impressionism, the foremost artists of which are van Gogh, Gaugin and Cézanne; Pointillism, in which Seurat is the major figure; Fauvism, including Matisse, whose artists were labelled *fauves* (wild beasts), because of their shocking synthesis of strong colours; the Nabis movement, headed by Bonnard and Vuillard, who later drifted towards Intimism, a style of art that focuses on intimate domestic interiors; Cubism, headed by Picasso and Braque and followed by Juan Gris (however, Picasso goes beyond the scope of Cubism. He was one of the greatest draftsmen in the history of art, and his work covers a multitude of styles); Surrealism, whose main representative, Salvador Dali, has expressed himself through drawing as well as through painting; Expressionism, represented by Nolde, Ensor, Modigliani, and Grosz, for whom drawing is of major importance; metaphysical painting and drawing, with De Chirico and Carra; Futurism, which exalted machines, speed, and, in some cases, the

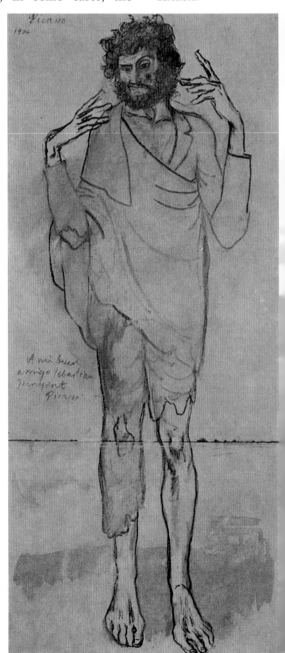

Fig. 120 Picasso (1881-1973). *The Beggar.* Watercolour on ochre paper. Picasso Museum, Barcelona.

116

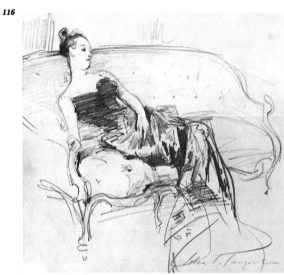

117

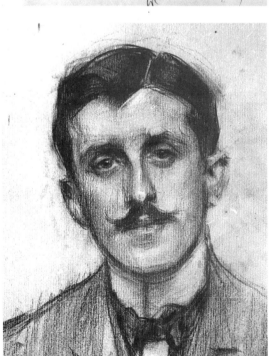

118

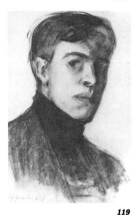

119

Fig. 116 Sargent (1856-1925). Lead pencil. Fogg Museum of Art, Harvard University, Cambridge, Massachusetts.

Fig. 117 Casas (1866-1932). *Portrait of Joaquin Alvarez Quintero.* Charcoal. Museum of Modern Art, Barcelona.

Fig. 118 Nolde (1867-1956). *Portrait of an Italian.* Xylograph. Albertina, Vienna.

Fig. 119 Hopper (1882-1967). *Self-Portrait.* Charcoal. National Portrait Gallery, Washington, D.C.

violence of 20th-century life; abstract art, which began with a watercolour by Kandinsky and was developed by Mondrian; Op(tical) art, of which Vasarely is a major figure; and Pop(ular) art, among whose major followers is the American artist R. B. Kitaj, an exceptional draftsman of figurative subjects.

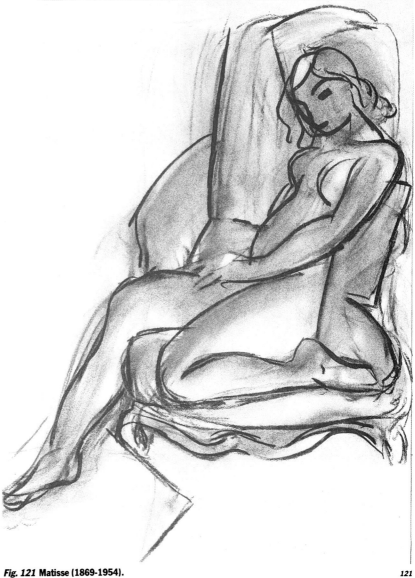

Fig. 121 Matisse (1869-1954).
Woman in an Armchair.
Charcoal.

121

123

122

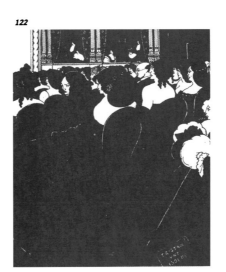

Fig. 122 Beardsley (1872-98).
The Wagnerians. Indian ink.
Victoria and Albert Museum,
London.

Fig. 123 Léger (1881-1955).
Face and Hands. Ink over
pencil. Museum of Modern Art,
New York.

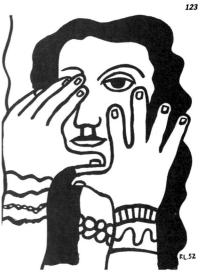

Drawings by modern masters

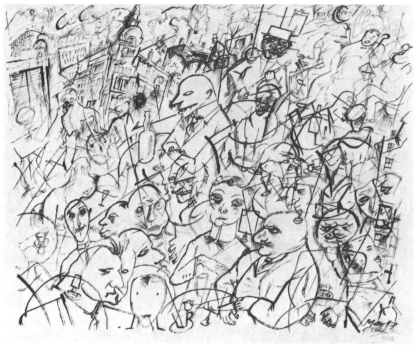

124

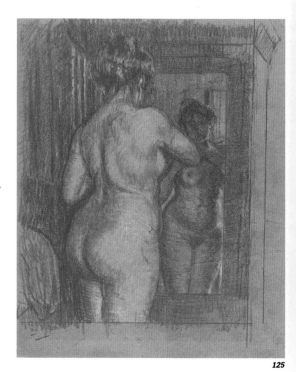

125

Fig. 124 Grosz (1893-1959).
Men in a Café. Lead pencil.
British Museum, London.

Fig. 125 Sickert (1860-1942).
Woman in Front of a Mirror.
Blue pencil and white pencil on
grey paper.

Fig. 126 R. B. Kitaj (1932-).
Marynka Smoking. Pastel over
charcoal pencil. Collection of
the artist.

Fig. 127 Schiele (1890-1918).
The Artist and His Model. Lead
pencil. Albertina, Vienna.

126

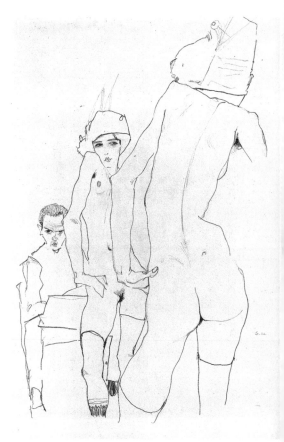

127

Materials.

How, where, and with what to draw

The essentials needed for drawing are: a 2B pencil, paper, a rubber, and some sort of drawing board. Of course, the pencil can be softer or harder, the paper can be high or low quality, white or coloured. Or, instead of a pencil, you can use another drawing instrument, such as charcoal, crayon, chalk, coloured pencils, pen, or even a brush for drawing with watercolour or ink. However, this variety of media does not alter the basic fact that to produce the best drawing of all you need only paper and pencil. Drawing is the basic graphic technique. It is the perfect means for obtaining fine-art pictures,

such as figure studies, portraits, sketches, composition studies, and preliminary studies for finished pieces; or for commercial art, such as illustrations, television commercials, and advertisements. But, how does one go about learning to draw? Where? With what? Let's go step by step, beginning with the 'how and where' first. We'll explore places where you can draw, in a studio or outdoors, and the basic equipment you'll need: furniture, lighting, sketchbooks, drawing boards, easels, and materials. After this, we'll look inside the studio at drawing techniques. We'll begin by looking at the illustrations on these pages.

Fig. 130 Sitting on a stool, a chair or an armchair, leaning the board against your lap or a table or, as in the picture, against the back of a chair, are good positions for drawing whether you are working in your own studio or in a classroom with a model. These positions for drawing come in handy when there is no easel available or when you are drawing on site.

Fig. 131 When you draw outdoors, you can use a cardboard portfolio, or clipboard, as a support, resting it on a stone, a ledge, or any other convenient surface, while you use anything suitable as a seat. This way you will only need to carry a pencil, a rubber, and the portfolio. But don't forget to bring a pair of metal clips, always essential to keep the paper smooth.

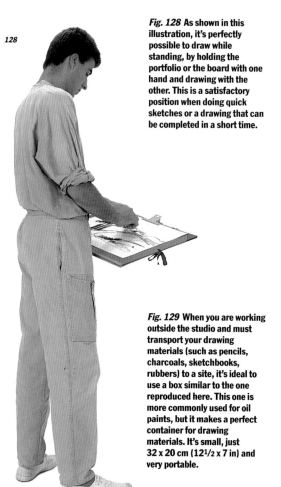

128

Fig. 128 As shown in this illustration, it's perfectly possible to draw while standing, by holding the portfolio or the board with one hand and drawing with the other. This is a satisfactory position when doing quick sketches or a drawing that can be completed in a short time.

129

Fig. 129 When you are working outside the studio and must transport your drawing materials (such as pencils, charcoals, sketchbooks, rubbers) to a site, it's ideal to use a box similar to the one reproduced here. This one is more commonly used for oil paints, but it makes a perfect container for drawing materials. It's small, just 32 x 20 cm (12½ x 7 in) and very portable.

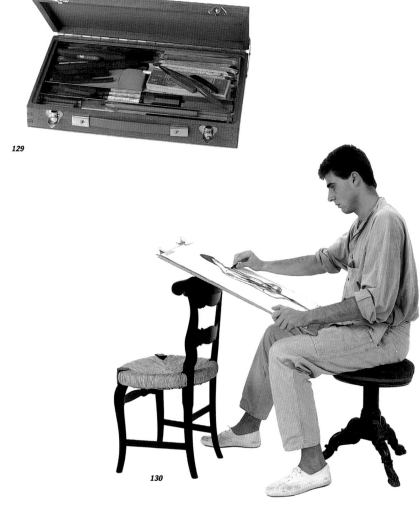

130

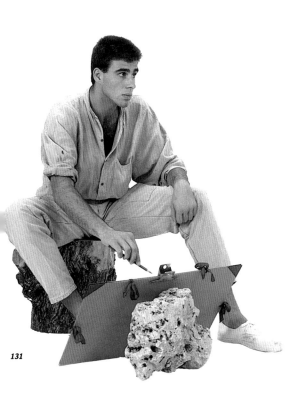

132

Fig. 132 It's convenient to keep several portfolios of different sizes in the studio in order to store your paper, to keep your finished drawings, or to use as a support when drawing outdoors. Note the black portfolio with the metal handle to help in transporting the drawings or your paper supply.

Fig. 134 This is a workshop easel complete with wheels set up for drawing, with a wooden board and drawing paper held by two clips. This classic model allows the artist to tilt the working surface forward in order to work more comfortably and to eliminate reflections. The distance between the seat and the easel enables the artist to come in closer when drawing in detail, or to lean back when observing the whole.

131

Fig. 133 This is the short-legged version of the folding easel-box. Although this box is often used for oil painting, it works just as well for drawing when you work with a portfolio or a wooden board as a support and drawing paper instead of a canvas. The box can be used as well, not only for oil paints, but for drawing materials and tools. To complete your equipment, add a folding stool.

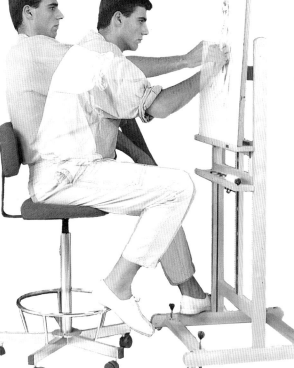

133

134

The studio: lighting and furnishing

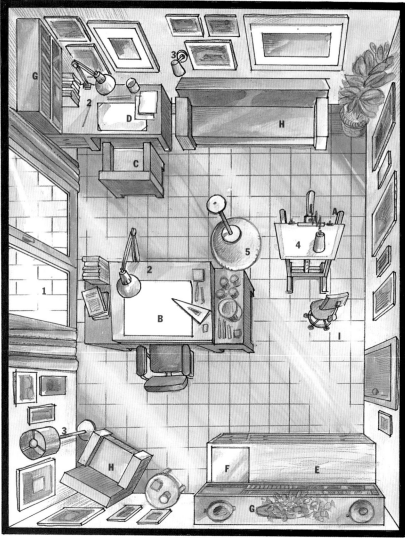

135

A studio can be any room or any corner of a room in your home. It can be any spot where a table can be placed near a window. As for furniture, you'll need a simple board and a chair. Of course, there are much more elaborate types of studios such as those set up specially for drawing.

In practice, when you are ready, the studio becomes a place where you may want to draw someone's portrait, sketch your cat, or make a figure study (particularly if you have hired a live model). The studio is also the place where you'll be alone to experience the emotion of drawing.

A 4 × 3 m (13 × 10 ft) room, or larger, similar to the one shown in Fig. 135, with similar

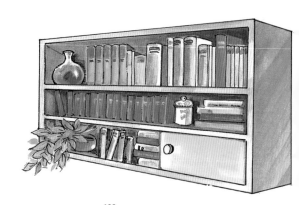

138

Fig. 135 Here we have a painter's studio 3.5 m (11 ft 6 in) wide by 4.5 m (14 ft 8 in) long, drawn to scale, as are the dimensions of the furniture. Included is everything needed to work comfortably. Notice the direction of daylight from the left-hand side in relation to the table and the easel.

136

Fig. 136 This 'scissor-style' drafting table, classic for drawing, has been available for over a hundred years. Its folding tabletop can be adjusted to the angle you wish.

Fig. 137 The modern table, like the 'pioneer' by the U.S. manufacturer Americana, is both elegant and functional. It has a top that can be tilted to any angle, drawers for extra materials, and a crossbar to rest your feet on.

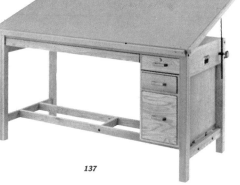

137

Fig. 138 This piece of furniture serves as a bookshelf or a counter with specially added drawers for storing paper and drawings. The top drawer can be fitted with translucent glass with a lamp inside to use as a tracing table or for looking at slides.

furnishings, would make an ideal studio. The following is a list of the lighting and furnishings necessary for the professional studio.

Lighting
1. A window that lets in daylight
2. Table lamps
3. Auxiliary lamps
4. Lamp with extendable arm attached to the easel
5. Ceiling lights

Furnishings
A. Workshop easel
B. Drawing table with sloping board (Fig. 136)
C. Armchair
D. Auxiliary table
E-F. Glass-topped drawer table (Figs. 135, 138)
G. Bookshelves
H. Several chairs or a sofa for the model
I. Three-legged stool for drawing at the easel

Take a look at the table shown on this page. It is designed for drawing with a tabletop easel that can take the form of a desk. The right-hand side is meant for keeping materials and tools within reach. The armchair is for drawing at the table, and the wheeled stool is for sitting at the easel.

Fig. 139 Here an artist is drawing a portrait in his studio. Note the design of the table that has been especially made for the studio: the central board is adjustable and can be tilted to the desired angle; the auxiliary spaces on both sides are excellent storage areas, with drawers to keep the art materials and store the sketches and studies in progress. Note also the adjustable easel on top of the central board, the lamp with an articulated arm to direct the light, and the chair with attached wheels to allow for easy movement.

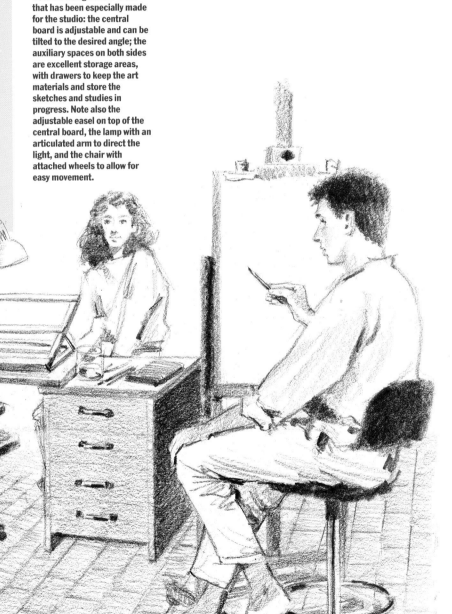

139

The studio: lighting and furnishing

Fig. 140 The materials and tools for drawing are many and varied: soft and hard lead pencils, charcoals, pastels, Conté crayons, pens and Indian ink. In addition, there are auxiliary materials that are also necessary. Note these in the photograph below.

1. Fixative spray to fix drawings done in pencil, charcoal, Conté crayon or pastel. Fixative is not advisable for pastel drawings because it can alter the colour.
2. Graduated metal ruler, 50 or 70 cm long. A ruler should be made of metal so that it won't be damaged when cutting paper or cardboard with an x-acto knife or razor blade.
3. A metric triangular scale rule 30 cm long.

4. Set square and triangle made of transparent plastic.
5. Clip for securing paper to the board: the best clips are the widest ones, the 'bulldog' kind, which can be used not only to hold the paper but also to stretch it when painting with watercolour.
6. Roll of adhesive masking tape, used to frame a wash or a watercolour before starting to paint. The tape is positioned like a frame and comes off easily when finished, leaving the edges perfectly clean and sharp.
7. Rubber cement used for glueing paper to paper, cardboard or wood.
8. Paper towels, essential for painting washes, cleaning brushes, and erasing

preliminary charcoal sketches.
9. Glass container for watercolour washes. When you use Indian ink, the water should be distilled. When painting outdoors, an unbreakable plastic container is advisable.
10. Pencil sharpener.
11. Sharpener made especially for lead pencils.
12. Drawing-pins to hold the paper to the board.
13. Razor blade or x-acto knife to cut paper or cardboard.
14. Large scissors for cutting paper.

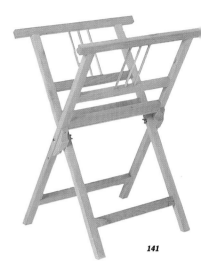

141

Fig. 141 A stand for large portfolios, for holding drawing papers, and for protecting works-in-progress and finished works, is essential in a studio.

140

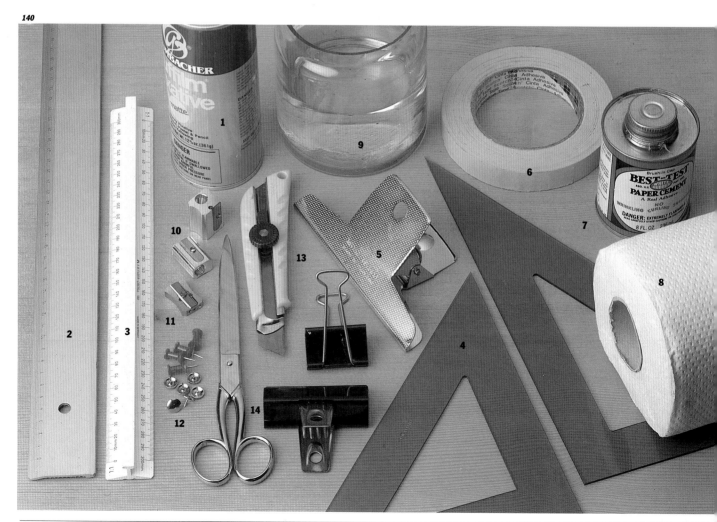

Drawing papers

With the exception of some specialized papers such as metallic paper, synthetic paper, or certain very thin silk papers, all forms of paper can be used for drawing. One of the most famous pastel drawings, *Vase with Flowers*, by the Post-Impressionist Odilon Redon, was drawn on cardboard.

The most available type of paper is medium-quality and smooth, made of wood pulp and manufactured by machine or moulds. High-quality papers such as Canson, Fabriano, Schoeller, Whatman, and Grumbacher contain a high percentage of rag and are made with great care. They are also expensive, which is why some manufacturers don't make them. High-quality papers can be distinguished by a mark bearing the name of the manufacturer, which appears on the paper either stamped in relief or in the traditional watermark, which can be seen by holding the paper up to light. Among drawing papers commercially available, you can find the following textures:

A. Smooth paper
B. Fine-grain paper
C. Medium-grain paper, semi-rough
D. Coarse-grain paper, rough
E. Ingres paper, white and coloured
F. Coloured papers
G. Canson coloured paper (called Mi-Teintes)

There are other more unusual kinds of paper such as rice paper, particularly suitable for sumi-e; laid 'grattage' paper, suitable for drawings that are meant to imitate wood-cuts; parole papers lined with cloth or laminated with an aluminium sheet; and poly-ester paper.

A. *Smooth paper* has an almost imperceptible grain. It is pressed smooth while hot, and is often called hot-pressed paper. Particularly suitable for pen and pencil drawing, smooth paper provides an excellent surface for developing contrasts and light and shade effects. It is very suitable for drawing portraits.

B. *Fine-grain paper* is very good for drawing with graphite pencil, wax, or coloured pencils. The grain of the paper enhances the final result without losing the harmony and the smoothness of shading and tonal gradations.

C. *Medium-grain paper* is particularly suitable for drawing with pastels, crayon, coloured chalks, wash, and for watercolour painting.

D. *Coarse-grain paper* is generally used for watercolour painting.

E. *Ingres paper* has been on the market for more than one hundred years. It is excellent for charcoal drawing. Its special woven texture is clearly visible against the light, and evident when the drawing is finished. Ingres is also a good surface for oil crayons and pastels. Today, however, there is a tendency to use medium-grain or coarse-grain papers when drawing with coloured media.

F. Canson coloured paper (Mi-Teintes) is a fine-grain paper without ridges. It is manufac-tured in a wide range of colours (see page 57, Fig. 146). The grain on the 'right' side is coarser than on the back, although the quality is the same on both sides, with the advantage that the artist can choose between a coarser and a finer side. Mi-Teintes provides a good texture and an ideal sizing for drawing with charcoal, chalk, crayon, pastels, and coloured pencils.

Fig. 142 **To distinguish the best-quality drawing paper, manufacturers stamp their dry mark in one corner of the sheet, or they print their logo with the traditional watermark, which can be seen by holding the paper up to the light.**

142

Drawing papers

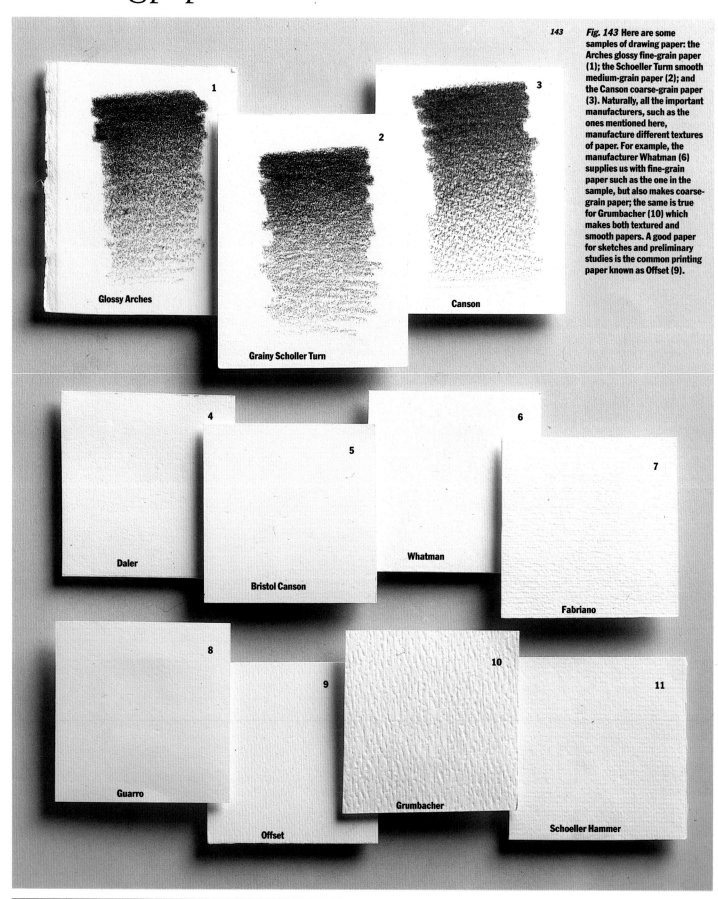

143

Fig. 143 Here are some samples of drawing paper: the Arches glossy fine-grain paper (1); the Schoeller Turm smooth medium-grain paper (2); and the Canson coarse-grain paper (3). Naturally, all the important manufacturers, such as the ones mentioned here, manufacture different textures of paper. For example, the manufacturer Whatman (6) supplies us with fine-grain paper such as the one in the sample, but also makes coarse-grain paper; the same is true for Grumbacher (10) which makes both textured and smooth papers. A good paper for sketches and preliminary studies is the common printing paper known as Offset (9).

1 Glossy Arches
2 Grainy Scholler Turn
3 Canson
4 Daler
5 Bristol Canson
6 Whatman
7 Fabriano
8 Guarro
9 Offset
10 Grumbacher
11 Schoeller Hammer

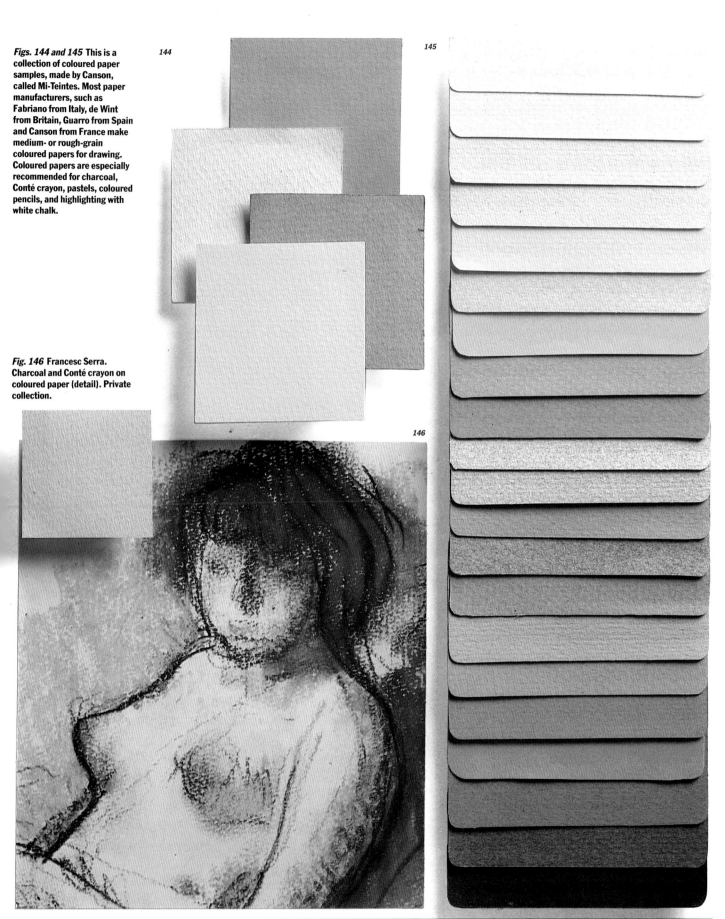

Figs. 144 and 145 This is a collection of coloured paper samples, made by Canson, called Mi-Teintes. Most paper manufacturers, such as Fabriano from Italy, de Wint from Britain, Guarro from Spain and Canson from France make medium- or rough-grain coloured papers for drawing. Coloured papers are especially recommended for charcoal, Conté crayon, pastels, coloured pencils, and highlighting with white chalk.

Fig. 146 Francesc Serra. Charcoal and Conté crayon on coloured paper (detail). Private collection.

144

145

146

Papers: sizes and weights

Paper is counted in *reams* and *quires*. A *ream* is 500 sheets; a *quire* is 25, regardless of size. The weight of the ream and its conversion to grams per square metre determine how thick the paper actually is. Paper can range in weight from a medium weight to the heavy and superheavy. Drawing paper is sold in single sheets or mounted on cardboard with standard measurements from 1/2 Imperial, 381 × 559 mm (15 × 22 in), to Antiquarian, 787 × 1,346 mm (31 × 52 in). Otherwise, the following are standard measurements: 10 × 15 cm, 12 × 18 cm, 20 × 25 cm, 23 × 30 cm, 28 × 36 cm, 36 × 43 cm, 46 × 61 cm, 38 × 50 cm, 38 × 56 cm, 48 × 61 cm, 61 × 92 cm (4 × 6 in, 5 × 7 in, 8 × 10 in, 9 × 12 in, 11 × 14 in, 14 × 17 in, 18 × 24 in, 15 × 20 in, 15 × 22 in, 19 × 24 in, 24 × 36 in).

It can also be found in rolls of 92, 102, and 152 cm (36, 42, 60 in) wide × 920 cm (300 in) long, in blocks of 20 or 25 sheets bound by the spiral system, or glued together on all four edges and backed by thick cardboard, thus forming a compact unit that keeps its shape. This block system is ideal for wash and watercolour papers. Keep in mind that most papers for wash and watercolour painting are perfectly suitable for pencil drawing, charcoal, crayon, chalk, and pastels. There are some exceptions, however. One is the coarse-grained paper specially manufactured for watercolour painting. Another exception is the grainless paper that is particularly suitable for drawing with pen.

147

148

Fig. 147 Drawing paper is sold in individual sheets, in pads glued to cardboard, and in rolls (maximum size: 2 m (6 ft) wide x 10 m (30 ft) long). As shown in the illustration, some papers have irregular edges called barbs; this is characteristic of handmade paper.

Fig. 148 Drawing paper is also sold in spiral-bound pads, and in sketchbooks where the paper edges have been glued together.

Paper manufacturers

Arches	France
Canson & Montgolfier	France
Daler	UK
Fabriano	Italy
Grumbacher	U.S.A.
Guarro	Spain
Schoeller Parole	Germany
Whatman	UK

Attaching, mounting and stretching paper

While you are drawing, paper must rest on a drawing board or be attached to one. The drawing board provides a smooth, even surface. The paper should be attached to the board with tape or, better yet, with metal clips like those shown in Fig. 140.

However, when it comes to working with a medium such as watercolour, which requires moistening the paper, special methods must be used because the paper can become warped from the wetness. Obviously a warped watercolour, marred by an uneven, wrinkled surface, cannot be regarded as professional. To solve this problem, look at Figs. 150-5, where you can see how to mount and stretch paper with gummed tape. Securing your paper to the board can also be done with drawing pins. To achieve a taut surface, you can attach several clips around the paper or attach the paper with metal staples using a staple gun such as the type used by carpenters (see Fig. 153). Stapling can be done only when the paper is thick enough, 220 to 225 grams at least. If the paper is thinner than that, you'll need to mount it.

149

150

151

152

Fig. 149 When you're painting in washes, with Indian ink or watercolour and your paper is not thick enough, you'll need to moisten, mount, and stretch the paper in order to prevent it from warping. To saturate the paper sufficiently, hold it in both hands and wet it under the tap or submerge it in water for at least two minutes.

Fig. 150 After wetting the paper, lay it on a wooden board, and smooth it out so that there are no bulges or wrinkles.

Fig. 151 Secure one side of the paper with a strip of gummed tape.

Fig. 152 Continue to tape the other sides until the paper is framed. Then, let it dry horizontally for four to five hours. You will then be able to paint on a smooth, taut surface, without any danger of its buckling.

Figs. 153 and 154 A paper that has been moistened can be also stretched by fastening it with metal staples from a staple gun. If the paper is heavy enough (more than 200 g), the stretching can be done by using clips.

153

154

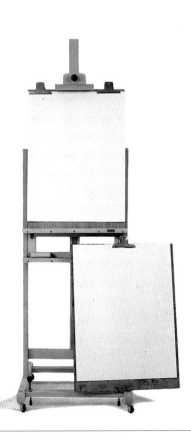

Fig. 155 When drawing in charcoal, Conté crayon, coloured pencil, or pastel, it's not necessary to mount or stretch the paper. You only need to secure the paper to a board with drawing-pins or metal clips.

155

The lead pencil

The graphite pencil, more commonly known as the lead pencil, is the most frequently used tool for drawing. Graphite is a solid mineral that has a metallic brightness and a waxy, greasy consistency. It was discovered in Cumberland in 1560, but it was not until 1640 that it reached France as an implement for drawing. In 1792, during the French Revolution, England broke its ties with France and stopped supplying France with graphite. It was then that the French engineer and chemist Nicolas Jacques Conté developed the Conté crayon, composed of a mixture of graphite and clay and covered with cedarwood. Conté also developed soft-lead and hard-lead pencils to create darker or lighter effects by changing the amount of graphite in relation to the clay.

The original quality of these early pencils has been improved. Today, manufacturers make pencils of different quality and gradations, namely:

1. *High-quality pencils with seventeen gradations* (Fig. 157). Those marked with a B (soft) will give you a darker line and are meant for general drawing. Those marked with an H (hard) give a lighter line and are often used for drafting or mechanical drawing. HB and F are intermediate grades and are good for general kinds of work.

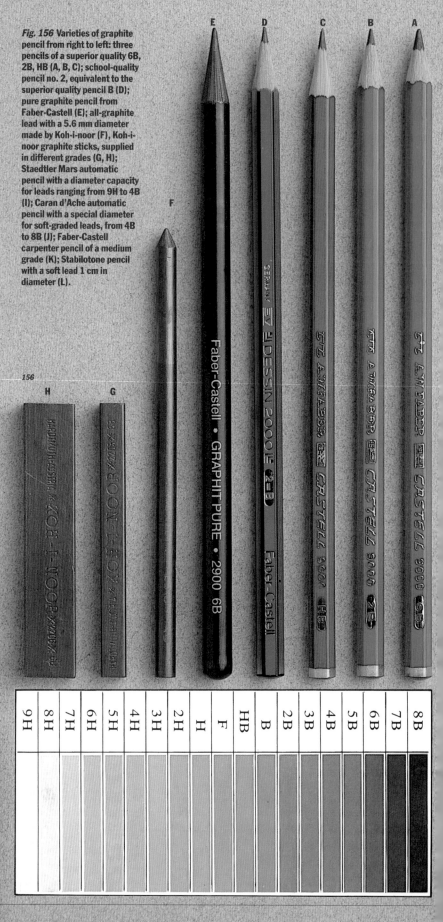

Fig. 156 Varieties of graphite pencil from right to left: three pencils of a superior quality 6B, 2B, HB (A, B, C); school-quality pencil no. 2, equivalent to the superior quality pencil B (D); pure graphite pencil from Faber-Castell (E); all-graphite lead with a 5.6 mm diameter made by Koh-i-noor (F), Koh-i-noor graphite sticks, supplied in different grades (G, H); Staedtler Mars automatic pencil with a diameter capacity for leads ranging from 9H to 4B (I); Caran d'Ache automatic pencil with a special diameter for soft-graded leads, from 4B to 8B (J); Faber-Castell carpenter pencil of a medium grade (K); Stabilotone pencil with a soft lead 1 cm in diameter (L).

9H	8H	7H	6H	5H	4H	3H	2H	H	F	HB	B	2B	3B	4B	5B	6B	7B	8B

Rubbers

2. *School-quality pencils with three gradations.* Soft: no. 1, equivalent to 2B, and no. 2, equivalent to B. *Hard:* no. 3, equivalent to H.

The following is a list of pencils you'll need to begin drawing:

One 2B pencil: This is the most commonly used pencil. It's a soft pencil that not only gives intense blacks and soft greys but is also capable of producing thin lines.

One 4B and one 6B pencil: These are good for broad contours, quick sketches, and for blackening in dark areas.

One no. 2 school-quality pencil: For general use and light shading.

Pencils can also be found in different sizes and in different types, allowing for different strokes and effects. Note the *all-lead* pencil, the *5mm lead* used with clutch-type pencils, and the *graphite stick* (Fig. 156). The clutch-type pencils are specially devised to hold thick, soft leads such as a 6B.

Finally, note in Figs. 158 and 159 the function and possibilities of a rubber as a drawing tool.

Fig. 158 Kneaded rubbers (A) or those made of plastic or rubber, which are more compact but just as smooth (B,D), are best for a waxy medium such as graphite, but they are not absorbent enough for erasing charcoal or pastel. For less waxy mediums, use rubbers that are more pliable (C) and more absorbent. It is my opinion that rubbers should be used only as a last resort; it is often better to start again than to damage and hurt the fibre of the paper.

Fig. 159 Rubbers can be used as a means of drawing, to 'open up' white areas and highlight edges. Look at these drawings of a half mask of Beethoven. On the left is the drawing before intensifying the shadows and picking out the lights (A). On the right the drawing was finished with the lights pulled out with a rubber (B).

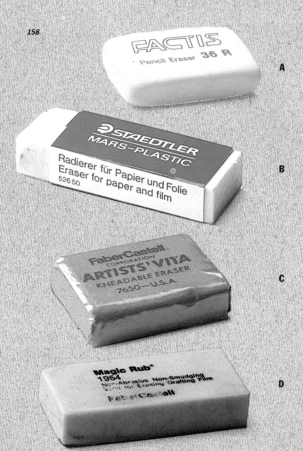

158

A

B

C

D

Fig. 157 Graphite leads range from the soft B grades to the medium-grade HB, to the hard H grade. Note the intensity of the blacks in the B-grade leads, the very softest and blackest is the 6B and the very hardest is the 9H. Artists generally prefer the softer leads (the 2B is the most commonly used pencil), but for filling in light tonal values and subtle details, it's often better to use the harder, more delicate H leads.

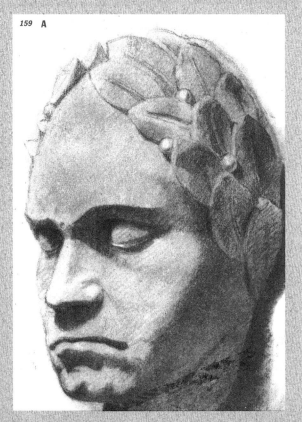

159 A

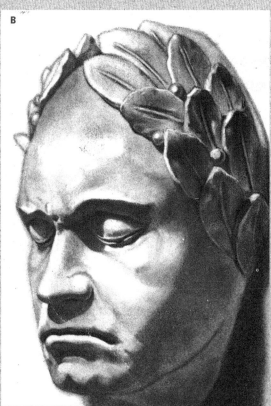

B

Stumps

The stump is a two-ended drawing tool. It is usually made of rolled paper, although some are made of felt or chamois leather. It is used for rubbing and blending, when you want to blend lines or areas drawn with lead pencil, charcoal, crayon, chalks, or pastels. You should use two or three stumps, thick, medium, or thin, keeping one end for intense and the other for lighter rubbing.

For drawings that require the rubbing out of very small areas, use stumps as sharp as pencils. Some manufacturers make this kind of stump, like the one in Fig. 160 (far left). In Fig. 161 you can see the process for making your own stump by using a triangle of paper (see measurements in A); rolling it as if it were a hand-rolled cigarette (B – E) and closing it with a strip of gummed tape (F).

Fig. 160 Stumps come in different sizes. Use each stump for one colour only, and keep one end for dark tones and the other for lighter areas.

Fig. 161 Here is a way to build yourself a small stump with a sharp point for drawing small forms. Start with a triangle of spongy-type paper, such as newspaper. Then, roll this paper as if you were rolling a cigarette and secure the rolled paper with adhesive tape.

160

161

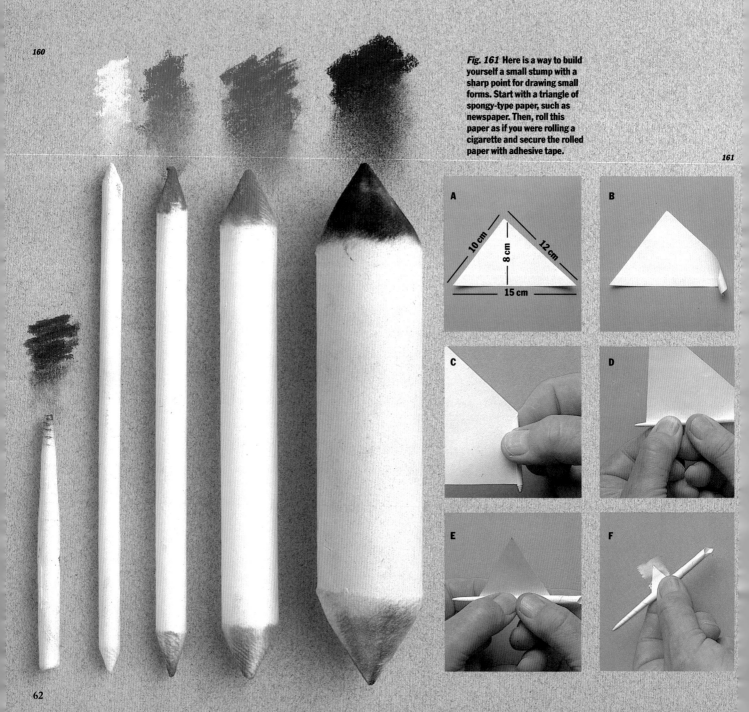

Fingertip blending

Many artists prefer to draw and blend with their fingers rather than with paper stumps. There are several reasons for this: fingertips are pliant; they easily adapt to the corrugations of the paper. Fingertips are moist; they combine this moisture, no matter how slight, with the waxy quality of graphite to produce a more intense black. Fingertips generate heat, and when they are rubbed against the graphite, the heat helps to blend and intensify the toned areas. Finally, fingers are simply a more convenient method of blending. Fig. 162 shows you how to blend using all five fingers, including the thumb. Notice that the little finger is used on its side which allows the tip to provide more accurate blending. Even the lower palm area can be employed in blending, as shown in Fig. 164.

163

A

B

Fig. 162 The tips of the fingers are an excellent way to blend areas created by lead pencils, charcoal, and pastels. Note in illustrations 3, 5 and 6 that the blended areas have been made with the tips of the fingers.

Fig. 163 Note in these examples that the greys obtained with a stump (B) are more intense than those in which the stump was not used (A).

162

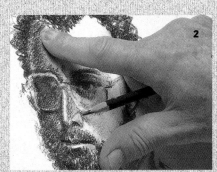

1

2

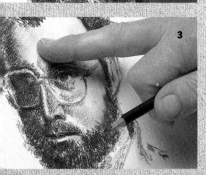

3

4

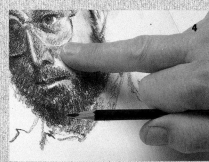

5

6

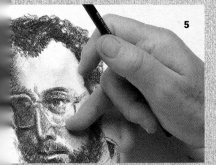

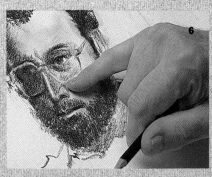

164

Fig. 164 Different parts of the hand can be used for blending: the tips of the fingers and, occasionally, for large areas, the lower part of the palm.

How to hold the drawing instruments

You can draw standing in front of an easel, with the board in a vertical position; or you can draw sitting, with the board more or less slanted. In either case, you always draw in a position where you are likely to get the most complete view. When you are drawing, your distance from the paper should never be the same as if you were writing or doing fine detail work. In drawing, you need to be further back.

The minimum distance from the artist's eyes to the drawing paper should be between 45 and 65 cm.

In Fig. 165, you can see how the drawing position (absolutely standard, by the way) conditions our way of holding a pencil, stump, Conté crayon, or any other drawing tool. These are two ways of holding the pencil when you are doing relatively large drawings, say about 50 × 30 cm (16 × 12 in.). For very small drawings you would use the pencil similarly to the way in which you would use it to write.

Fig. 166 *Standard position:* in this position the pencil is held slightly upward to facilitate the movement of the hand and the pencil. Keep in mind that when writing, you move your hand every five or six letters. When drawing, you hold the pencil in such a way that lines can be changed whenever and wherever you need. This allows for continuous lines without raising the pencil or stopping the hand.

Fig. 167 *With the pencil inside the palm:* this is the usual and most practical way for the artist to draw lines for shading and tonal gradations. The arm is stretched and follows the whole drawing, moving upwards or downwards, to the left or to the right without impediment.

Fig. 168 *A variant of the pencil inside the palm:* this way of holding the pencil allows you to press on the paper while drawing, to enhance a shaded area.

Basic strokes with lead pencil

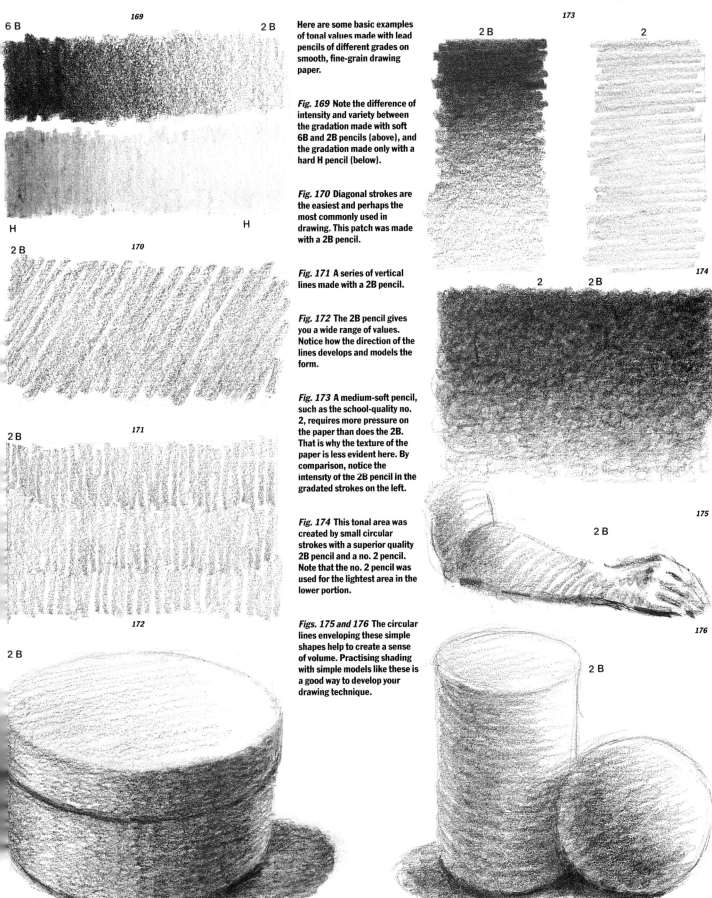

169

6 B 2 B

H H

170

2 B

171

2 B

172

2 B

173

2 B 2

174

2 2 B

175

2 B

176

2 B

Here are some basic examples of tonal values made with lead pencils of different grades on smooth, fine-grain drawing paper.

Fig. 169 Note the difference of intensity and variety between the gradation made with soft 6B and 2B pencils (above), and the gradation made only with a hard H pencil (below).

Fig. 170 Diagonal strokes are the easiest and perhaps the most commonly used in drawing. This patch was made with a 2B pencil.

Fig. 171 A series of vertical lines made with a 2B pencil.

Fig. 172 The 2B pencil gives you a wide range of values. Notice how the direction of the lines develops and models the form.

Fig. 173 A medium-soft pencil, such as the school-quality no. 2, requires more pressure on the paper than does the 2B. That is why the texture of the paper is less evident here. By comparison, notice the intensity of the 2B pencil in the gradated strokes on the left.

Fig. 174 This tonal area was created by small circular strokes with a superior quality 2B pencil and a no. 2 pencil. Note that the no. 2 pencil was used for the lightest area in the lower portion.

Figs. 175 and 176 The circular lines enveloping these simple shapes help to create a sense of volume. Practising shading with simple models like these is a good way to develop your drawing technique.

Lead pencil techniques

When talking about lead pencil techniques, there are some elementary, though necessary, comments that need to be made. If you draw with a clutch-type pencil, the following applies; but if you draw with a wooden pencil, I think hand sharpening (with a knife or an x-acto is much better because you are able to control the shape, length, and sharpness of the lead (Fig. 177). If you want to get lines as thick as the diameter of the lead, the pencil must be held in the standard way, as if for writing, slanting the pencil about 45° (Fig. 178). If you hold the pencil inside your palm, the gradient will be 30° or less. The wedge of the lead will be wider then, and so will the lines (Fig. 179). If you draw with the 'back' of the lead, you can also get fine lines (Fig. 180). Drawing with a graphite stick (see page 60, Fig. 156, G and H) and sketching with the stick in a flat position (as in Fig. 182) will give you the best shading effects. To darken a shape progressively, you have to turn the pencil every now and then, very slowly, as you are drawing (Fig. 181).

On the facing page you will see some less common pencil techniques. The top row reveals the influence of the paper's texture on the final image. If you are drawing a complicated image (such as this face), and you are using a rough-grain paper, the result will be coarse and blurred-looking (Fig. 184). However, if you use a fine-grain paper (Fig. 183) or are drawing a larger figure (Fig. 185), you will get a smoother look. Figs. 186 to 188 show the combined use of pencils using several gradations to create contrast and depth. The last row of drawings shows how the blending techniques (Figs. 189, 190) are capable of producing outstanding artistic quality.

Fig. 177 To sharpen pencils, you can use a pencil sharpener; however, make sure it's the kind of sharpener that gives the pencil a long point (B), or you can use an x-acto knife or razor blade, where you can better control the length of the lead.

Fig. 178 Note the width of the line of a lead pencil when holding it the typical way, at approximately a 45° angle.

Fig. 179 The smaller the angle of the pencil in relation to the paper, the wider the resulting line.

Fig. 180 If you turn the pencil perpendicular to the paper, you can obtain lines as fine as these.

Fig. 182 If you hold a graphite stick flat, the resulting stroke appears wide and uniform.

Fig. 181 To intensify lines while drawing, there is no method better than slowly turning the drawing instrument on its side.

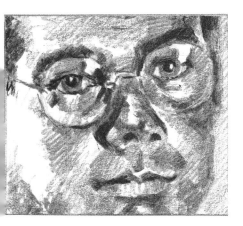

Fig. 183 This drawing has been made with a soft 2B pencil on a high-quality glossy paper. This type of paper has an almost unnoticeable grain, which gives the shaded areas a tonal uniformity even though they have not been blended.

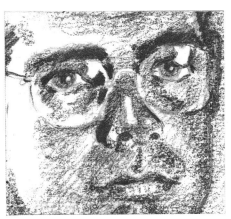

Fig. 184 The same drawing made with a soft 2B pencil, but on a medium-grain paper (also high-quality) will present this imprecise finish, with gradations.

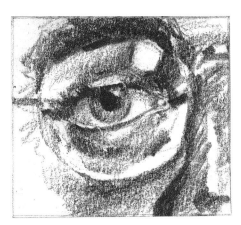

Fig. 185 When drawing larger versions of the same drawing, using the same 2B pencil and medium-grain paper, the gradations are less coarse, the shapes better defined.

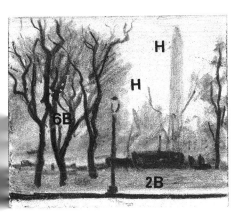

Fig. 186 An H pencil gives a less intense black than a 6B. By combining different grades of pencil in the same drawing, it's possible to present a range of effects and values.

Fig. 187 By playing with the white of the paper, which, in this case, is fine-grain, and using only a soft 2B pencil and an extrasoft 6B, you can achieve drawings of extraordinary contrast and energy.

Fig. 188 When blending areas made by a graphite pencil, you can use either a stump or your fingertips. Blending with fingertips is more effective and allows better control of the range of greys and intensities.

Fig. 189 Simply drawing with a lead pencil and blending for light and shade effects can be a new and exciting artistic experience, particularly in the art of the portrait.

Fig. 190 A lead pencil that has been stumped or blended can give an infinite range of value and contrast when used on high-quality glossy or smooth paper. Once the pencil has been blended it offers a uniform, harmonized finish.

Fig. 191 Lead pencil can be used effectively on coloured paper when highlighted with white chalk. It's better to use a coloured paper such as Canson Mi-Teintes rather than one intended for drawing with charcoal or charcoal pencil.

Possibilities of the lead pencil

There are no limits to the possibilities of the lead pencil. It is the most basic and classic tool in the art of drawing. It can encompass all subjects: landscapes, urban environments, seascapes, interiors, still lifes, and portraits. But some subjects seem more appropriate than others for using the pencil: sketches, studies, and portraits come readily to mind. With the humble pencil you can sketch in the street, at home, or from nature, make composition studies, draw the live model. Look at the examples of drawing with the lead pencil on these pages to get an idea of the range possible with this most common of tools.

192

Fig. 192 Landscape drawn with a soft 2B pencil and a graphite stick on glossy paper (actual size).

193

194

195

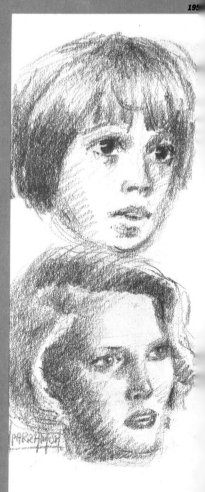

Fig. 193 Urban landscape (235 x 200 mm) drawn with H, 2B, and 6B pencils emphasizing the sense of space with lighter tones in the background and more intense darker shades in the middle ground and foreground.

Fig. 194 Drypoint line drawing, made with a 2B pencil.

Fig. 195 Sketches of heads made with a 2B pencil on fine-grain paper.

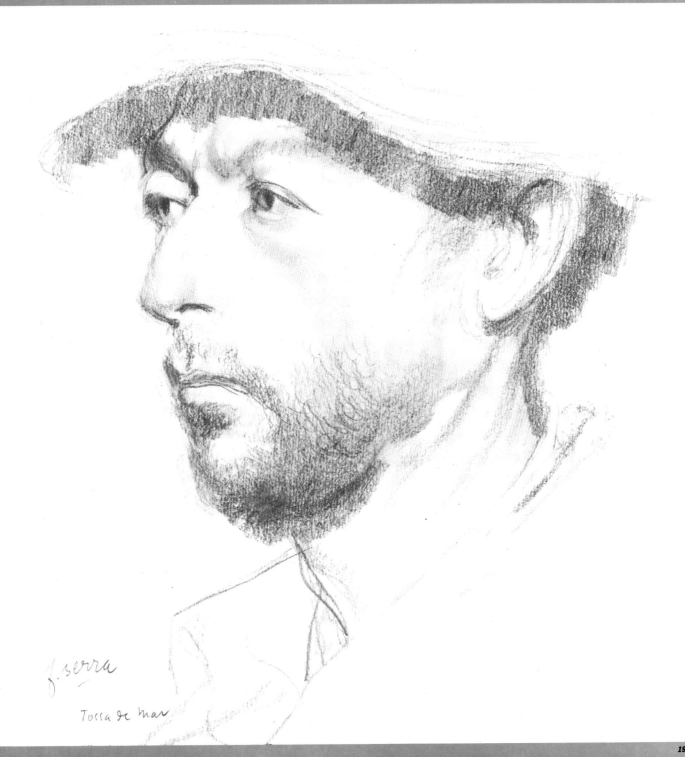

196

Fig. 196 **Francesc Serra.** *Study.* **Private collection.**
This is an excellent example of a portrait made with
lead pencil. Apart from this drawing's strong sense of
form, its quality comes from combining subtly
blended areas with strong line.

Charcoal and charcoal pencils

One of the earliest materials used for drawing was a burnt twig cut from a vine, or a willow or a nut tree, that is: charcoal. It is a primitive drawing tool that was used by the Greeks, the Romans, and by artists in the Middle Ages and the Renaissance. In the 16th century fixatives were discovered, and drawing with charcoal on white or blue paper was Titian's and Tintoretto's favourite method. Guercino, in his turn, preferred to use charcoal bathed in linseed oil to get a denser and more intense black. Today artists tend to use charcoal for contour drawings, for sketching the model, for composition studies, and for sketches and preliminary drawings for finished paintings. Charcoal is useful in these cases because it can be easily erased with a piece of cloth or paper.

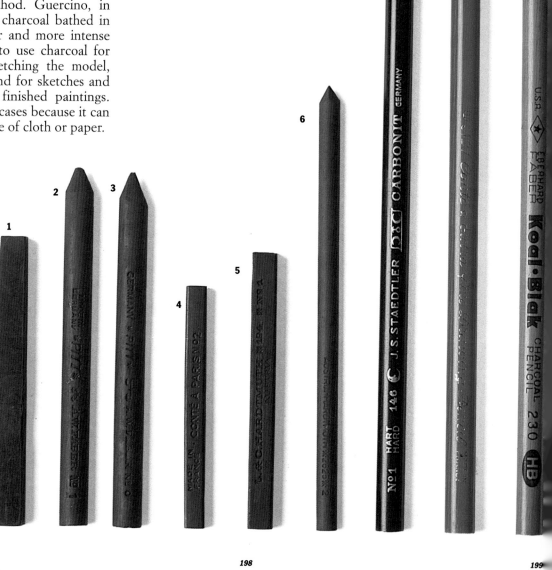

Fig. 197 Here are some pencils and bars for charcoal drawings. From left to right: a chalk stick, an artificially compressed plaster similar to pastel (1); Faber-Castell bars of artificially compressed charcoal which comes in six different grades (2, 3); Conté stick of artificially compressed charcoal (4); Hardmuth stick of charcoal and clay (5); Hardmuth leads of charcoal and clay that can be used with a special automatic pencil (6); charcoal pencils of different brands (A, B, C); two sizes of charcoal, which are carbonized branches of willow, grapevine, or walnut (7, 8).

Figs. 198, 199 and 200 As you will see on the following pages, charcoal, charcoal pencil, and variants of these media can be combined with coloured pencils. These drawings are also effective when highlighted with white chalk or combined with Conté crayon.

Charcoal is available in sticks of about 15.24 cm in length, and the diameters range from 5 mm up to 1.5 cm. Manufacturers generally produce three degrees of hardness: soft, medium, and hard.

Charcoal pencil is a derivative of charcoal that is made of a charcoal lead and agglutinating substances covered with the wood of the pencil. It is also known as Conté pencil. Charcoal pencil can be found in three, four, and sometimes six gradations. These are usually distinguished by numbers or letters and come in extra soft, soft, medium and' hard.

In addition to charcoal and pencils, there are other charcoal drawing products of excellent quality. These are made of pressed charcoal or artificial coal that in some cases have been mixed with clay and agglutinizing substances

Brand	Extra soft	Soft	Medium	Hard
Conté Faber-Castell	3B	2B	B	HB
'Pit' Koh-i-noor	–	Soft	Medium	Hard
'Negro'	1,2	3,4	5	6

to achieve the perfect integration of the coal (particularly in soft gradations) and the strength and density of pastels. There are also cylinder-shaped leads made with clay that produce a matt surface, which is an intense and hard-to-erase black (Fig. 197). Manufacturers produce these sticks in different gradations. Finally, there is a substance called dust charcoal, which is generally used in combination with chalks or pressed charcoal and is meant to be blended with stumps and fingertips.

7

8

Fig. 201 Some manufacturers, such as Conté, offer a complete set of materials for charcoal drawing, including stumps, white chalks, sanguine pencils, compressed charcoal, white chalk, Conté crayons, and an absorbent rubber especially for charcoals.

201

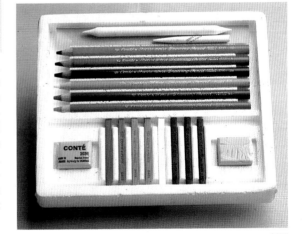

202

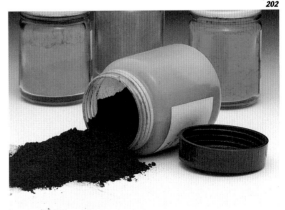

Fig. 202 You can buy powdered charcoal to use only with a stump, or combined with black or white chalk. This combination can be made also with coloured clay and chalks of the same colours.

200

Charcoal and charcoal pencils

The greatest drawback when using charcoal, and to some extent this is true of charcoal pencil, is that it is difficult to keep the point sharp, which forces you to draw less precisely and often on a larger scale; you can't draw miniatures with charcoal. The studies of figures made in charcoal are usually made on sheets of paper 35 × 50 cm. The imprecise properties of charcoal also make it a much freer and looser medium than the lead pencil (see examples on pages 74 and 75). The larger scale and freer realization also determines the way charcoal should be held (see Figs. 203, 204, 205).

Charcoal and charcoal pencils are particularly suitable for studies, for modelling light and shade effects, and for creating volume. Therefore, it is useful for the artist to choose models and lighting conditions that take advantage of charcoal's special properties. Keep in mind that in most art schools, a typical project includes the rendering of sculptures with either charcoal or charcoal pencil. As you will see later in the practice chapter, the use of the stump and fingertip blending is particularly important when undertaking assignments of this sort.

Charcoal is easily erasable. If you rub a piece of cloth or paper against the paper, the mark disappears, though not completely. If the stroke was intense, a slight residue of charcoal, difficult to erase even with a plastic rubber, will remain on the paper. Because of the volatile nature of both charcoal and charcoal pencils, it's necessary to fix the drawing once it has been completed. Fixatives are nothing more than a coat of sprayed liquid, which, after drying, forms a film that covers and protects the drawing. Fixatives are sold in bottles and aerosols. Drawings can also be fixed with a mixture of sugar, water, and alcohol sprayed with a hand pump, or with hair spray. However, the safest and most practical way of fixing is with an aerosol devised for this purpose.

Fig. 203 Because charcoal is unstable, you can't lean or rub against a charcoal drawing. To avoid smudging the surface, you should draw with the tip of the charcoal away from your hand, as shown in the illustration.

Fig. 204 For applying broad tonal areas, the best technique is to break a piece of charcoal and use it on its side to achieve the wide, uniform lines shown in the illustration.

Fig. 205 By drawing with the flat side of the piece of charcoal, but skimming it lightly over the paper, you can achieve lines of great charm and spontaneity.

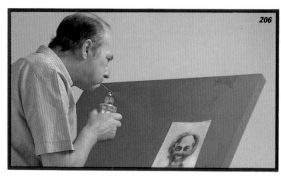

Fig. 206 A manual spray fixative liquid is sprayed out of a tube bent at a right angle.

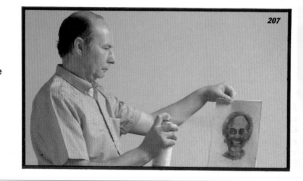

Fig. 207 When using an aerosol fixative, place the drawing on an inclined board, or hold the container up in the air as you spray. In any case, spraying with a fixative must be done progressively, step by step, using two or three coats. Remember to wait for the first one to dry before applying the second one.

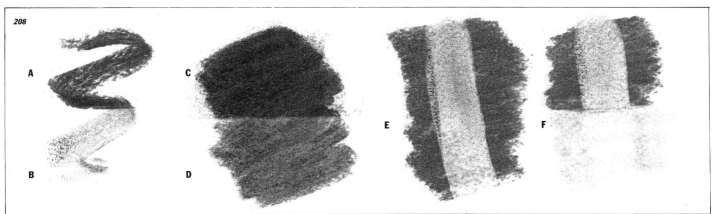

Fig. 208 Charcoal can be easily erased. By brushing your finger over a charcoal line, you will lift most of the charcoal powder, smudging the line (A, B). Even if you blow an area blackened with charcoal, part of the powder will disappear, which reduces the value of the area (C, D). If you pass a clean finger through a black charcoal area, your finger will pick up the charcoal, creating a stripe of less intensity that is clearly lighter (E). Finally, if you rub vigorously with a cloth on this charcoal spot, the rag will remove all the charcoal, smudging the adjacent areas and leaving just the faintest trace of tone. The faint grey tone can be removed somewhat with a rubber, but you can never get back the absolute white of the paper (F).

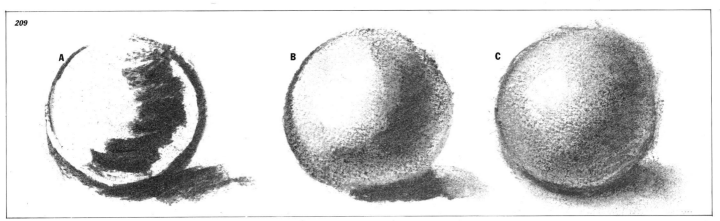

Fig. 209 Drawing a sphere with charcoal. Charcoal is an ideal way to combine the speed of a pencil with light and shade capabilities. To demonstrate, let's draw a sphere: in the first step (A), I draw the outline and fill in two areas with dark colour – the cast shadow and the shaded area on the sphere. These areas are then blended with the finger to model the sphere (B). In C, I have reinforced the dark and medium tones by blending them with the fingers. Reserve a clean finger to enlarge the bright area of direct light, and then reinforce the cast shadow by blending its edges. For a final touch, I highlight the area struck by direct light by using an absorbent rubber.

Fig. 210 Usefulness of an absorbent rubber. By moulding a rubber into a cone shape or a pencil-point shape you can draw small, detailed forms such as shown here. On the right (B), an area filled in with charcoal and then erased vigorously will not disappear completely but will leave a light grey tone.

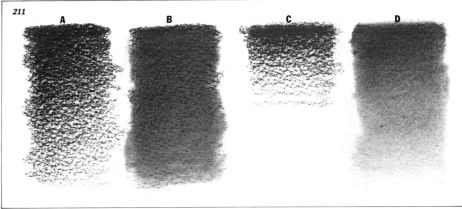

Fig. 211 A gradation created by a charcoal pencil (A), when blended, will darken and lose the original tone (B). To achieve a subtle gradation like the one in figure A, fill in a smaller area with the charcoal pencil, and then spread it with the stump or the fingertips (C, D). This will confirm the idea that, in general, blending intensifies charcoal markings.

Possibilities of charcoal drawing

According to the historian Heinrich Wölfflin, art in the Western hemisphere underwent a change during the Baroque period in the 17th century. At this time, the emphasis in art became less linear, and forms became more modelled and were rendered by means of massing and light and shade effects. Charcoal is an ideal medium for attaining these effects; it is possible actually to 'paint' while drawing in charcoal through shading or massing. You only need to take a piece of charcoal and sketch some lines with it in a zigzag fashion or darken the paper to see how easy it is to make your lines wider or to produce subtle shades of grey. Or, you can increase the pressure until you arrive at a real blackness and rub your fingertip against the paper, and paint!

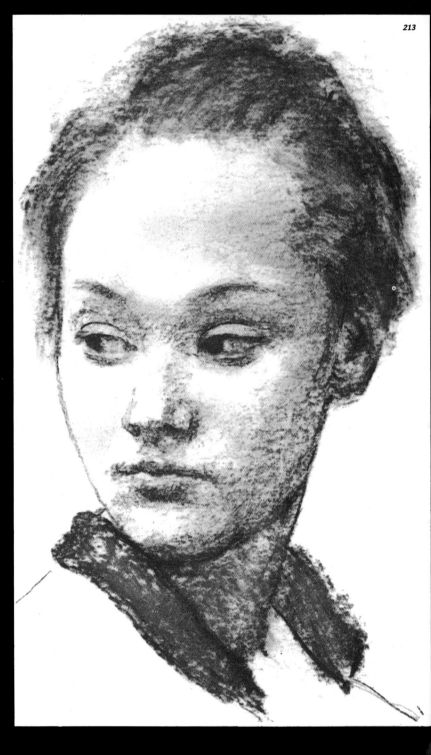

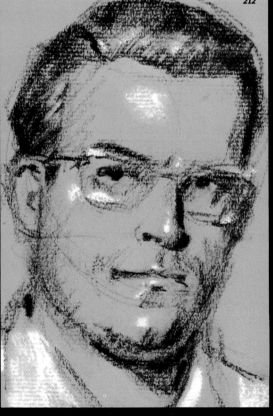

Figs. 212 and 213 José Parramón. *Sketch for a Portrait.* Charcoal pencil and white chalk on coloured paper. (Above) Francesc Serra. *Head Study.* Charcoal. Both drawings are good examples of the potential of charcoal to capture form with massing and light and shade. In the drawing by Serra, with the exception of the line that defines the cheek at the left, everything else is created with values and masses. In the sketch on the left, the pictorial concept is confirmed by the lost-and-found edges, but also by the lack of colour and the use of highlighting to bring out form and pull out the lights.

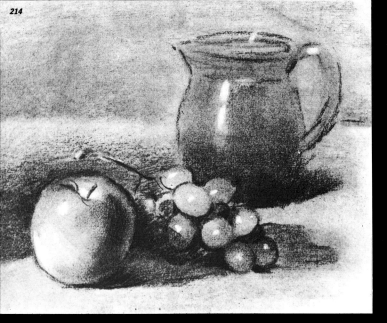

214

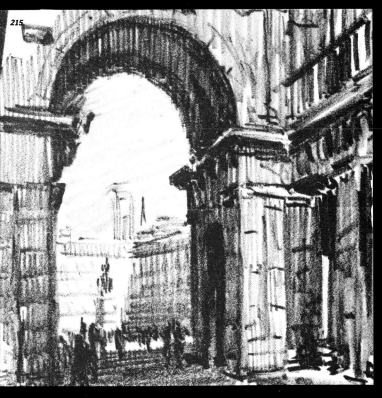

215

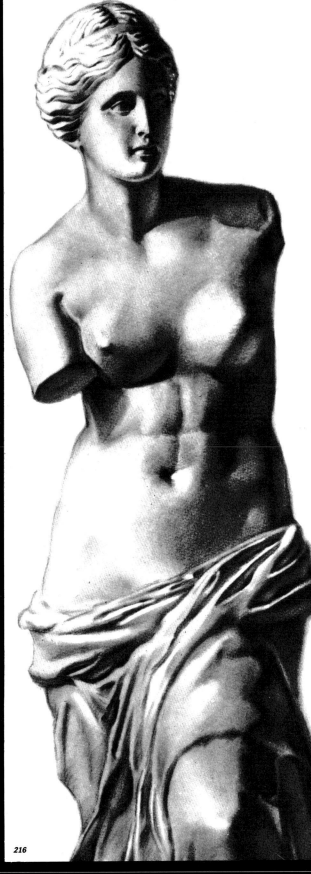

216

Figs. 214, 215, and 216 José Parramón.
Here are three different charcoal drawings.
In the still life, I have worked and blended the
charcoal with the fingers, darkening it later
with a charcoal pencil. In the sketch of one of
the entrances to the Plaza Mayor in Madrid,
I drew in charcoal without blending. In the
drawing of the Venus de Milo, I began by
indicating where the light and shade effects
would go with the charcoal. I then erased
the charcoal with a rag, and over that
base, I drew in the rest of the drawing with
charcoal and created its shaded areas with
the stump and the fingertips.

Chalks and sanguines

One hundred and fifty million years ago a great portion of the earth was under the sea. Fish, molluscs, and many other organisms developed there. Seventy million years later the so-called orogenetic movements made the land emerge from the water. In some areas, layers of limestone of organic origin appeared. These layers were soft, white, and grey, and are still visible in many places. Many of these layers contain fossils of that period, which is known to geologists as the Cretaceous Age.

Chalk is a kind of limestone which is made into sticks by mixing it with water and some agglutinating substances (Fig. 217: 1, 4, and 8). It is used to enhance white areas on a charcoal or sanguine drawing.

Chalk comes in different colours. For pure colours it is made up of colour pigments, and for intermediate colours it is mixed with white chalk. Chalk manufacturers, who some years ago only used to make five or six different colours (white, grey, dark sienna, ultramarine blue, sanguine, and black) have expanded their selection with 12, 24, 36, and even 72 different colours! Some manufacturers such as Koh-i-noor, which produces 12- and 24-colour boxes, still call them chalks; others, such as Rembrandt, which makes 15-, 30-, 45-, 60-, 90-, and 180-colour boxes, label them pastels. However, even though such a range of colours is now available, the chalks most frequently used in drawing are still the original colours: sanguines, dark sienna, blue, black, and white.

Fig. 217 Here we have a selection of sanguines, chalks and pencils. From left to right: white, dark sienna, and sanguine Conté crayon (1, 2, 3); white and sanguine Hardmuth leads of a 5 mm diameter (4, 5); and sanguine, dark sienna, and white Conté pencils (6, 7, 8).

Fig. 218 Some years ago the range of oil crayons and oil pastels was limited: just two or three siennas, plus a sanguine, a dark blue, and a dark green. These colours were enough to create high-quality drawings on coloured paper highlighted with white chalk. Today, however, manufacturers have increased the number of colours up to sets of 12, 24, 36, 72, and 180.

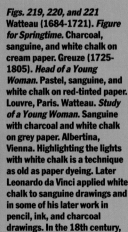

Figs. 219, 220, and 221 Watteau (1684-1721). *Figure for Springtime.* Charcoal, sanguine, and white chalk on cream paper. Greuze (1725-1805). *Head of a Young Woman.* Pastel, sanguine, and white chalk on red-tinted paper. Louvre, Paris. Watteau. *Study of a Young Woman.* Sanguine with charcoal and white chalk on grey paper. Albertina, Vienna. Highlighting the lights with white chalk is a technique as old as paper dyeing. Later Leonardo da Vinci applied white chalk to sanguine drawings and in some of his later work in pencil, ink, and charcoal drawings. In the 18th century, most artists drew with mixed media. Watteau, for example, drew *à trois crayons* (in three pencils), by which he meant charcoal pencil, sanguine, and white chalk.

Sanguine is made up of iron oxide and some chalk. It was first used for drawing by the year A.D. 1500, and historians agree that Leonardo da Vinci was the first artist to use it. Today sanguine can be found in the form of Conté crayons and pencils, in two- or three-colour variants (Fig. 217: 3, 5, 6, and 7).

Artists began to use white chalk as an enhancer at the beginning of the 15th century, when the use of paper – either white or tinted – was becoming commonplace. Botticelli, di Credi, Lippi, Perugino, Verrocchio and others have left examples of this technique applied to drawings made with a metalpoint. But when Leonardo began to draw with sanguine on cream-coloured paper, most artists of that period began to use the combination of sanguine (or charcoal), coloured paper, and white-chalk enhancements. That formula reached its heyday in the 18th century with Fragonard, Boucher, and particularly with Watteau, who popularized *le dessin à trois crayons*; that is, the combination of charcoal pencil, sanguine, and white chalk on cream-coloured paper.

Then, as now, sanguine drawings, with or without white chalk, need to be fixed.

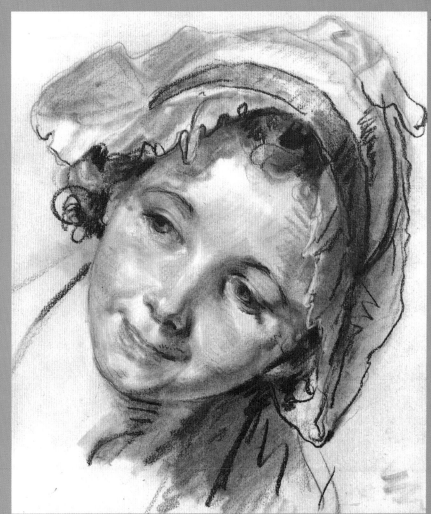
220

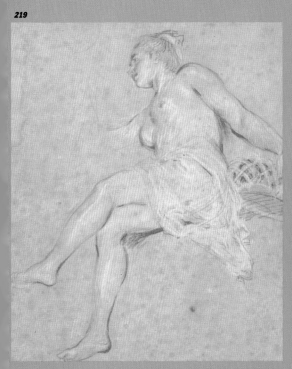
219

221

Combined techniques

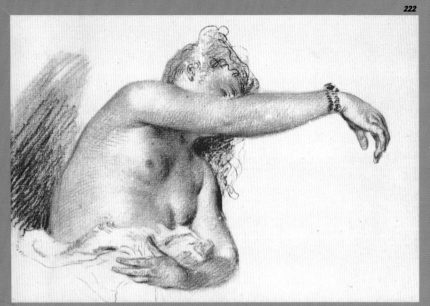

222

223

224

Fig. 222 Watteau (1684-1721). *Study of a Nude*. Black chalk and sanguine on cream paper. Louvre, Paris. Sanguine, or Conté crayon, on cream paper is an excellent way to represent the colour of flesh. You can achieve a perfect result with this medium by reinforcing some areas with black chalk or charcoal pencil.

Fig. 223 Boucher (1703-70). *Young Girl with a Rose*. Black chalk, sanguine, and pastel on ochre-grey paper. This drawing is an inspired example of the potential inherent in combining various media.

Fig. 224 Rubens (1577-1640). *Portrait of Isabella Brandt*. Charcoal pencil, sanguine, and white chalk on a light sienna paper. The drawing of the eyes has been emphasized with a pen and Indian ink. By using only sanguine and charcoal and later highlighting with white chalk, Rubens has obtained colour nuances that are really extraordinary. This is a masterful lesson on the possibilities offered by paper that is similar in colour to flesh combined with the richness of mixing a single colour with black and white.

225

The means for drawing are many and varied: lead pencil, charcoal, charcoal pencil, compressed charcoal bars, pastels, pen and ink, reed pen, ballpoint pen, felt-tipped pen, Rapidograph, or Indian ink washes. It is no wonder that with this diversity of methods, the artist will try to mix techniques to enrich the work. There is no doubt that the possibilities of these mixed techniques are extraordinary, as you can see in the examples in these pages.

Fig. 225 Badia Camps. *Study of Figure.* Private collection. Black, grey, and coloured pastels. This drawing is an example of the possibilities of pastel as a drawing medium.

Drawing with pen and ink

The oldest method of drawing with black or sepia-coloured inks is the reed pen. But by the year A.D. 600, codices were written in ink with a reed pen, actually made of bamboo cane. Dürer used the reed pen for drawing and so did van Gogh and Matisse, but most of Rembrandt's outstanding drawings were made with a quill made from goose, swan or crow feathers. By the end of the 18th century, the first metallic pen, or 'Perry', appeared. It was named after its inventor, the Englishman James Perry.

The reed pen, the quill pen, and by the 19th century, the metallic pen were the only tools known and used for drawing with Indian ink, which was invented about 2,500 years B.C. However, in the 20th century, drawing with a pen offers a range of about twelve different kinds of pens that in general produce a drawing in black or dark ink applied to white paper, with very little tonal gradation. A sampling of the variety of pens and inks available is shown below.

Black Indian ink can be found in solid form, made into sticks, or in liquid form, kept in flasks and bottles. The stick form of Indian ink is used for wash drawings made with a brush, whereas liquid Indian ink is used for drawing with metallic pen, brush, or reed pen. Inks are also available in different colours, among them: sepias and siennas for pen and wash drawings; soluble white ink for making small white shapes enhancing drawings with white. There are also other types of ink, such as blue inks for fountain pens and black and coloured inks for drawing and technical pens.

The classic drawing pen is the metallic nib, which can be adapted to a wooden handle. You can use different types of metallic nibs with the same handle: flat-bodied, flat-tipped, round-tipped, and so on. The Graphos Company manufactures a type of handle with a small container for ink and about seventy differently shaped nibs. Some people draw with a fountain pen, which contains a special cartridge for ink.

As you can see in Fig. 226, the brushes most widely used are those made of sable (5), mongoose (6), sizes no. 3 to 6. For special effects, rubbings, pointillist effects, and so forth, you can use a brush of pig bristle (7), or a Japanese sumi-e- style brush for wash painting (8). Black ballpoint pens are a good tool for continuous line drawings; but the ideal tool for this type of regular line of constant thickness is the technical pen. Technical pens have the advantage of coming with independent ink cartridges. They can be used with a great variety of nibs, ranging from a very fine (size 6 × 0) to a relatively wide line (size 7). Felt-tip pens can also be used to achieve a distinct style of pen drawing. They are available in three tip sizes: fine, medium, and broad.

Fig. 226 Today there are different materials and tools that allow us to enrich ink drawing techniques. From left to right: an Indian ink bar that is meant to be dissolved in distilled water and applied with a paintbrush (1); Liquid 'China' ink used for drawing with a pen, brush or reed pen (2). A Perry-type metal nib with a drawing handle, and (above) three kinds of pens in everyday use (A, B, C). An ordinary fountain pen used for drawing with blue ink, not suitable for black Indian ink (4), although there is a fountain pen made especially for drawing with Indian ink. Brushes for drawing with black of coloured Indian ink: sable, mongoose, bristle, Japanese, and deer hair (5, 6, 7, 8). A black ballpoint pen (9). A Rapidograph for drawings that require lines of a constant thickness; it is sold with nibs for drawing lines as fine as 0.13 mm and as thick as 2.00 mm (10). Felt-tipped pens: fine point, medium point, and thick point (11, 12, 13). A black coloured pencil (14). A reed pen (15). Burnt sienna Indian ink (16). A white Indian ink soluble in water (17). A china palette with wells where you can dissolve Indian ink (bar or liquid, black or coloured inks) in distilled water (18).

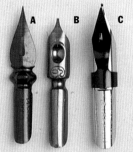

226

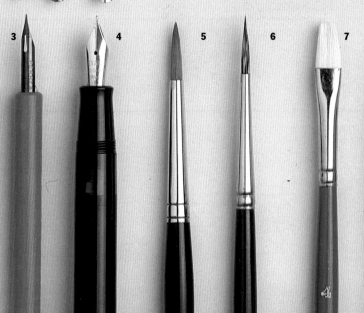

Fig. 227 This ink drawing was made with a Perry-type metal nib. There are no continuous medium values here, but you can obtain tonal gradations by laying in series of lines.

Fig. 228 Van Gogh, *The Garden at St Paul's.* Indian ink. Van Gogh did this drawing with ink, occasionally wetting the pen in distilled water, or in sepia diluted with water, in order to create lighter colour values. A neglected garden such as this one was a valuable subject for van Gogh. In a letter to his brother Théo, he said: 'This desolate garden, with all these pine trees under which the grass and the weeds grow tall and neglected, has been good enough for me to work.'

227

228

16

Fig. 229 Dürer. *Praying Hands.* Black and white ink on blue paper. Albertina, Vienna. Note the use of white ink in this drawing.

Fig. 230 In this detail of a drawing made with Indian ink and a reed pen, note the variety of line widths and values that the reed pen is capable of producing.

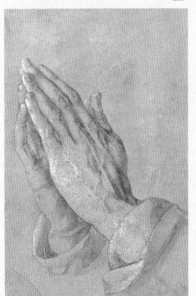

229

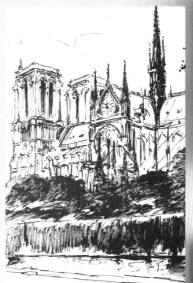

230

17

18

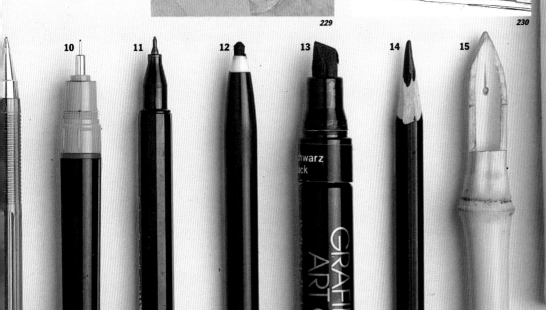

Techniques of pen drawing

How to hold the pen. A pen can be held in the normal way when you want to draw fine or medium-sized lines.

The pen should be held more slanted to draw thick horizontal or diagonal lines.

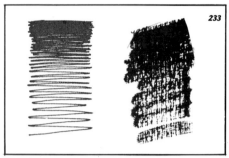

Paper for ink drawings. A high-quality, glossy drawing paper is an excellent surface for drawing in ink using any type of pen. A rough, medium-grain paper is a good choice when you want to emphasize the effects of drybrush and the reed pen.

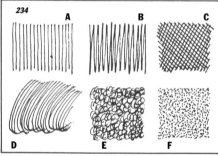

Penstrokes drawn with a metal pen or Rapidograph. Note the effect of penstrokes made with separated lines (A); zigzag lines (B); crosshatched lines (C); curving lines (D); little circles (E); and, simply, a grouping of dots (F).

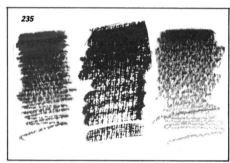

Penstrokes drawn with a reed pen, a drybrush, and a black coloured pencil. In the following examples, I used a rough, medium-grained paper.

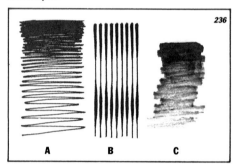

Tonal gradations. From left to right: a gradation made with a metal nib, initiated with thick zigzag lines and finished with separated fine lines; series of fine parallel lines thickened and gradated with the metal nib; crosshatching made with a reed pen.

Metal pen. This illustration shows you the possibilities of creating several values and a sense of space with a metal nib. Note how the contour lines serve to envelop and define the forms.

Black coloured pencil. The black coloured pencil, black wax pencil, and black lithographic pencil work well on fine- or medium-grain paper. This loose, sketchy style of drawing offers many possibilities for creating fully realized drawings.

Pen and graphite pencil. When combining these two mediums, begin by modelling the form with a pencil. Then with the Rapidograph pen, trace a series of identical parallel lines. Finally, use the metal nib to intensify the initial pencil shadings.

Metal pen and drybrush on fine-grained paper. Note the possibilities of drybrush applied on a drawing where a metal nib has been already used to highlight some contours. Note also the direction of the contour lines and the penstrokes that define and envelop the forms. In this drawing, metal-nib penstrokes strokes are subtle in comparison to the bolder drybrush lines.

Graphite pencil on glossy paper. This drawing was initially developed with modelling and shading and later tonal areas were created by dots, a technique known as pointillism.

Masking fluid, graphite pencil, and washes. Masking fluid is a product that enables you to reserve white areas of your drawing when painting in washes of ink or watercolour. In this case, the drawing has been stained with a wash of Indian ink. This method of staining is done by saturating a

piece of Bristol board with Indian ink and then pressing it to the drawing so that the ink is transferred to the drawing by pressure. Depending on the amount of pressure and the quantity of the ink, you get various shades of grey, from very dark to very light.

The masking fluid can be removed with a soft rubber, and later you can define some forms with the Rapidograph, and paint other areas with a wash of Indian ink.

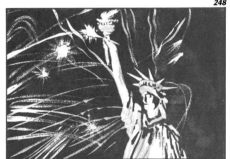

Reserving white areas with masking fluid. The masking fluid used in watercolour to reserve white areas of the paper can also be used to reserve white areas when you are drawing with Indian ink. The process is the same: once the major shapes have been drawn in, you fill in the white

areas with the masking fluid. You can then paint over the reserved areas with the ink wash. Finally, you erase the masking fluid and retouch small areas with a metal nib.

Reserving white areas with white Indian ink. Small white shapes, such as dots and lines, can be drawn over black Indian ink once it is dry. The finish of these reserved areas is not as clean and hard-edged as the ones reserved with masking fluid.

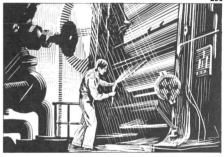

Ink line drawing. A line drawing has no tonal areas and is solely developed with regular and constant lines. It's best done with a graphite pencil, a ballpoint pen, or a fine-line felt-tipped pen.

White ink on dark coloured paper. On a black or dark-coloured paper, you can use white soluble ink to create the lights and shades of a drawing. Paint in the light areas with white ink, leaving the shaded and dark areas to be formed by the dark colour of the paper.

Imitating a boxwood engraving with drawing. On a special Bristol board called 'grattage' by Canson, you can draw in negative shapes by painting the board with black Indian ink and then scratching in white lines with a well-sharpened lancet.

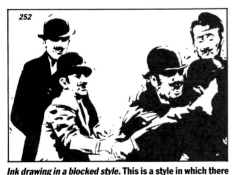

Ink drawing in a blocked style. This is a style in which there are no halftones, only black masses defining the forms. You can draw with a brush and Indian ink, but the results are better with black gouache.

Finger painting. This is done by rubbing your fingers over a wet wash in order to achieve soft blurred forms and lines. In finger painting, you need to study the degree of moisture used to apply the wash. You can use Indian ink and distilled water or watercolour and ordinary tap water.

Japanese wash: sumi-e. Sumi-e is a Japanese ink-drawing technique that requires special training. It is done with Indian ink and a bamboo brush on fine-grain watercolour paper.

Drawing with a reed pen

At first sight, with its dark, medium, and light greys, a drawing by reed pen may look like one made with lead pencil. But on closer inspection the strokes you see do not have a gloss, the blacks are matt, and, as a general rule, the drawing has an intensity and strength characteristic of Indian ink.

When you draw with a reed pen, the amount of pressure you exert on it is the main determinant of the degree of tonal gradation you get. Of course, it's not possible to get a light grey such as the one of the mountain on this page if the reed is taken directly from the ink-pot and is excessively loaded.

To use the reed correctly, you first immerse it in the ink and tap off the excess ink on the ink-pot rim; experiment with strokes on a scrap piece of paper until you get the gradation or value intensity you want; and then go immediately to the actual drawing. A word of advice: the scrap testing paper should be of the same kind and quality as the original, otherwise you won't be able to duplicate the effect you want. The reed pen is basically a simple technique. To succeed in this medium, you just need to practise until you have a good command of the more-or-less ink and more-or-less pressure game. In spite of this, you'll find that you won't always achieve a perfect uniformity and regularity, but so much the better: small accidents and little imperfections are often just the thing to give a certain sparkle to a work of art.

Fig. 255 The reed pen is a drawing instrument available in art-supply stores. However, you can make one yourself by using a common reed or an old paintbrush handle, tapering it to a point at one end, and making a small incision or cut at the end to hold the ink.

Fig. 256 When drawing with the reed pen, you should have on hand a scrap piece of drawing paper of the same quality as the one being used, in order to discharge the excess ink that could be in the reed and to control the intensity of the lines.

Fig. 257 This drawing was made on glossy paper. To begin, I filled in the basic shapes with dark colour and later put in the intermediate tones.

Fig. 258 Notice in the finished drawing the variety of line thicknesses. These differences were created by the position of the reed pen in relation to the paper surface. Also notice the different directions of the penstrokes, horizontal for the mountains in the background, diagonal for the rooftops, and vertical for the walls.

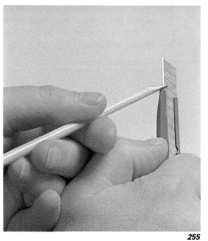

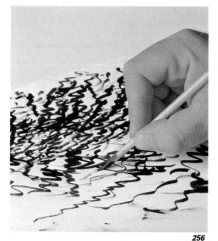

255

256

257

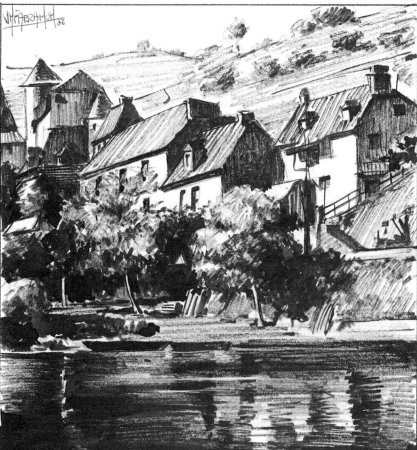

Brushes and Indian ink

Jesús Blasco, a good friend of mine, who is a well-known illustrator in Europe, used to say, 'Brushes are a most plastic tool. They make you feel more at ease.' Blasco paints with sable brushes nos. 2 and 3 for linear strokes, and with a no. 5 for washes and background tone. He uses Canson glossy paper.

Brushes and Indian ink make a very good drawing combination. For example, with brush and ink, you can use the drybrush technique, which consists of rubbing the brush with scarcely any ink against the paper. This technique will give you brushstrokes of varying values, depending on the amount of ink and pressure exerted. Of course, the paper you use must be either of fine or medium grain. A fine texture is suitable for small-format drawings, but larger drawings require medium-grain papers. The paper should be of good quality, well glued, so that its grain is textured enough to pick up the small amount of ink on the brush.

Fig. 259 This drawing was done on fine-grain paper, its grain size slightly larger than the one in Fig. 261. I worked with sable brushes, nos. 8 and 4. As with the reed pen, you also need to have a piece of scrap paper to discharge the excess ink and to test the tones and intensities before beginning the final drawing.

Fig. 260 It is important to compose the basic structure of the model's face with the major shaded areas. I did this with a medium-grade pencil – an HB – and then redrew the features with Indian ink and a no. 4 brush.

259 260

Figs. 261 and 262 Light grey tonal areas can be achieved by a brush that is half dry. To get darker greys, intensify them progressively with several applications of the brush. First draw the contour lines of the model, not only the internal ones but also the external. Then, to create a sense of volume, use a wetter brush to fill in with softer gradations of tone; this will serve to soften the hardness of the contours.

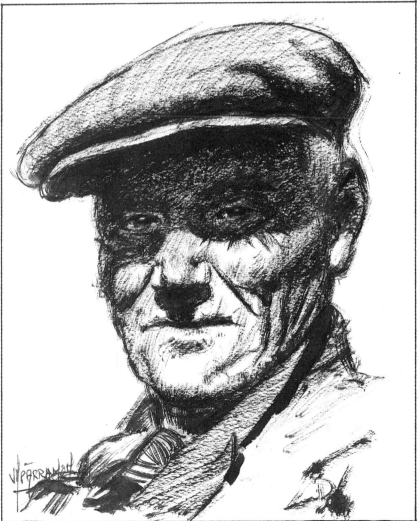

262

Coloured pencils

Drawing-painting with coloured pencils is in fashion now. I use the term *drawing-painting* because when you work with coloured pencils you are not only drawing, you are making tonal gradations, mixing colours, contrasting colours, experimenting with colours – in a word, painting. Drawing with coloured pencils is a fine way of getting started in the art of painting.

263

264

1 2 3 4 5

Fig. 263 This metal box comes with two tray sets of 72 pencils, made by Rexel Cumberland. Also available are a set of 24 water-soluble pencils and a set of 72 'all in colour' sticks.

Fig. 264 From left to right are five coloured pencils: (1) a Derwent Studio red pencil made by Rexel Cumberland; (2) a Faber-Castell coloured pencil; (3) a school-quality pencil made in Germany by Staedtler; (4) a soft water-soluble Prismalo II pencil made by Caran d'Ache; (5) a school-quality pencil made by Lyra-Rembrandt.

Fig. 265 Below is the 60-colour pencil set made by Faber-Castell. Note the great range of colours and subtlety of tones. Faber-Castell has also introduced to the market a 36-colour set of water-soluble coloured pencils.

265

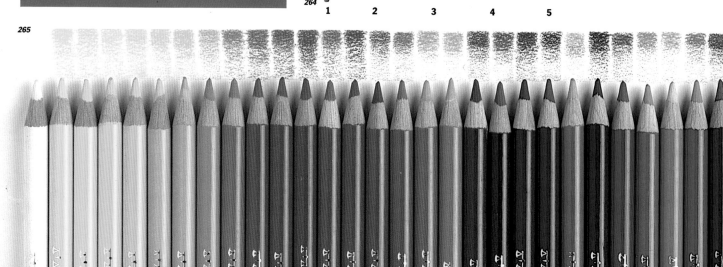

The lead of a coloured pencil consists of coloured pigments agglutinated with a special type of wax and some varnish; then the compressed ingredients are protected with a layer of cedarwood. Standard-quality coloured pencils can be found in 12-colour boxes. But for the purposes of the artist, the high-quality coloured pencils are recommended. They come in metallic boxes of 12, 24, 36, 40, 60, and 72 pencils. Caran d'Ache manufactures a maximum range of 40 colours. Berol and Faber-Castell offer a range of 60 (see the bottom of this page). The brand Rexel Cumberland has a top range of 72 different colours. These manufacturers also provide additional colours.

Some brands of coloured pencils make a distinction between those that are water resistant and those that are water soluble. Caran d'Ache colours are water soluble, and they are made in two different gradations: Supracolor I, and a softer one, Supracolor II. Faber has recently put on the market the Albrecht Dürer 'watercolourable' pencils, in boxes of 12, 24, and 36 colours. Rexel Cumberland offers, in addition to its box of 42 water-soluble pencils, the novelty of square-shaped leads of different colours, without wood protection. These new leads measure 8 mm x 12 cm long and are covered with lacquer to prevent their rubbing off on one's fingers. They are perfect for backgrounds and large tonal areas, and are manufactured in 72 different colours, though they can be bought in special ranges of 12 colours, classified as bright, shade, and pastel colours.

Figs. 266 and 267 Is it better to sharpen pencils with a knife or with a pencil sharpener? Although there is no unanimous opinion on this subject, it seems more practical, quicker, and cheaper (the pencil lead doesn't break so easily) to use a good pencil sharpener so long as it gives you a long point.

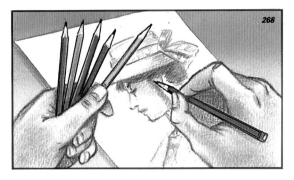

Fig. 268 Holding only one pencil at a time is usually not a practical way to work with coloured pencils. Also if you leave your pencils scattered on a work table, you risk damaging them. It's a better idea to hold all pencils you need in one hand as you draw with the other hand.

Fig. 269 A pencil should not be held at too wide an angle from the paper; this position runs the risk of breaking the pencil lead.

Fig. 270 High-quality coloured pencils can be expensive, so you should make the most of them. When they get too short to hold by hand use a metal pencil holder.

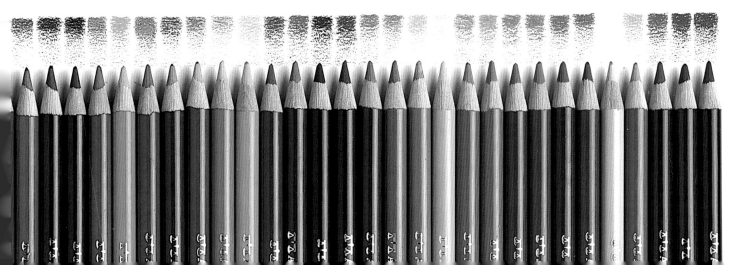

A lesson in colour from van Gogh

From the age of 19 until his death, van Gogh wrote 256 letters to his brother Théo. The last one (undated) was found on his body on 29 July 1890, after he had committed suicide at the age of 37. His brother Théo died six months later.

The well-known book *Letters to Théo*, which has been translated into many languages, is about van Gogh's private drama, his loneliness, and his anxiety. But it also deals with his ideas, his knowledge, and his achievements in drawing and painting. One of the most interesting and informative of van Gogh's ideas to be found in the letters is on his theory of colour: 'There are only three colours which are truly elementary in nature and which, when they are mixed two at a time, produce three more compound colours which may be called *secondary*.'

As an illustration of van Gogh's theory, look at the three primary colours on this page: yellow, blue, and red (Fig. 271). These three colours

271

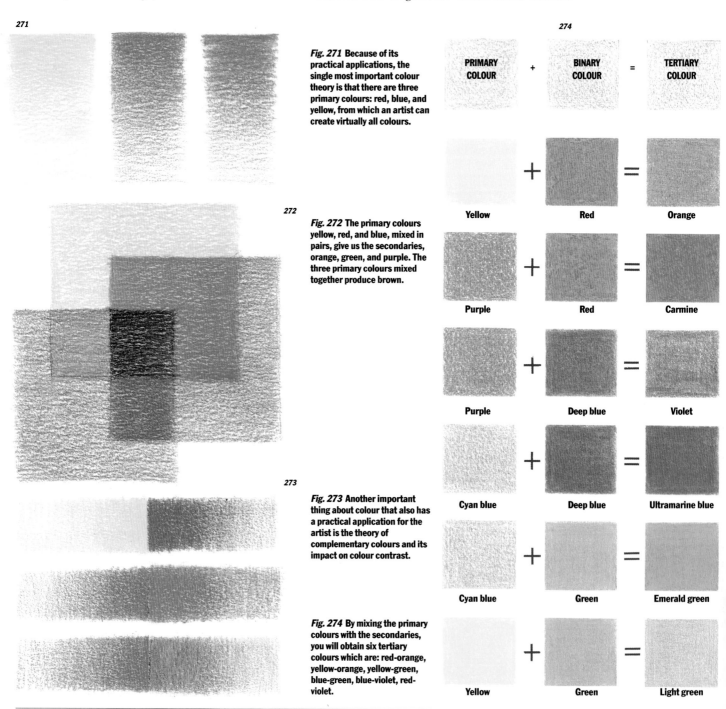

Fig. 271 Because of its practical applications, the single most important colour theory is that there are three primary colours: red, blue, and yellow, from which an artist can create virtually all colours.

272

Fig. 272 The primary colours yellow, red, and blue, mixed in pairs, give us the secondaries, orange, green, and purple. The three primary colours mixed together produce brown.

273

Fig. 273 Another important thing about colour that also has a practical application for the artist is the theory of complementary colours and its impact on colour contrast.

Fig. 274 By mixing the primary colours with the secondaries, you will obtain six tertiary colours which are: red-orange, yellow-orange, yellow-green, blue-green, blue-violet, red-violet.

274

PRIMARY COLOUR	+	BINARY COLOUR	=	TERTIARY COLOUR
Yellow	+	Red	=	Orange
Purple	+	Red	=	Carmine
Purple	+	Deep blue	=	Violet
Cyan blue	+	Deep blue	=	Ultramarine blue
Cyan blue	+	Green	=	Emerald green
Yellow	+	Green	=	Light green

mixed together 'beget', as van Gogh used to say, the three secondary colours: orange, green, and violet (Fig. 272).

If you look at the right-hand column (Fig. 274) you will see how to compose the six tertiary colours by mixing one primary and one secondary. From top to bottom these are: orange, carmine, violet, ultramarine blue, emerald green, and light green.

To prove this theory to yourself, there is no better medium than coloured pencils to experience that:

All the colours in nature can be composed by mixing the three primary pigment colours: yellow, red, and blue.

Van Gogh also talks about complementary colours and says that when two primary colours (yellow and blue, for instance) are mixed, the result (green) is the complement of the primary that did not take part in the mixture (red). Thus, we can say with van Gogh that:

Purple is the complement of yellow
Orange is the complement of blue
Green is the complement of red

But, you may ask, what is the use of knowing what the complementary colours are? Van Gogh's answer to this question is the same as any experienced artist's. A knowledge of colour theory helps you to:

Create contrasts: the juxtaposition of two complementaries, says van Gogh, 'will increase their intensity so much that the human eye will hardly be able to bear it'.

Paint with broken colours: 'If two complementary colours are mixed in unequal amounts the result will be a broken colour, or a variety of grey.' (This rule applies when you are drawing-painting with coloured pencils or watercolours.)

As an epilogue to this short lesson, try drawing-painting any subject with only three primary colours (and perhaps black). I have done this exercise using 11 colours and black and with three colours (and black). The result is obvious if you look at Figs. 275 and 276. Why, then, you may wonder, do manufacturers sell boxes with 60, and even 72 different colours?

Let me show you the answers on the following pages.

275

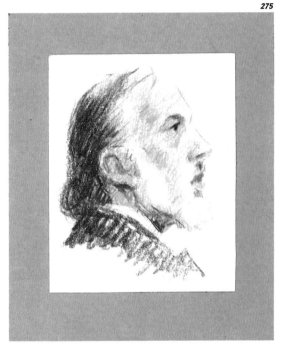

276

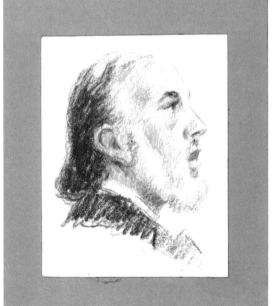

Figs. 275 and 276 Using only the three primary colours plus black and white, it is possible to compose all the colours in nature. For example, the head drawn above was 'painted' using 11 colours plus black and white. The head below was 'painted' with only the three primary colours, plus black and white. As you can see, the result is not identical but acceptable, and it confirms in practice the basic precepts of colour theory.

Drawing/painting with coloured pencils

Use coloured pencils for preliminary drawings. Use light blue, light grey, or light sienna, depending on the amount of cool, neutral, or warm colours offered by the model. Never use a lead pencil because pencil marks remain visible against the subsequent colour application.

Use the white of the paper for white areas of the drawing. Usually the white of the paper acts as white colour in a drawing. White coloured pencils are not effective because they are neither opaque nor capable of covering colours.

Colour mixing by superimposing colours. With modern sets of 40 pencils, you can always choose to use one colour to create the direct colour you want. However, subtle colour changes and nuances are best achieved by superimposing one colour over another.

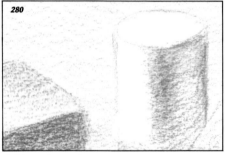

Build up colour gradually. As you can see in this step-by-step example, coloured pencil technique is developed by a progressive build-up of colour.

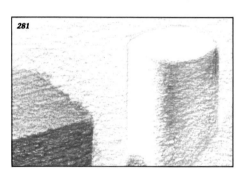

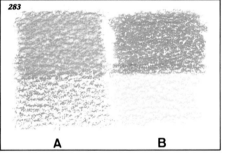

A B

Practise colour mixing with the same colours. Over a grey-blue tonal area, I have superimposed yellow to obtain a light green (A). By changing the order of the colours, that is, starting with the yellow and then superimposing blue, the resulting green is darker (B).

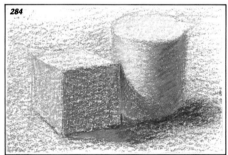

Pastel colour effects. The cube and cylinder of the above drawing (Figs. 284, 285) were drawn, at first, with the same pencils and colours, but later, in the figure on the right, I used a white coloured pencil over the blue in the

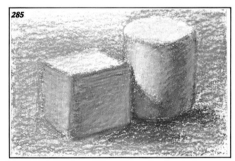

background, the rosy planes of the cube, the shadow projected by the cube on the cylinder, and the light reflected by the cylinder. The whiteish patina achieved here is similar to the soft look of a pastel drawing.

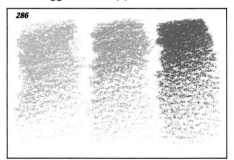

The size and texture of coloured pencil paper. A coloured pencil drawing is usually not large. Either 20 x 25 cm or 25 x 30 or 35 cm are advisable sizes. It is also recommended that the grain of the paper should be related to the size of

the drawing: for a large work, a fine or medium-grain (Fig. 286) paper works well; for a small work, use a paper with a very fine texture.

Coloured pencils on coloured paper. Coloured papers, such as cream, light blue, grey, or salmon, make a wonderful surface for drawing-painting with coloured pencils. They help to harmonize the colour and allow you to highlight the whites with white pencil.

Colour theory and practice. This scale of colours of the spectrum (Fig. 289) was developed by using the three primary colours. The spectrum in Fig. 290 was drawn with twelve different pencil colours. It is obvious that in the right-hand picture there is a greater richness and diversity of colour. For example, compare the range of greens, blues, purples, and violets you see, and you'll come to the conclusion that more colours will give you better results.

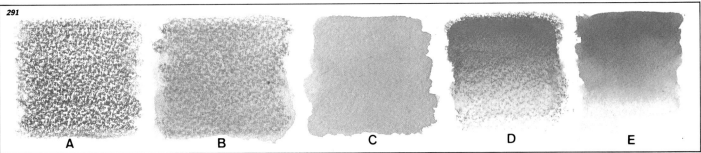

Water-soluble coloured pencils v. watercolour. In the examples, compare the quality of water-soluble coloured pencils with swatches of real watercolour. In Fig. 291, you can see a toned area filled in with a blue pencil (A), and then the same area after it has been dissolved with a brush charged with water (B). Swatch C was created by using a blue watercolour wash. The next gradation was drawn in with a dark carmine pencil and later dissolved with water (D), and beside it I have painted the same carmine-coloured gradation with watercolour (E). Note that the watercolour swatches are cleaner and more transparent than are coloured pencils combined with water.

The wash technique using a water-soluble coloured pencil. This is a very helpful technique, used primarily for small washes and made with a single colour. It is even easier than a simple watercolour wash.

The importance of line direction. As I have said before, you can paint as well as draw with coloured pencils. When you draw, however, the lines created are distinctive. These lines are the most important element in determining and developing the forms of your drawing. For example, if you are drawing the sea, lines will tend to be horizontal, or if you are drawing a field of grass, lines typically will be short and vertical.

The coloured pencil as an auxiliary medium. In contemporary illustration, as demonstrated in this picture by Maria Rius (Fig. 294), the watercolour medium is

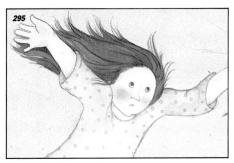

perhaps the most commonly used. However, pastel and coloured pencil are often used for finishing touches. In this case, coloured pencil can be found in the girl's hair.

Coloured pencil finishing of marker drawings. Light-coloured pencils, such as yellow, white, and pink, are usually applied over dark areas of drawings done with markers to represent fog or, as in this case, the effects of a geyser (drawing by Claude de Seynes).

A subject such as you see here with this range of broken colours and greys can be drawn with only three colours: yellow, purple, and cyan blue. (In order to get a better harmonization I drew on Canson grey paper.) It is much more practical and effective to draw with different colours, freely, without any conditions, and avoiding mixtures which, very often, do not help in getting the exact tone or the ideal colour you want. Note in Fig. 297 the colours and numbers used for the seaport scene.

The last example in Fig. 297 is of white ink or possibly white gouache. White ink allowed me to enhance the drawing with a brush, a much better technique than using a white pencil. It created the brightness of the water in the foreground and the background, in addition to the illuminated areas of the ships, such as balustrades, masts, and so forth.

298

299

Faber-Castell polychrome colours used for this subject

White 101

Ochre 184

Burnt ochre 167

Burnt umber 180

Sepia 175

Light carmine 127

Light blue 146

Cobalt blue 144

Prussian blue 151

Silver-grey 196

Medium grey 197

Dark grey 1989

Black 199

White ink

297

300

Figs. 298, 299 and 300. Boats in the Port of Amsterdam. On grey Canson Mi-Teintes paper, I draw this theme with a *silver-grey 196* pencil and I start painting the silhouettes of the houses in the background with *sky-blue 116.* With *white 101,* I highlight the sky and the water gradating from the background to the foreground, the lights on the boats, etc... Next, I proceed with the hulls and the dark reflections of the boats on the water, first with *Prussian blue 151* and then with *dark grey 198* and *black 199.* Notice that there are small reflections left where you can see the blue. I use *medium grey 197* and *dark grey 198* in the port, behind the boats, and also *medium grey 197* in the foreground of the water, leaving some clear strips representing the movement of the water. *Ochre 184, burnt ochre 167, toasted umber 188,* slight touches of *carmine 127* ... and finally *white ink* in the brightest brilliances, on the water in the background and foreground, on the boats, balustrades, masts, etc...

Finish with coloured pencils of drawings made with felt-tipped pens. With light coloured pencils: yellow, white, pink, etc... it is normal to paint over the dark areas of the drawings made with felt-tipped pens, to represent the fog, or as in this case, the effects of a geyser.

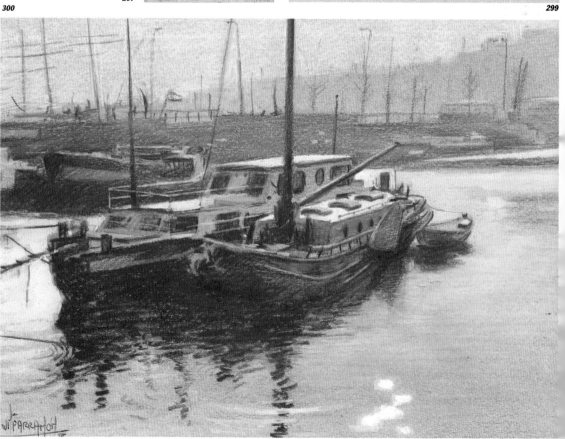

Water-soluble coloured paints

301

The use of water-soluble coloured pencils allows you to make gradations similar to painting and to define and to build form through pencilstrokes. It also allows you to blend colours with brush and water, like painting with watercolours.

Are water-soluble coloured pencils, in effect, a combined technique? Certainly! The two methods are practically inseparable. Of course, it is possible to draw-paint a subject using this kind of coloured pencil as if it were not water soluble, but it is an added benefit to be able to combine the linear effects of a dry medium such as pencil with the softer, liquid effects of a water medium.

In the drawing below, note the areas where pencilstrokes have been blended with water (such as the sky), and the grey areas where the outlines are highlighted by the texture of the paper (such as the trees, the cars, or the land, Fig. 304).

Fig. 301 When working with coloured pencil, don't use a lead pencil for a preliminary drawing because its surface could show through the colour. Instead, make your preliminary sketch with a sky-blue pencil. Note that in the illustration the shadow areas are also sketched in with a sky-blue pencil.

Fig. 302 This is the first stage of colour before any applications of brush or water. Note that the areas intended for watercolour, such as the sky, tend to be larger in the drawing.

Fig. 304 In the finished drawing, I have used watercolour for the sky, the shadowed areas of the church, the street area and, to a lesser extent, the trees. When the watercolour areas had dried completely, I used coloured pencil for the finishing details.

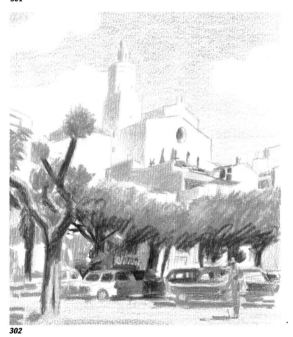

302

Caran D'ache watercolour colours and soft Prismalo II used for this subject

Ochre 035		Dark green 229	
Khaki 249		Medium grey 005	
Sienna 059		Umber blue 141	
Purple 090		Sky blue 160	
Carmine 080		Black 009	
Yellow green 245		White 001	

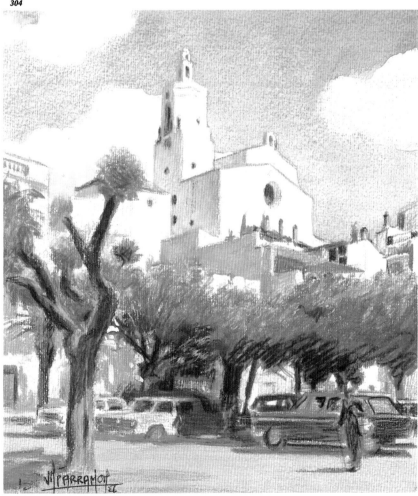

304

Markers

Markers are commonly used today, particularly in commercial art and advertising, but also in architecture and interior design.

The marker was developed by the Japanese in the 1960s. It is a sort of fountain pen with a container inside to carry the ink to the tip. The ink is made with pigments and alcohol, or rather, xylen, a liquid very similar to alcohol. Besides permanent markers, which contain xylen, there are also water-based markers that are non-toxic and made specifically for children's use.

There are three types of markers available on the market today with three different-sized points: the regular point made to fill large areas very quickly; the pointed nib, for general work; and the ultrafine point for drawing and sketching. There are several quality brands on the market including Ad markers (200 colours); Design Art markers (120 colours); Staedtler Mars Graphic 300 markers (60 colours); Berol Prismacolor Art markers (116 colours); and Pantone markers (312 colours). There is also a type of paper especially devised for drawing with felt markers. However, if you can't find this type of paper you can always use a glossy-type paper, such as Bristol.

Fig. 305 In the box on the right are listed five common makes of felt-tipped pens, their country of origin, and the number of colours.

Well-known markers

Manufacturer	Country of origin	Colours available
Ad markers	USA	200
Eberhard Faber Design Art markers	USA	120
Staedtler Mars Graphic 300 markers	Germany	60
Berol markers Prismacolor markers Pantone markers	USA	116 (broad tip)
Letraset markers	UK	204 (fine tip) 108

Fig. 306 Felt-tip pens are available in three versions: wide, medium, and fine tip. Notice the special design of the Magic Marker felt-tip pen, built with an inkwell from which a wick stems, that permits drawing with it and which, if necessary, can be unscrewed so as to open the inkwell to recharge it or to use the ink with a brush.

306

307

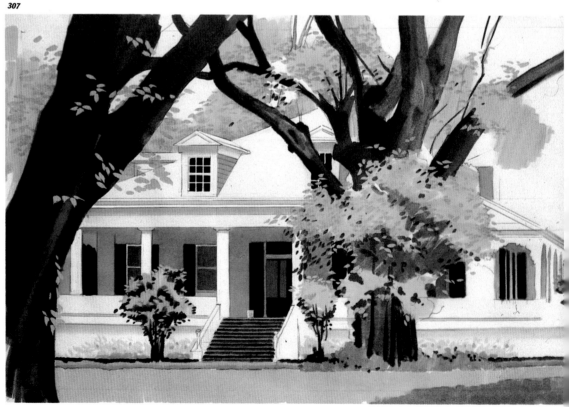

Fig. 307 Claude de Seynes. *Louisiana House.* De Seynes is an expert on felt-tip pens. He is the author, with Jean Naudet, of a book on their use. De Seynes establishes in this book the following minimum assortment of felt-tip pens needed:

light yellow
intense yellow
light orange
light pink
medium red
cadmium red
mauve
light blue
vivid blue
green-blue
Prussian blue
light green
medium green
dark green
fir green
light beige or ivory
intense beige or sand
red-brown
sepia
flesh
light cold grey
medium cold grey
light warm grey
medium warm grey

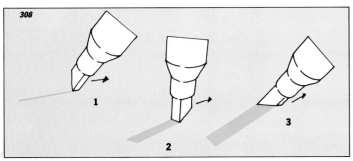

Three ways of drawing with a felt-tip pen. The side and rectangular point of a felt-tip pen enable you to draw three line widths: a fine line made with the edge of the point (1); a medium line made with the narrower frontal side (2); and

a wide line made by holding the pen at an angle (3). *Gradually from light to dark.* As with watercolour painting, felt-tip pens use the paper surface for white areas. Felt-tip colours are transparent and it is not possible to

superimpose a light colour over a dark one. You must build up colour with felt-tip pens, and develop your drawing from less colour to more colour and from light to dark.

Intensify tonal areas with the same colour. The same colour applied in successive coats will darken the colour, as you can see in these illustrations. The one in Fig. 311

has a single coat of colour, and the one in Fig. 312 has several applications.

Mixing colour with transparent ink. The ink in felt-tip pens is transparent. Mixing colours can be done in the same way as with watercolours, by superimposing one or several coats of colour or by blending the colours.

Draw with direct colour. Although it is possible to compose one colour by mixing two or more others, it is preferable, when working with felt-tip pens, to work with the exact colour. This is why manufacturers offer sets of up to 312 colours.

Drawing in background areas. As shown in the example, the typical way to lay down colour with felt-tip pens is to draw in lines horizontally, diagonally, or vertically, with a wide-tip pen fast enough for the ink mark of one stroke to blend with the next one.

Achieving tonal gradations. The above gradation was created with three colours. The blending of one colour with another was achieved by applying the colours in rapid succession before they were completely dry.

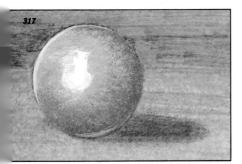

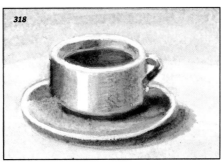

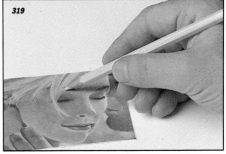

Practical applications of tonal gradations. Tonal areas were done in two stages in this example. First, horizontal lines were drawn in, reserving the white of the paper for the high-key areas. Then darker, more intense applications of colour were laid in the shaded areas.

Retouching with white ink or gouache. The white circles of the top of the cup and of the plate were retouched with white ink. This is an accepted technique often practised by artists who use felt-tip pens and markers.

Retouching felt-tip drawings with coloured pencils. Illustrators often use coloured pencils to outline or draw details over darker felt-tip pen drawings.

Wash techniques

A wash simply means a neutral-colour water-colour application. A wash drawing is made with a brush, water, and one or two neutral colours, such as black, black and sepia, or dark brown and sepia. These colours are generally watercolour pigments. However, a wash drawing can also be made with black or sepia Indian ink, a brush, and water, on condition that the water has been distilled, because Indian ink shouldn't be mixed with tap water. Wash drawing is a necessary step before tackling watercolour painting. Wash techniques are the same as watercolour techniques with the advantage that colour problems are eliminated. For example, when doing a wash drawing, you won't have to think about such problems as colour mixing, colour contrast, or colour harmony. This is clearly an advantage: you learn the wash technique first, and then go on to the complexity of drawing or painting with colour.

In addition to wash drawing being an excellent preliminary to actual watercolour painting, wash is a time-honoured technique all by itself. It has been used by all the great masters – ancient and modern – from Leonardo and Michelangelo to Rubens and Rembrandt, to van Gogh and Picasso.

Now let's tackle the wash technique in the best of all possible ways: by doing it!

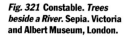

Fig. 320 Lorraine. *Landscape with a River. View of the Tiber from Mount Mario, Rome.* Sepia. British Museum, London.

Fig. 321 Constable. *Trees beside a River.* Sepia. Victoria and Albert Museum, London.

Fig. 322 Xu Hong. *Group of Horses* (fragment). From the album of paintings by the artist. Wash. Private collection.

320

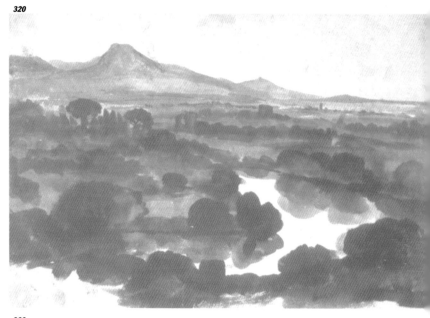

322

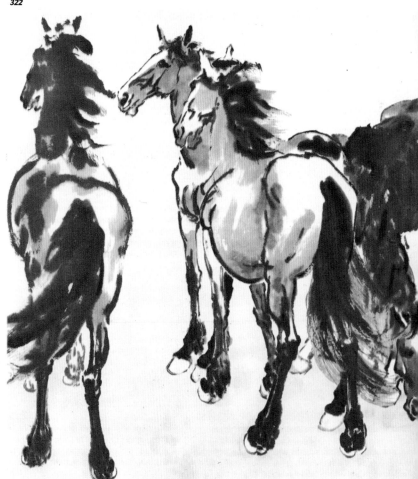

321

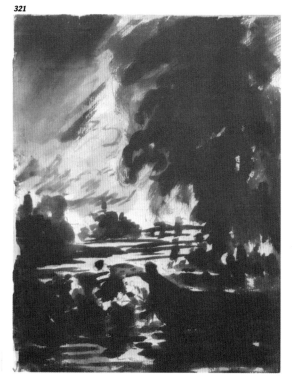

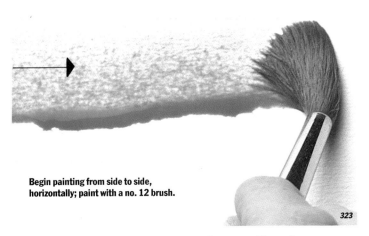

Begin painting from side to side, horizontally; paint with a no. 12 brush.

323

Fig. 323 Dry wash in a medium tone. Draw a 15 x 15 cm square. Then, using a cobalt blue wash, wet the brush with plenty of colour and begin painting a band 2 to 3 cm wide at the top of the square.

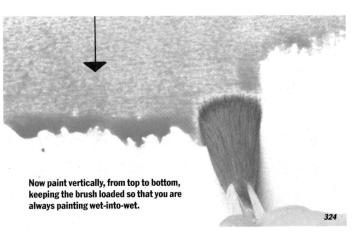

Now paint vertically, from top to bottom, keeping the brush loaded so that you are always painting wet-into-wet.

324

Fig. 324 To control the accumulation of paint and to keep it from running, the board should be slanted as necessary. Continue to maintain the moisture, working quickly. Keep displacing the wash, moving towards the bottom, painting horizontally, always leaving enough paint on the bottom edge.

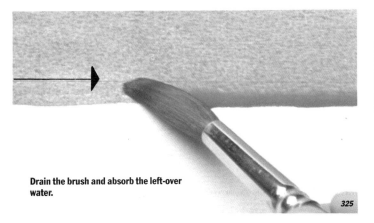

Drain the brush and absorb the left-over water.

325

Fig. 325 Now, absorb the paint accumulated on the bottom edge of the square. To do this, blot the brush with a paper towel and absorb the paint accumulated at the bottom edge until you have a regular, uniform tone over the whole square. The uniformity in the colour of a medium-dry tone wash depends on three things: the quality of the paper, the slant of the board, and the brush and the amount of paint on it.

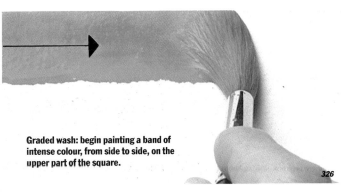

Graded wash: begin painting a band of intense colour, from side to side, on the upper part of the square.

326

Fig. 326 Dry graded wash. Sketch a square 15 x 15 cm and get ready to paint a graded wash using cadmium red or vermilion in the area specified.

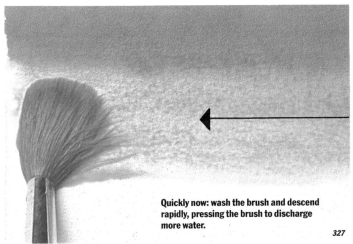

Quickly now: wash the brush and descend rapidly, pressing the brush to discharge more water.

327

Fig. 327 Wash the brush, drain it slightly on the edge of the water jar, and apply it to the bottom half of the red band, dissolving and gradating downward and painting from side to side horizontally. Move towards the bottom gradually, putting pressure on the brush to release more water.

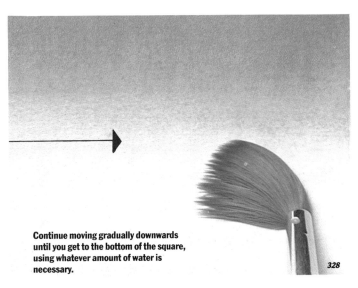

Continue moving gradually downwards until you get to the bottom of the square, using whatever amount of water is necessary.

328

Fig. 328 Wash the brush again, and drain it, and continue controlling the amount of water, going over it, retouching. You have to move quickly, measuring the water and working mainly in the bottom portion, which at this stage is the only area that allows for repeating and retouching.

Wash techniques

329

Opening up white spaces by absorbing colour. In wash drawing or watercolour painting, there is often the need to open up a white area in a still-wet wash. Begin by washing

330

the brush and draining it with the help of a paper towel. Apply the brush to the still-wet wash area, and the brush will absorb the water and the colour underneath.

331

Opening up a white area. If you want to obtain an even whiter area, apply the drained brush once again. By repeating this operation several times you can achieve an almost perfect white.

332

Dry method of opening up white areas. In a wash already dry, it is also possible to open up white areas. Begin by wetting the area with a brush and clean water. At the same time, rub gently with the brush, diluting and lifting the

333

colour. Later, with a paper towel folded several times, absorb the water you applied. Repeat this operation several times until you get a satisfactory white.

334

Opening up a white area with bleach. Common bleach, watered down by 50 per cent and applied over a dry wash, is a quick, effective way to remove pigment. But the brush must be synthetic in order to resist the corrosive action of the bleach.

335

Example: scrubbing out whites in dry paint. When you want a white in a dark area in an already-dry watercolour, it's advisable to do it with a synthetic flat brush, which has stiffer bristles than sable. Begin by moistening the chosen area with lots of water. Let the water sit for a few minutes,

336

allowing it to soften the paper and the paint, and then rub softly with a clean, rinsed brush until the deposited water begins to get cloudy with the loosened paint.

337

The brush should first have been washed and drained with the help of a paper towel. Apply the brush to the still-wet wash area, and the brush will absorb the water and the colour underneath.

338

Reserving white areas with masking fluid. Masking fluid is a product with which you can reserve lines, highlights, or small white areas. You apply it with a synthetic brush, and you can remove it, once it has dried, with an ordinary rubber. Note in these pictures, from left to right, the

application of the masking fluid over the initial drawing of some daisies; the later possibility of painting around and over the masking fluid without any alteration of its preserving abilities; the appearance of the drawing after the masking fluid has been erased, showing the white of

the reserved areas; and, finally, the finished painting, where the reserved white becomes very convincing daisy petals.

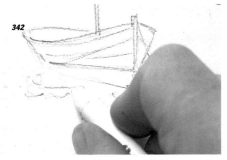

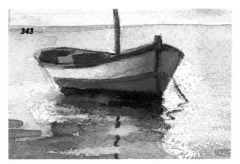

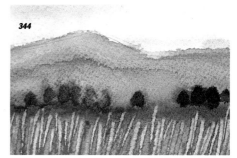

Reserving white areas with white wax. White wax can also be used to preserve the whites before you begin to paint. Once an initial drawing is completed, fill in white areas with a white wax crayon. Then you can paint over these

waxed areas because the wax will repel the watercolour pigment.

Scratching out whites in wet paint with a bevelled brush handle or a fingernail. You do this simply by scratching when the paint is still damp and the colour is somewhat thick.

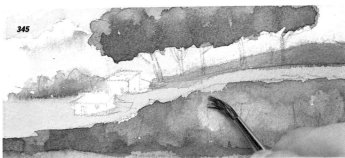

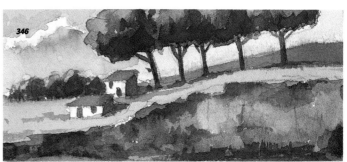

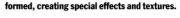

Textural effects with turpentine. Apply a synthetic brush loaded with turpentine over a freshly painted, still-damp

area. When the turpentine comes into contact with the watercolour, light-coloured, irregularly shaped spots are

formed, creating special effects and textures.

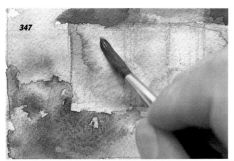

Rubbing with the brush. This technique, also called drybrush, consists of painting with an almost *dry brush*, which, when rubbed, reproduces the rough texture of the paper.

Textural effects with water. A brush loaded with water, applied to a still-damp recently painted area, will produce

very rich textural effects, which will enrich the colour and style of your painting.

Textural effects with salt. If you sprinkle salt on a recently painted still-damp area, the grains of salt will absorb the pigment and form some curious spots, light in colour and

diffused. This effect can be used for the background areas of a watercolour, creating effects of surprising quality. When the paint is dry, the grains of salt sticking to the

painting can be removed simply by rubbing them gently with your fingers. Or you can paint over them without any problem.

Wash techniques

Cube, cylinder, pyramid, and rectangle. With these four basic shapes you can carry out an exercise of wash drawing that brings to reality the previous discussion. You will need the following materials (Fig. 353):
Drawing paper for watercolour painting
A sheet of beige drawing paper (Mi-Teintes)
Paper towels
A bottle filled with water
Palette
H pencil
Rubber
A tube of cobalt blue watercolour
A tube of burnt umber watercolour
Sable brushes nos. 8, 14
Synthetic brush no. 12
On the facing page (Fig. 354) you will see on a small scale the patterns of the four basic shapes mentioned. For this and other exercises, it would be a good idea if you first build these models by yourself. Note also in Fig. 357 (the finished drawing) the type of lighting, the position of the various shapes, and the angle of the light. To complete the exercise, use washes of the cobalt blue and burnt umber to fill in the basic shapes.

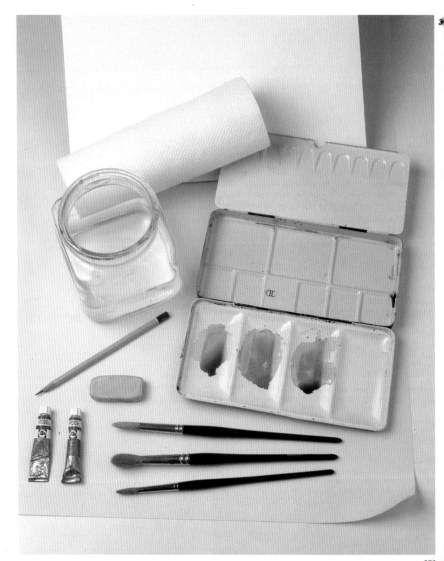

Fig. 353 Materials and tools needed for this exercise.

Fig. 354 For constructing these models, use a lightweight Bristol board, cutting it with a mat knife, x-acto, or razor blade. Try to cut a clean edge and follow the measurements given. It is not at all difficult to do, and you'll enjoy having the model in front of you.

355

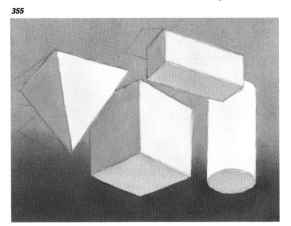

356

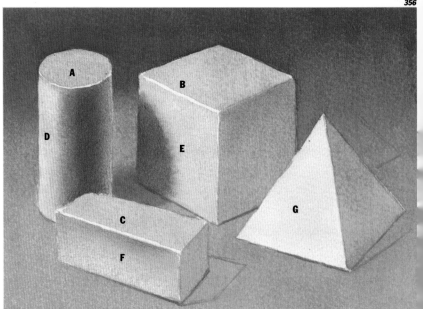

75mm

80mm

95mm

50mm

35mm

85mm

95mm

160mm

Painting a still life with wash

Begin by testing, on a scrap piece of paper, the range of colours that you can obtain by mixing cobalt blue and burnt umber. You will observe that by mixing these colours, you obtain a complete range of warm, neutral and cold greys, plus black, and a range of blues and siennas, depending on which colour dominates and how much water you use.

Fig. 355 To begin, I sketch in the still life with an H pencil. With the drawing upside down, which for me is a better way to control the various gradations, I start with a strong burnt umber wash for the upper part of the background and the shaded areas of the cube, the prism, and the pyramid. When this wash is dry, I cover the light-filled areas of the forms with masking fluid, and I paint the surrounding areas with a warm dark grey, almost black. Then, I wait until the wash is dry, and finish off with a cold grey on the upper faces of the cube, the cylinder, and the prism.

Fig. 356 With a very light warm grey, I fill in the D, E, and F faces, reserving at the same time brilliances on the A, B, C edges. But note that I leave the pyramid's triangle a pure white. Once more, I must wait until the grey is dry. Then, with clean water, I moisten the body of the cylinder (D) and the faces of the cube, painting wet-into-wet with colour over the cylinder and its shadows that project onto the cube.

Fig. 357 With the drawing upside down again, I lay a very blueish grey gradated from top to bottom on the cube, pyramid, and prism. When it is dry, I remoisten these areas, and lay down the shadows projected underneath the four basic forms with a warm intense grey mixed with burnt umber.

357

Oil crayons and oil pastels

Oil crayons are basically made with pigments and wax. Oil pastels, developed about twenty years ago, are made with pigments and oil. Oil pastels are associated, as their name suggests, with pastel, a traditional medium that is centuries old.

But, despite their differences, oil crayons and oil pastels are two methods whose possibilities and techniques are very nearly the same. Among these common features:

● Oil crayons and oil pastels are used by rubbing them against the paper. They can be blended with the fingertips.

● Both mediums are opaque, and light colours can be superimposed over dark colours.

● Both wax colours and oil pastels are difficult to erase. If you find it necessary to erase, you must first scrape off the waxy surface with a knife. After the waxy colour has been scraped off, you can reapply new colour without contaminating it with the first.

● If a light colour is covered with a dark one and a knife, or x-acto blade is scraped against the surface, the lighter colour will reappear.

● Both these media are soluble in turpentine.

● Fixative works on both media.

You may wonder at this point if, in effect, these two products are really the same. Yes and no: there is a small – but important – difference: oil crayon is harder, less malleable, and more impermeable. When you mix oil crayon colours, the resulting combination becomes stiff. It is thick, glossy, and grainless, and the pigment slides along the surface of the paper. This quality makes it necessary to scrape off the wax first before you can draw in a clean line of a light colour on top. Oil pastels, on the other hand, are softer and more pliable. They allow a touch of light colour on the dark one, as do real pastels.

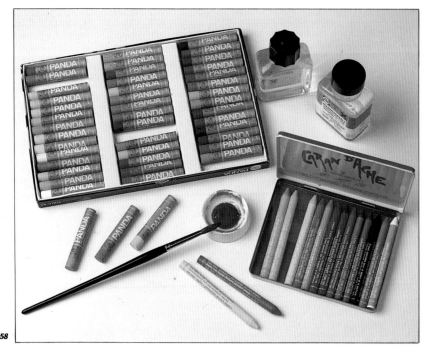

358

Fig. 358 **The above illustration shows Caran d'Ache's assortment of 30 Neocolor oil crayons, and a set of 45 Panda oil pastels made by Talens. Both these media can be dissolved in turpentine and mixed together, both can be protected with fixative.**

Fig. 359 **This drawing and those on the opposite page were painted on a dark brown Ingres paper. But this drawing was painted with oil crayons, while the others were done with oil pastels. When comparing these details of an old man's head, you can see that oil crayons have a harder line and more definition. On the other hand, oil pastels offer a greater opacity and a better impasto.**

Oil pastel painting techniques

360

Finger-blending technique. Both oil pastels and oil crayons can be gently rubbed and blended with the fingers.

361

Covering possibilities. Here, over a dark carmine spot, I have added grey and white strips. When using oil pastels and oil crayons, you can paint light colours over dark.

362

Erasing is difficult. First I fill in the area completely with dark carmine colour. Then, I scratch out the area with an x-acto which partly eliminates the colour (A). Finally, I rub the area vigorously with a rubber (B), but, as you can see, the colour has not been completely eliminated.

363

Drawing in negative. When applying a dark colour over a light one, you should work slowly and carefully in order to achieve a complete covering. Once you have done this, you can scratch out the covering colour to reveal the initial colour underneath.

364

Turpentine washes. Oil crayons and oil pastels can both be dissolved in turpentine, using a synthetic brush. You can then paint washes just as if you were using water-soluble coloured pencils.

362

Painting glazes. If you dissolve oil pastel or oil crayon shavings in a little turpentine, you will get a liquid colour that allows you to paint transparent glazes over your paintings. This technique works better with oil pastels.

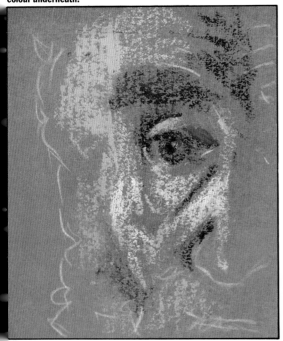

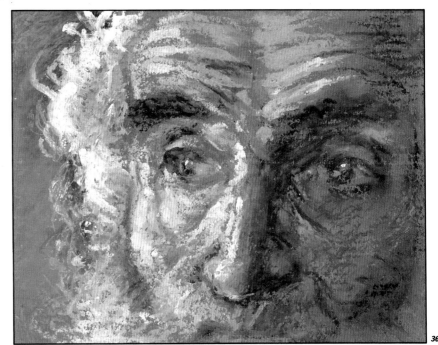

367

Fig. 366 The initial preliminary sketch for the picture shown above was made using a white coloured pencil. The finished painting was done progressively, with several layers of colour. This method is a good way to develop the volume and form of the image.

In this case, light colour was used for the highlights and the shadowed areas are the dark brown of the Ingres paper.

Fig. 367 Techniques for oil pastels are almost the same as the ones used for oil crayons, with the notable difference that oil pastels are softer than oil crayons. This characteristic can be clearly seen in the above example drawn with oil pastels. Note the capacity of the light colours to cover, and note also the impasto effect. When applying oil pastels to paper with any pressure, you can create outstanding textures similar to some of those you can get from painting with oil paint. Although a certain amount of practice is necessary to achieve optimum results by this method, there is no doubt that it is worth experimenting with it as a new means of drawing-painting.

Pastels

Fig. 368 Shown below is a pastel set comprising three trays and a total of 180 colours made by Talens. Talens also offers assortments of 15, 30, 45, 60, and 90 colours. Sets are also available in colours selected especially for portraits and landscapes in boxes of 45, 6C, and 90 colours.

Pastels are made up of earth and pulverized pigments agglutinated with water and gluing substances, but without the liquid base of oils, varnishes, and essences which, in watercolour and oil painting, have an influence on the purity and richness of the colour. This quality is what makes pastels somewhat fragile and unsteady. They should not be fixed (or even touched!) and, to some extent, they should not even be mixed. So my advice to you is: *When working with pastel colours, use each colour singly, using mixtures only to adjust values.*

Fortunately, pastel manufacturers understand this characteristic and pastels come in sets of 12, 18, 24, 36, and 48 sticks. You can also get beautiful wooden boxed sets of 99 colours (Schminke), 72 colours (Faber-Castell), and even 180 colours (Rembrandt). Rembrandt also has special sets for both portrait and landscape work; these come in sets of 46, 60, and 90 colours.

Pastels can be mixed and blended, and light colours can be painted over dark colours. In fact, fingertip blending and strokes are often alternated to get a painterly effect. Keep in mind that instead of your fingertips you could also use paper stumps, but, as I have said previously, your fingertip is superior because of the natural oil in your skin. It is this oil that agglutinates and fixes pastel colour.

The drawing paper used for pastel work should be medium to coarse grain. Coloured paper is generally preferred, although white is acceptable. Pastels can be rubbed off with a kneaded rubber or with a piece of cloth or paper towel. Charcoal, charcoal pencils, Conté crayon, and white chalk are excellent auxiliary media to combine with pastel.

Pastels are affected by contact with moisture. If you wet a pastel stick with saliva, the intensity of the colour will increase, but after a few seconds, it dries and recovers its usual colour. However, if you touch pastel and have grease on your fingers, the stain remains and the colour stays. Also, grease or sweat on a finger could get onto the surface you are working on. Pastel will not adhere to an oily surface. Fixatives do not contain oil, but they have some agglutinating substances that do change the refraction of light. This property darkens the colours on the one hand, but also makes them more transparent, causing them to lose their covering capabilities. Therefore, fixing a pastel drawing means losing opaqueness and luminosity. What can you do then to prevent this reaction while still being able to keep the surface of your drawing intact?

In a handbook published by Talens, the manufacturer of Rembrandt pastels, it is suggested that you fix only a few areas at a time and retouch the most affected ones later. This technique makes the fixative coating adhere better. Degas preserved his pastels by moistening the drawing paper with turpentine, which, he observed, helped to keep them.

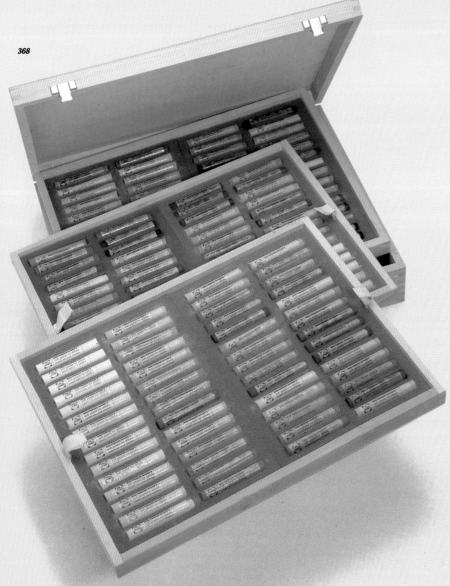

368

It is my opinion that pastels should never be fixed, which means you must protect your drawings with a sheet of paper in such a way that it prevents contact with anything else. Then, when a drawing is completed, you will need to frame (Fig. 385) your pastel with a sheet of glass and a thick passe-partout frame to avoid contact with the glass. That is the method used by great museums to protect the work of such masters as Rosalba Carriera, Chardin, Quentin de La Tour and Degas.

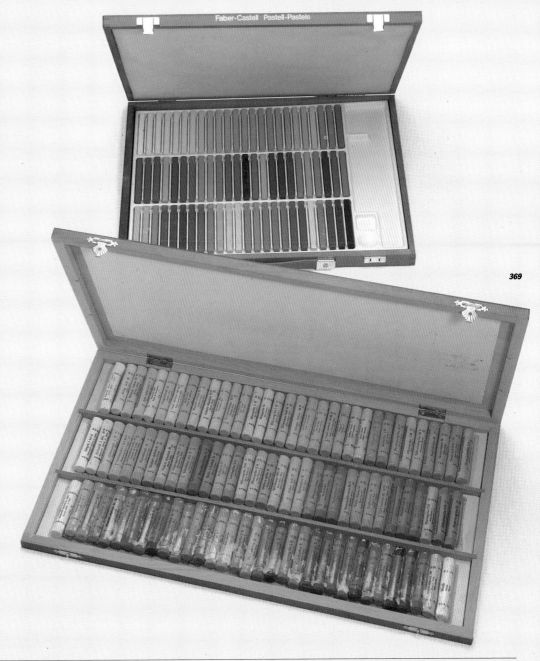

369

Fig. 369 Shown here are pastel sets by Schminke (99 colours) and Faber-Castell (72 colours). Both manufacturers offer smaller assortments of 12, 24, and 36 colours.

Because you can't mix pastel colours easily, a large assortment is necessary for drawing. And the wooden boxes are essential for keeping and ordering the pieces and ends of pastels. Many artists make a series of compartments inside the boxes where they classify according to colour temperature warm, cool, and neutral, or according to broad areas of subject matter, such as portraits and landscapes.

Pastel painting techniques

The rigid support: the board or the vertical easel. Although you can always mount your paper on cardboard and work horizontally, a pastel is best worked supported by a standard upright easel. Not only is this a better position from which to work, but it also allows the pastel dust to fall off the drawing.

Work with small pieces of pastel. A pastel artist's box contains plenty of small pieces, such as the one shown here. These pieces are perfect for making fine lines, with the pastel turned on edge, or for shading, with the pastel laid flat against the paper.

Linear and tonal qualities. When drawing fine lines with pastel, you must hold the pastel stick as if it were the end of a pencil, using the most pointed edge. To fill in tonal areas, hold the stick as shown in the picture, using the flat side of the stick.

Covering capabilities. Here, you can see how light colours, such as yellow or white, can be drawn over a darker blue or red area to give an opaque coverage, especially when applied to dark coloured paper. Unfortunately, the covering quality lessens when the drawing is fixed.

Mixing and blending with the fingers. Because of the large selection of pastel colours available, you are always able to use the exact colour you want. Therefore, the need to mix is lessened. Nuances of colour can be achieved from a wide range, even within a single hue. Blending colour is another matter, however. Pastels are easily blended with the fingers, but a stump might possibly be too harsh a blending tool and cause the pastel powder to loosen and crumble rather than blend.

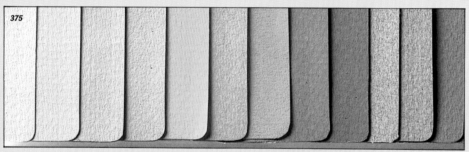

Pastel papers: white and colour. Pastel papers can be white, but the results are often better with coloured papers, where the middle value of the paper makes a good background for light and dark values, using light and dark coloured pastels. The paper shown above is Canson's Mi-Teintes, an excellent paper for pastel work.

The subject can determine the colour of the paper. In the case of this landscape, a green paper was an appropriate choice. When drawing a portrait or figure, however, a warm-toned paper in cream, ochre or sienna would probably be more suitable.

Drawing papers have two sides. In actual practice, it makes very little difference which side of a pastel drawing paper you draw on. However, there are slight differences between the front and back, so the pastel artist has the advantage of choosing the most appropriate texture.

Erasing pastel. To erase an area of a pastel drawing, rub gently with a clean cloth until the area is fairly clean. You probably won't be able to remove all the pigment, but it won't be difficult to draw over it and get a good coverage.

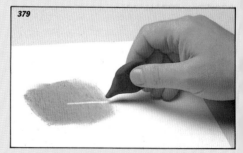

Erasing and drawing with an absorbent rubber. Although it is very difficult to erase pastel, you can remove little details or open small white areas or lines with a malleable absorbent rubber, such as a kneaded rubber. Since this type of rubber is very soft and flexible, you can adapt it to any particular form to remove small spots of colour.

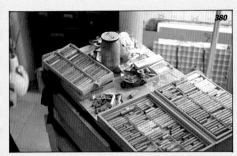

The palette box. When working with a wide assortment of pastels (60 or more colours), since the breakage of the sticks creates two or three times the original number, you can understand the need for a storage box with compartments, which will allow you to classify the colours and make your work easier.

Cleaning is important. Pastel colours tend to pick up the colour of other sticks. Your fingers will also get dirty from the blending that is needed in most pastel drawings. So, after use, be sure to clean up the pastel sticks and your fingers with a cloth or a paper towel.

Auxiliary media. Soft charcoal pencils, sanguine pencils, and particularly white chalk pencils, are perfect ways to dress up a pastel drawing and create interesting effects.

Fixatives. Fixatives tend to darken pastel colours and alter their covering capacity. Some artists maintain that it is possible to fix drawings by spraying the surface very lightly, or by spraying and then retouching the damaged colour. But none of these methods is absolute or advisable in my opinion.

Protecting a pastel drawing. Since it is not advisable to fix pastel drawings, you must protect them some other way. I suggest that you cover them with a sheet of paper to avoid any rubbing or friction with other drawings or papers. Then once the drawing is finished you can frame it with a glass cover.

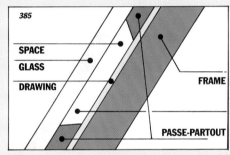

Framing. The fragility of pastel drawings requires a special framing technique. This technique, known as passe-partout, protects the drawing by providing a space between the drawing and the glass cover.

Fig. 386 Chardin's wife. Louvre, Paris.

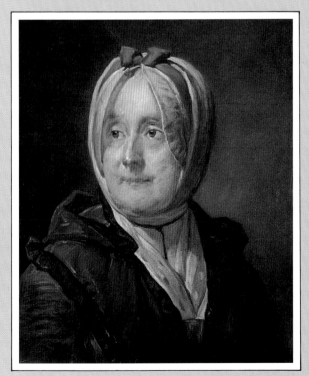

Pastel drawings or pastel paintings?

First in Venice, then in Paris, and later in Dresden and London, Venetian artist Rosalba Carriera drew hundreds of pastel portraits. In France, Quentin de La Tour devoted his whole life to portraits in pastel: he was the most famous portrait painter in the 18th century. Jean-Baptiste-Simeon Chardin showed a pastel portrait of his wife at the Paris Exhibition in 1775, and it is considered one of the best paintings of that time. Less than a hundred years later, Impressionism emerged, and with it, one of the best draftsmen in all art: Edgar Degas. Using coloured paper as a background for his pastel figures, Degas resolved edges, shapes, and gradations by means of sharp strokes. His exquisitely rendered pastels were truly a merging of painting and drawing, but Degas was foremost a draftsman and is reputed to have said 'I was born to draw.'

The pastel medium is unique in that it has the properties of both painting and drawing. The works of the above artists were executed in pastel, but should they be considered pastel drawings or pastel paintings? They are like paintings because the surface of the paper is entirely worked, which is similar to oil painting. And in the past, pastels were regarded as paintings. Today, museums tend to classify pastels as drawings.

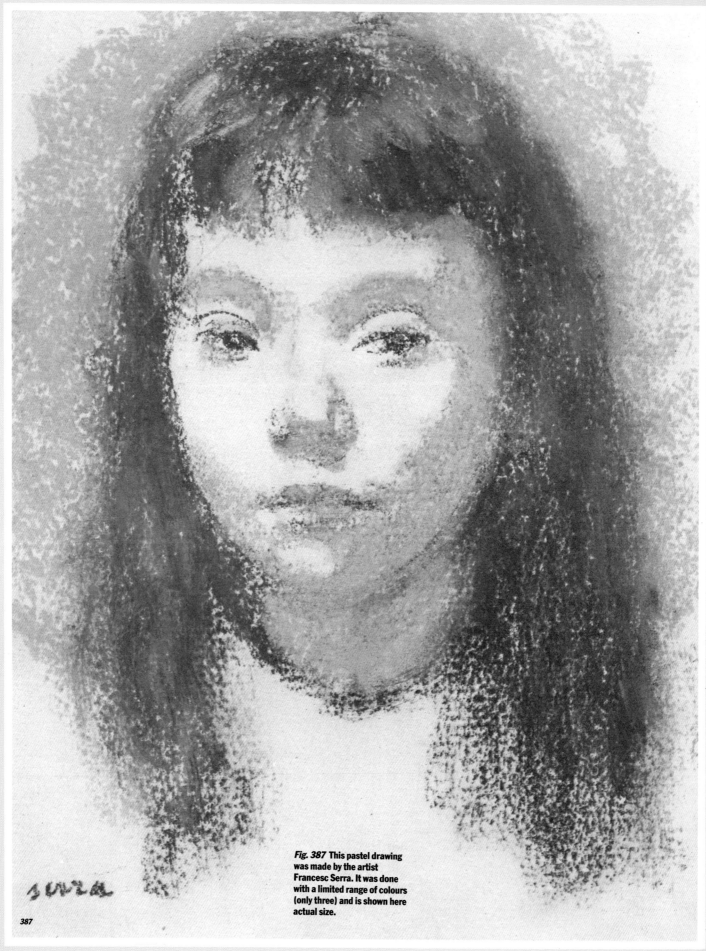

Fig. 387 This pastel drawing was made by the artist Francesc Serra. It was done with a limited range of colours (only three) and is shown here actual size.

387

LES
PRINCIPES
DU
DESSEIN;
OU
METHODE COURTE ET FACILE

Pour aprendre cet Art en peu de tems.

PAR LE FAMEUX

GERARD DE LAIRESSE.

A AMSTERDAM,

Chez DAVID MORTIER.

M DCC XIX.

Rudiments

Basic rules

One evening my good friends Ana and Jorge came to dinner. After the meal we were talking as we often do about art, and Ana expressed regret about not being able to draw. 'I've never drawn in my life. I don't even know how to hold a pencil.' So I gave her a 2B pencil and a sketchbook.

'Come on, have a try,' I said. 'Draw that chair. I'm sure you can.'

Ana seemed perplexed. 'But how?' and she burst into laughter.

But Ana was able to draw. First she drew a square, which was the basic shape of the chair. 'Good,' I said, 'Now draw a rectangle on top of the square; its measurements should be more or less the same as the projecting part, or the seat, of the chair. Easy, isn't it? This is the first step to take when drawing any model: you must calculate the general shapes and proportions of the object before you.'

'Proportions?'

'Yes, take a look and you'll see that the dimensions of the seat and the legs of the chair are approximately three parts wide and four parts high. Once you have solved the problems of relative height and width, you'll have to go on to the next basic element of drawing: perspective.'

'Perspective?' repeated Ana, who was now becoming very interested.

'Yes, perspective. Please stand here, in front of the chair, and look straight ahead. Imagine that there is a straight horizontal line. Imagine as well a point in the horizon, where all parallel lines, perpendicular to the horizon, meet the vanishing point, as it's called.

You are now going to draw the horizon line and the vanishing point. By the way, how tall are you, Ana?'

'Well, 1.80 metres with shoes on.'

'To calculate the placement of the horizon line, I take the height of the seat, which without the back is more or less 50 cm, and multiply it by three and a half. So the horizon line, which is equal to your height, will appear approximately three and a half times higher than the chair seat.'

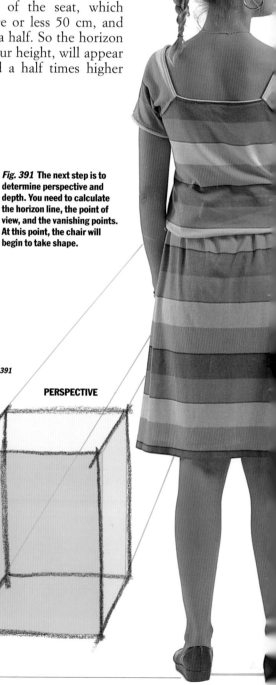

Fig. 392 When drawing the human body, it's helpful to use the canon system, which divides the body into eight equal units, each one the height of a man's head.

392

Fig. 389 This is the chair that Ana drew.

Fig. 390 Determining the correct dimensions and proportions is the first problem that the artist must solve. In this case, you begin by drawing a three-dimensional box, or cube, which corresponds to the projecting plane of, and the space under, the chair's seat.

Fig. 391 The next step is to determine perspective and depth. You need to calculate the horizon line, the point of view, and the vanishing points. At this point, the chair will begin to take shape.

389

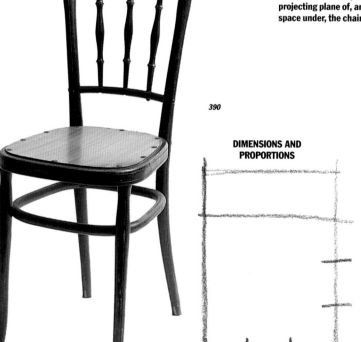

390

DIMENSIONS AND PROPORTIONS

391

PERSPECTIVE

'And then?' asked Ana.

'You only need to draw in the vanishing point, and then draw lines from the vertices of the rectangle of the seat to that vanishing point. Then draw another rectangle behind the first one, fitting it into the lines you drew as if the first one were made of glass, and you'll get a cube, or rather a rectangular prism in perspective' (Fig. 391).

'All right, but the drawing doesn't look like a chair.'

'It will. But first you must calculate the size of the back in relation to the seat. To do this, draw another rectangle and then some lines (whose sides have to meet at the vanishing point); these will become the crossbeams of the chair's seat. After this, you'll have the basic structure complete (Fig. 393). Then draw the chair within this structure. This is relatively easy since now you know the dimensions, relative proportions, and how to draw the chair in perspective.

'Terrific!'

Ana was drawing clumsily, but she was drawing!

'What else?'

'At this point, we must think about what the French artist Camille Corot called *values*. Values are basically light and shade effects: the gradation of tonal areas, value contrasts, and spatial complexities that bring life to your drawing.'

'But how do you go about drawing people?'

'Well, fortunately for us there is a system, or canon, which shows the ideal proportions of the human body. The system was devised by the artists of ancient Greece and revived by the masters of the Renaissance. According to the canon, a man's height is eight times the height of his head (Fig. 392). But, Ana, I can't tell you all about this in half an hour!'

'So you'll have to come to dinner every weekend,' said my wife laughing.

'Great!' cried Ana.

HORIZON LINE

1

2

CANON FOR THE HUMAN BODY: 8 HEADS TALL

3

4

5

6

7

8

Fig. 393 As you continue to construct the chair, you need to determine its basic structure, which consists of simple geometric forms, such as the cube and the rectangle.

Fig. 394 Once you have established the general shapes that make up the chair, these can then be fitted around the cube to establish spatial position.

Fig. 395 The final step is to model the form of the chair by producing light and shaded areas. In this way you develop the values, contrast, and linear direction of the drawing.

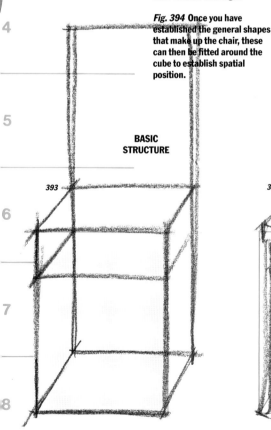

BASIC STRUCTURE

393

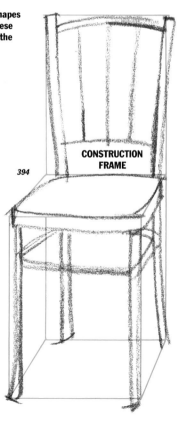

394

CONSTRUCTION FRAME

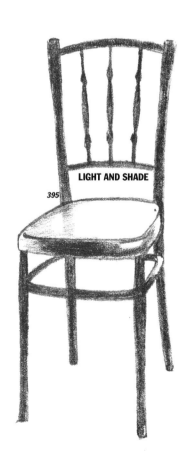

395

LIGHT AND SHADE

The mental calulations of dimensions

'Exercise your eyes and learn to see the true length and breadth of objects.' So directed Leonardo da Vinci in his *Treatise on Painting*, where he was writing about 'sight training, which is the main factor in drawing and painting'. In practice this main factor means the observation of the model prior to drawing it, in which you calculate the dimensions and proportions. These calculations are based on three methods of observation:

A. *Comparing certain distances with others.*

B. *Looking for reference points to establish basic lines.*

C. *Drawing imaginary lines in order to determine the position of certain objects in relation to others.*

We are going to study in a practical way the applications of these formulas for observation. Look at Fig. 398, where a still life of a green jug, an apple, a bottle of brandy, and a coffee cup is our example. All objects are on the table and the background is in reality a white wall; the lighting is daylight coming in from the side.

Do you have everything ready? Drawing board, paper, pencil? ... At this point an experienced artist would normally look at the model for a short while (say five or ten minutes) trying to understand in his or her own way the shapes, values, and colours, and calculating dimensions at the same time, comparing distances, looking for reference points.

Imagine the artist thinking aloud: 'The height of the cup is two-thirds of the total width including the handle (Figs. 396 A, B). The apple is the same as a sphere (Fig. 397). The

Figs. 396, 397, 398
Calculating dimensions and proportions is primarily done by comparing. For example, you will need to determine that the height of this cup is equal to two-thirds of its total width, including the handle; or that the apple, which is essentially a sphere, is as high as it is wide.

total height of the bottle measures the same distance from the edge of the jug to the edge of the cup, disregarding the handle (Fig. 399). The centre of the total width coincides with the left edge of the bottle (Fig. 400). The dimensions of the jug correspond to a square. If I imagine a line in the centre of that square, I get the upper limit of the cup, whose height is practically the same as the apple (Fig. 402). The height of the jug is half the height of the bottle. Both the base of the bottle and the base of the cup are at the same level. The width of the bottle is just a bit narrower than that of the cup and the apple (Fig. 403).'

If these mental calculations had been done on paper, you would have a rough structure that is practically complete, and you would be ready to draw the model (Fig. 404). But in this case you have only carried out part of the drawing in your head. The resolution – the real drawing – comes later.

Fig. 399 The first step is to calculate the dimensions and the proportions of the subject.

Fig. 400 Here, look for a central axis, which, in this case, coincides with the left side of the bottle.

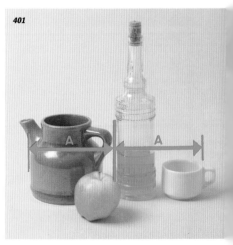

Fig. 401 Establish reference points and imaginary lines. Here, it is determined that the jug is essentially a square shape; the upper edge of the cup coincides with the centre of this square, and the height of the cup is almost the same as the height of the apple.

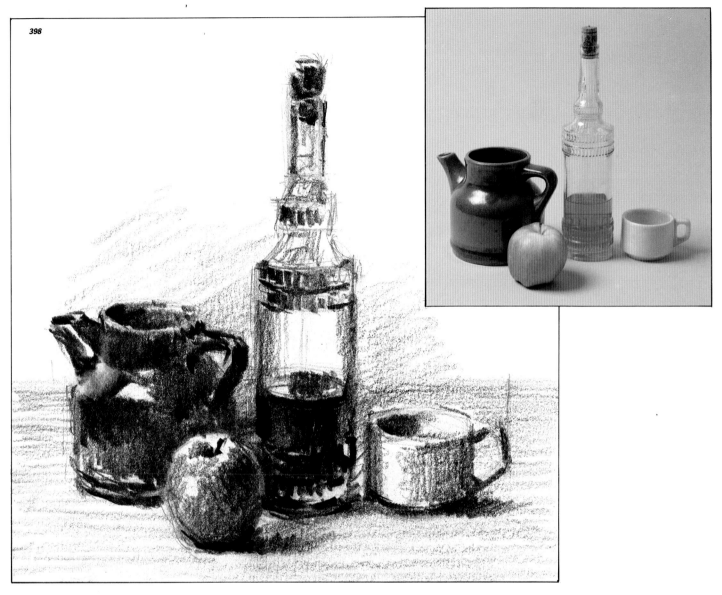

398

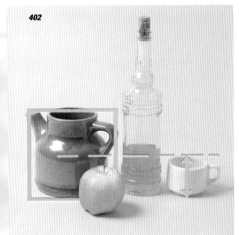

Fig. 402 In this example, you can see that the previous calculations have proved accurate. The cup does equal half the height of the jug, and the apple and the cup are the same height.

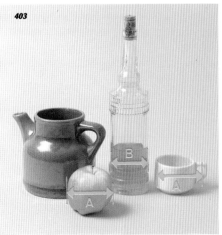

Fig. 403 Although some dimensions can't be exact, they can be adequate enough for the purposes of drawing by approximation.

Fig. 404 The sketch above is an example of how an artist uses a preliminary drawing to determine the general proportions of the subject. Without a sketch like this, it would be difficult for the artist to begin drawing.

Calculating dimensions and proportions

What exactly are proportions? Obviously, there are variations. The head of a dwarf is larger in proportion to his body than that of the average person. But a classical statue from Hellenic Greece shows the ideal dimensions and proportions of the human form.

In drawing, *proportioning means representing the life-size figure or object on a smaller scale, keeping the relative measurements of the model proportional*. In the example shown here (Fig. 407), the height of the cup approximates that of the apple; therefore, in your drawing, you will have to use the same scale of measurements so that these objects look in proportion to each other.

Of course, once you start to draw, the real dimensions of the model must be translated to the scale of the drawing paper. You will also need to consider the scale you want, so that the model does not appear too big or too small. To cope with changing scale, I recommend the use of two 90° angles cut out of black cardboard that you can put together to form a frame more or less rectangular or square in order to establish the best size for your scale. Remember, it is often a good idea to get closer to the model rather than further away if you want to avoid a frame that minimizes the subject (Figs. 405 to 407).

The reduction of the model proportionally to the size of the paper is easily solved when you are copying from a picture or a photograph. You can do so by dividing the photograph or picture into a grid made up of squares, reducing or enlarging those squares on your paper. This system has been used by artists throughout history, generally to enlarge sketches or transfer them onto walls or canvases. In the early 16th century, Albrecht Dürer wrote a treatise on dimensions and proportions in which he described and illustrated methods to solve this problem. One of these methods involved using a clear, squared-off piece of framed glass that was placed between him and the model. He then composed his picture by looking at what parts of the figure were enclosed in the various squares (Fig. 409). This idea was probably more theoretical than practical; as far as I know, nobody uses this system today. However, many artists use a grid system on paper to determine and compare dimensions. The most common method by which to determine basic proportions is the simple one that uses a pencil (or ruler or brush) placed in a vertical position and raised to the height of your eyes. You then hold out your arm and place the

405

40

Fig. 405 One way to understand better the significance of proportion, or ideal proportion, is to search out obvious disproportions, such as the carnival mask, which dwarfs the body upon which it rests.

407

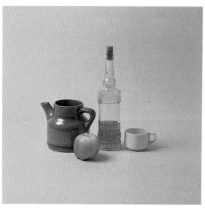

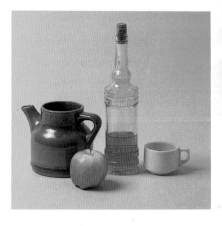

Figs. 406, 407 and 408 To decide how to frame the subject and determine how close the viewer should be to the objects in the drawing, take a cardboard frame painted black and study your subject *before*

beginning to paint. Better yet, do a quick postcard-size sketch suggesting the framing and composition of the subject.

Fig. 409 This is a drawing by Albrecht Dürer that he used to illustrate a treatise he wrote on dimensions and proportions. It shows a method for rendering a subject through a grid.

409

pencil in front of the model and literally measure the model against the pencil. To do this, you move your thumb up and down along the pencil until the part above the thumb coincides with the part of the model measured. Then repeat the same process, this time horizontally, comparing the dimensions (see Figs. 410 to 413). This process takes some time and experience, so for many artists this method can become a barrier that prevents them from proceeding with confidence. The proportions may be off sometimes, but draw carefully, continually comparing distances and using reference points, and this barrier vanishes because eventually your mind will think proportionally and the correct dimensions will appear almost instinctively.

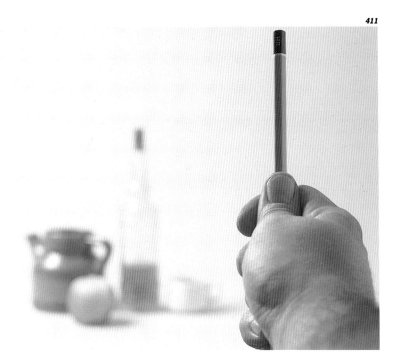

411

410

412

Figs. 410 to 413 The model's basic proportions are determined by measuring and comparing its height with its width. The measurements are taken facing the model, arm extended holding a pencil or brush in your hand. Then the relationship between the two measurements is calculated – for example, they may both be the same, or one may double the other.

413

Fundamentals of perspective

Perspective is a complex system of drawing built on specific principles that has been the subject of hundreds of books. Simply stated, perspective drawing is a way of reproducing the appearance of three-dimensional reality on a flat plane. Since this is a book for artists and not architects, we can assume that we are primarily drawing from the natural world with the model in front of us. For artists, the essentials of perspective may be summed up by the following.

First basic principle:

The horizon line

Except in special cases where you are drawing specific objects, such as a flower, an animal, or a hand, the horizon line is typically present in all subjects. As for its correct location, it is certainly not on the top of a mountain or at the bottom of a deep valley.
The horizon line is always in front of you, at eye level.
A perfect example of this can be found in a seascape. If you look straight ahead, without raising or lowering your head, the horizon is the line formed by the edge of the water and the sky, which is, of course, at the height of your eyes. This applies if you are standing or sitting. If you crouch down – always looking ahead, of course – the horizon line comes down with you. If you climb to the top of a mountain, the horizon line goes up with you.

Second basic principle:

The viewpoint

The viewpoint is located on the horizon line, at the centre of the viewer's field of vision – that is, right in front of you.

415

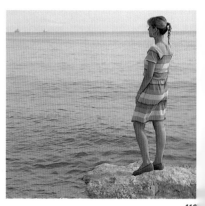

416

Third basic principle:

The vanishing point

The vanishing point is the place where receding parallel lines appear to converge. Vanishing points are always located on the horizon line. Locating vanishing points on that line gives the impression of depth or a third dimension.
The following are the three classes of perspective drawing:
1. *Parallel, or vanishing-point, perspective.*
2. *Angular perspective, or perspective with two vanishing points.*
3. *Oblique perspective, or perspective with three vanishing points.*
On the following pages, all three perspective systems will be explored on a practical level.

Fig. 414 A perspective drawing creates the illusion of reality by relating the observer; the object, and the picture plane. The horizon is assumed to be an infinite distance from the observer, the horizon line is placed at eye level.

Fig. 415 Since the height of the viewer's eye determines the location of the horizon line, it will change as the viewer's position changes. Thus, as shown here, the horizon line will drop if you assume a sitting position.

Fig. 416 If you look at a scene from a high point, the horizon line will also be high as you observe the view from the vantage point.

Parallel perspective (one vanishing point)

The cube is the basic form in perspective because it can be used as a unit to measure height, width, and depth at the same time. Theoretically, the cube can be multiplied and divided into any combination of height, width, and depth to provide a basis for drawing any object. Consequently, in each case I will begin the lesson by explaining the process of drawing a cube in perspective. In this first case I have drawn the cube above the horizon line, although it could also be the other way around. Notice that in Fig. 417 the vanishing point (VP) is also the viewpoint (PV).

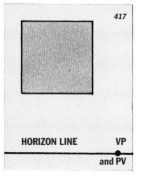

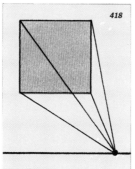

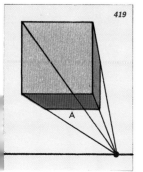

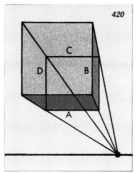

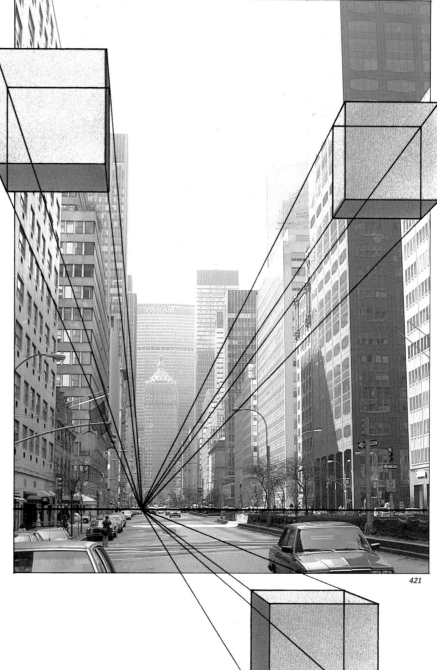

I begin by drawing a square. Next, I draw four vanishing lines from the vertices of the square to the vanishing point (Fig. 418). Then, I draw horizontal line A, thus establishing the lower side of the cube by sight (Fig. 419). Finally, starting from horizontal line A, I draw the vertical B, completing the cube. But I still have to draw lines C and D as if the cube were transparent, in order to test its proportions. Now look at the photograph of Park Avenue in New York City (Fig. 421). It's a typical example of parallel perspective with one vanishing point which is, at the very same time, the point of view. Note the position of the viewer's eyes (just suppose you were here), and pay attention to the hundreds of windows, doors, and other openings, which vanish in order towards one point on the horizon to form the third dimension. The

impression of space is even more evident here because of the contrast between the colour of the foreground and the background; the blue grey gives the impression of depth.

Fig. 421 This photograph of Park Avenue in New York City is a good example of parallel perspective with a single vanishing point. Note the convergence of all parallel lines perpendicular to the horizon. The cubes added to this drawing give you a better understanding of this kind of parallel perspective.

Angular perspective (two vanishing points)

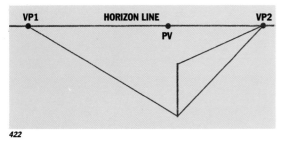

422

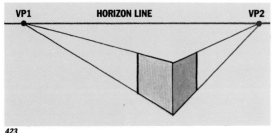

423

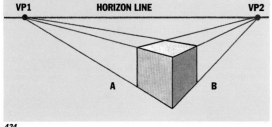

424

For this exercise, I place the viewpoint (PV) more or less in the centre of the cube and draw freehand the vertical corresponding to the closest edge. I place the vanishing points (VP) 1 and (VP) 2, and trace the first vanishing lines towards the right and towards the left (Fig. 422). I draw by eye the two lateral sides of the cube (Fig. 423), and then finish the drawing with the upper side. Notice that the angle formed by the base of the cube should always be more than 90° (Fig. 424).

The house in the photograph below is an example of angular perspective with the vanishing points out of the drawing, which is usually what happens in practice. Observe the situation and perspective of the cubes in order to better understand the perspective of the house. In this example, though, there is an element that makes it a bit more difficult, by which I mean the roofs, whose edges meet at a special vanishing point, which, from the artistic point of view, is not essential. This is understandable since the inclination of the roofs can be drawn by eye, only taking into account the convergence of the more slanted and visible lines such as A and B.

Fig. 425 Here we have a classic example of oblique perspective with two vanishing points that converge outside the image. Note the parallelism of the oblique lines going to the horizon on both sides. In this case, there is the exception of the inclined lines of the roofs, which can be resolved with a vanishing point that travels upwards; but since we are drawing and not making architectural renderings, these lines can be drawn easily by sight.

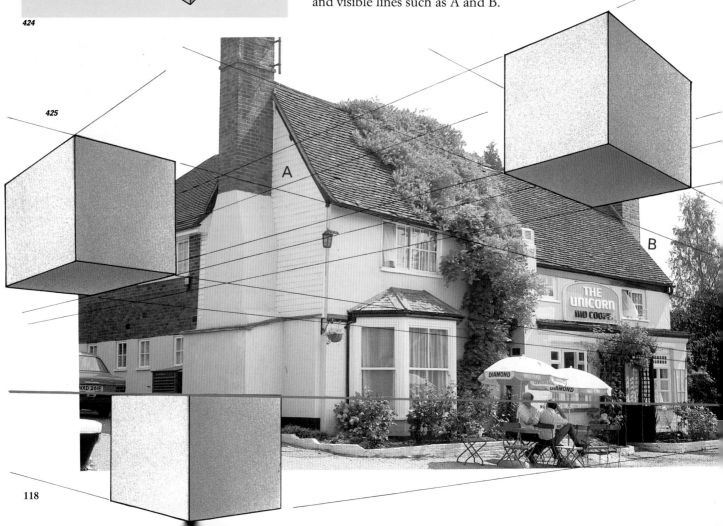

425

Oblique perspective (three vanishing points)

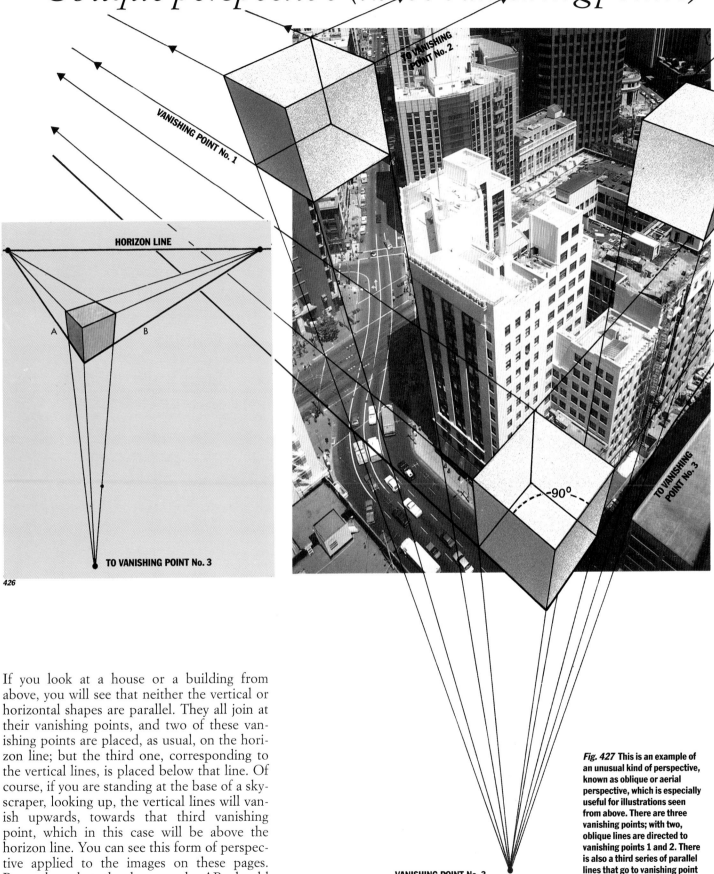

HORIZON LINE

VANISHING POINT No. 1

3r VANISHING POINT No. 2

A B

TO VANISHING POINT No. 3

426

TO VANISHING POINT No. 3

~90°

VANISHING POINT No. 3

If you look at a house or a building from above, you will see that neither the vertical or horizontal shapes are parallel. They all join at their vanishing points, and two of these vanishing points are placed, as usual, on the horizon line; but the third one, corresponding to the vertical lines, is placed below that line. Of course, if you are standing at the base of a skyscraper, looking up, the vertical lines will vanish upwards, towards that third vanishing point, which in this case will be above the horizon line. You can see this form of perspective applied to the images on these pages. Remember that the base angle AB should never be less than 90°.

Fig. 427 This is an example of an unusual kind of perspective, known as oblique or aerial perspective, which is especially useful for illustrations seen from above. There are three vanishing points; with two, oblique lines are directed to vanishing points 1 and 2. There is also a third series of parallel lines that go to vanishing point 3, which in this case is below the picture.

Grids in perspective

428

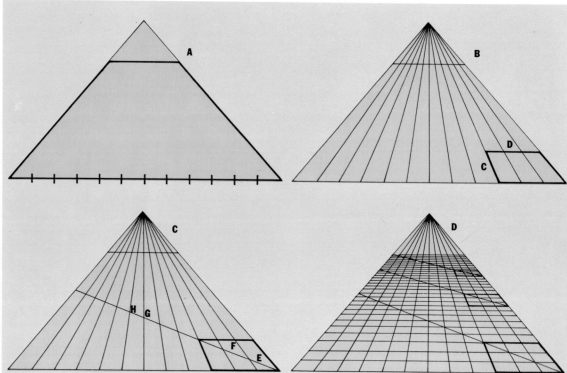

Fig. 428 **Process for drawing a grid in parallel perspective.**
A. Draw in perspective the total perimeter of the grid, and then, on the ground line, mark the number of 'tiles' that make up the grid vertically.
B. Taking three lines of tiles, draw by eye a square such as CD.
C. Trace a diagonal that crosses the points E, F, G, H.
D. Crossing the diagonal with the vertical parallels gives you the points of reference to trace the corresponding horizontal lines, which will complete the grid. Following the same process, you can repeat the sequence to infinity.

429

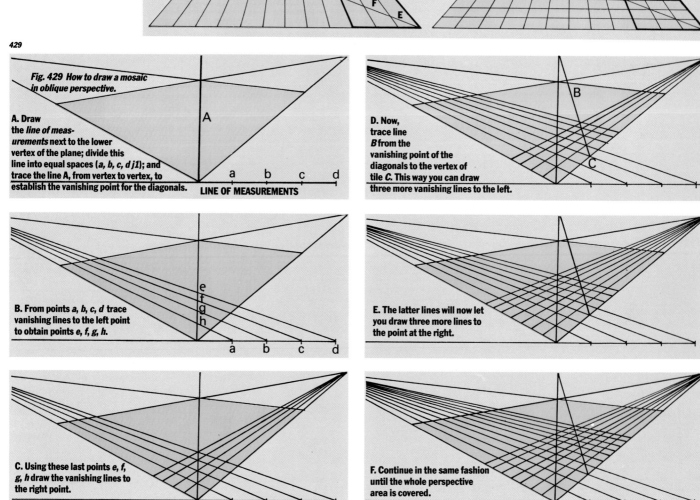

Fig. 429 *How to draw a mosaic in oblique perspective.*

A. Draw the *line of measurements* next to the lower vertex of the plane; divide this line into equal spaces (*a, b, c, d j1*); and trace the line A, from vertex to vertex, to establish the vanishing point for the diagonals. **LINE OF MEASUREMENTS**

B. From points *a, b, c, d* trace vanishing lines to the left point to obtain points *e, f, g, h.*

C. Using these last points *e, f, g, h* draw the vanishing lines to the right point.

D. Now, trace line *B* from the vanishing point of the diagonals to the vertex of tile *C.* This way you can draw three more vanishing lines to the left.

E. The latter lines will now let you draw three more lines to the point at the right.

F. Continue in the same fashion until the whole perspective area is covered.

Dividing spaces in depth

Fig. 430 A and B This building, seen from the front, is a symmetrical construction. You can draw this building in perspective by dividing its basic rectangle into two or more spaces with X-shaped lines. Using this method, you will automatically find the centre of each space.

Fig. 431 This illustration of an old Roman-style church was an exercise in perspective. The repeated receding spaces and geometrical scheme of the façade can be resolved using perspective, as seen in Fig. 432 below.

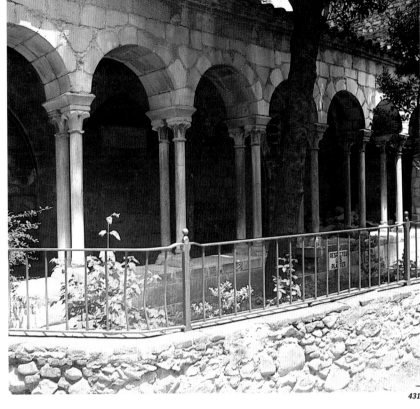

431

430

A

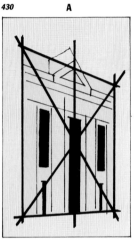

B

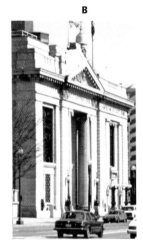

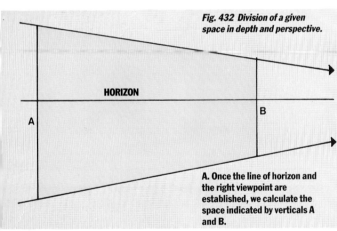

Fig. 432 Division of a given space in depth and perspective.

HORIZON

A

B

A. Once the line of horizon and the right viewpoint are established, we calculate the space indicated by verticals A and B.

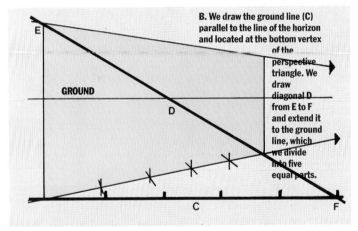

B. We draw the ground line (C) parallel to the line of the horizon and located at the bottom vertex of the perspective triangle. We draw diagonal D from E to F and extend it to the ground line, which we divide into five equal parts.

E

GROUND

D

C

F

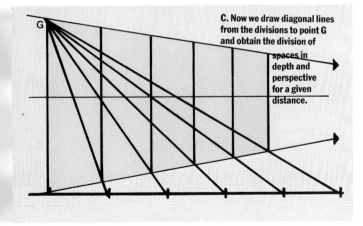

C. Now we draw diagonal lines from the divisions to point G and obtain the division of spaces in depth and perspective for a given distance.

G

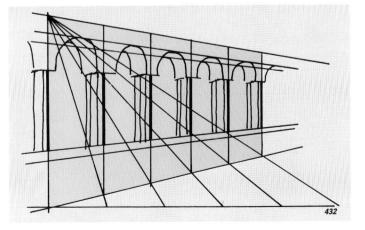

432

Shadows in perspective

Imagine the interior of a room seen in angular perspective, with some furniture or basic shapes, a lamp hanging from the centre of the ceiling, and a human figure standing under the lamp. The horizon line is at the level of the eyes of the figure, and the vertices of the walls converge to the vanishing points. Vanishing point 1 (VP 1)is inside the room, and vanishing point 2 is outside the picture (Fig. 433). As soon as we switch on the light, the projected shadows appear (Fig. 434).

Let's see how these shadows are produced. The first factor to take into account is: *artificial light is conveyed radially and in a straight line* (Fig. 434).

If we could materialize the beam of light that illuminates every shape, we would see a series of angles whose vertices are always at the source of light. Consequently, *the source of light becomes a vanishing point of light (VPL).* This new vanishing point allows the projection of all the necessary angles towards all the planes, edges, and vertices, determining the shape of the shadow. But there is still an element missing: *the vanishing point of the shadow (VPS).* The placement of this point is given partly by a vertical line from the point of light to the floor, and partly by a simple calculation of perspective, projecting to the floor the placement of the light on the ceiling.

Sunlight is conveyed in parallel lines. Therefore, when images are seen in oblique perspective (from above), shadows do not have any perspective at all (Fig. 435). In normal perspective, with images against the light, you will have two vanishing points: *the vanishing point of light, which is the sun, and the vanishing point of shadows, placed on the horizon, under the sun.* Finally, if you are working with a frontal light or with a frontal-lateral light, you will also have to work with two vanishing points: *the vanishing point of shadows, on the horizon, under the sun, and the vanishing point of light, placed under the vanishing point of shadows.* Always consider the incidence of the angle of illumination on the model (Fig. 437).

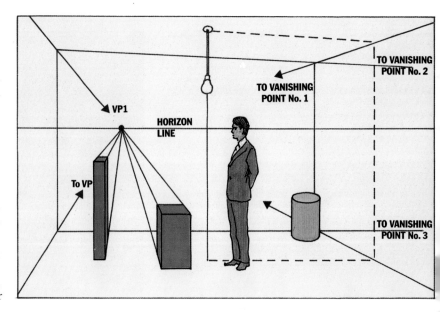

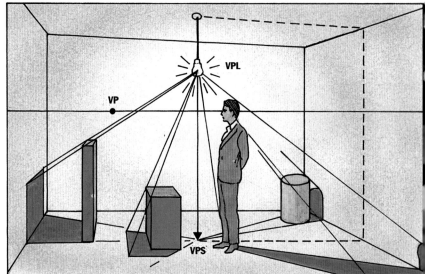

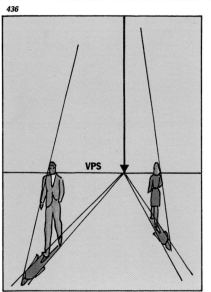

436

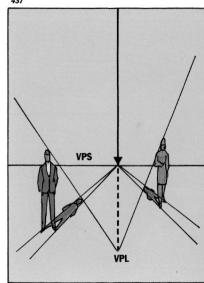

437

435

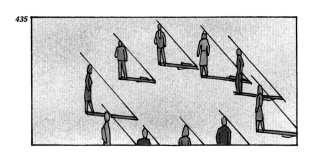

Guidelines

When we draw in oblique perspective, which is the perspective system most frequently used, it often happens that one vanishing point and sometimes even two disappear out of the picture. Such is the case with the house shown on page 118 (Fig. 425) and in the drawings shown here. In this case it is very difficult to establish the right perspective for all the elements in the model. Studying and practising the exercises in perspective explained on the preceding pages will help you understand how to use guidelines for establishing the correct perspective in your drawings. The sketches below illustrate the steps to building up these guidelines.

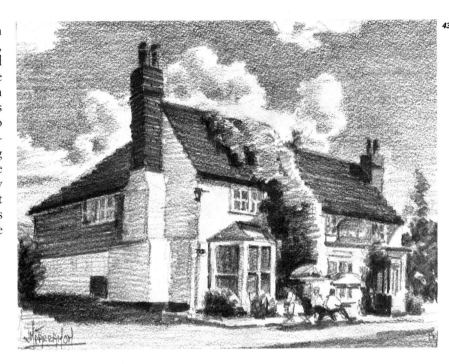

438

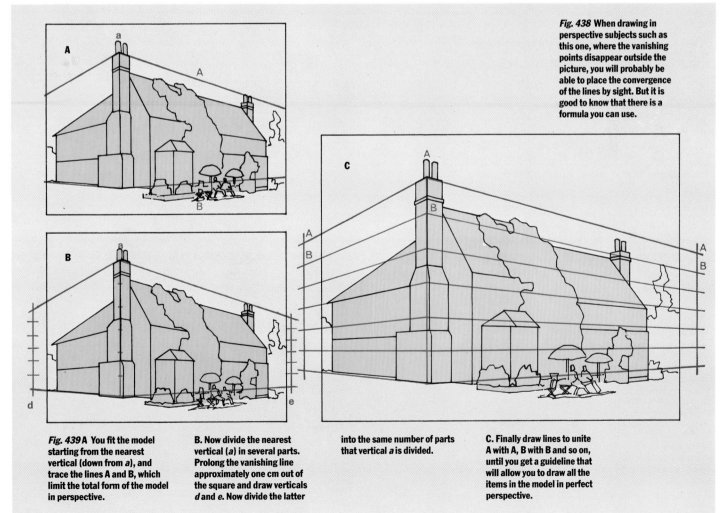

439

Fig. 438 When drawing in perspective subjects such as this one, where the vanishing points disappear outside the picture, you will probably be able to place the convergence of the lines by sight. But it is good to know that there is a formula you can use.

Fig. 439 A You fit the model starting from the nearest vertical (down from *a*), and trace the lines A and B, which limit the total form of the model in perspective.

B. Now divide the nearest vertical (*a*) in several parts. Prolong the vanishing line approximately one cm out of the square and draw verticals *d* and *e*. Now divide the latter

into the same number of parts that vertical *a* is divided.

C. Finally draw lines to unite A with A, B with B and so on, until you get a guideline that will allow you to draw all the items in the model in perfect perspective.

Perspective: examples

Drawing the circle in perspective

A B C D E

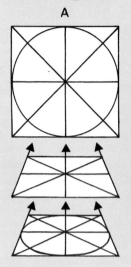

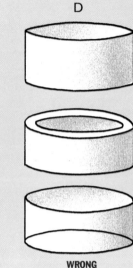
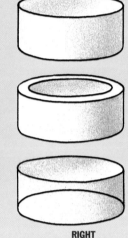

WRONG **RIGHT**

Fig. 440 A To draw a circle in perspective, you first need to draw a square and divide it with diagonals to locate the centre. Then draw lines through the centre to bisect the sides. Connect these points with a curved line, and you have a circle in plan.

Fig. 440 B The further the circle is from the level of the horizon line, the more evident is its shape. Thus, a thin circular plate placed at the level of the horizon will be transformed into a line.

Fig. 440 C As illustrated above, achieving the correct perspective of a cylinder requires a preliminary drawing to fit the shape into a square or prism.

Fig. 440 D, E The above illustration (D) shows the three common mistakes that people make when drawing cylinders. Top: Where the side intersects the base, the lines are angular rather than curved. Centre: The horizontal thickness is wider that the vertical. Bottom: The

upper circle of the cylinder is drawn with the same foreshortening as the lower circle; the lower circle should be less elliptical.

441

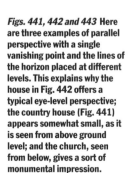

442

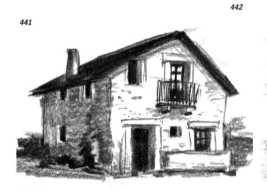

443

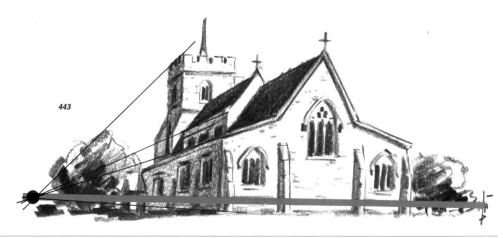

Figs. 441, 442 and 443 Here are three examples of parallel perspective with a single vanishing point and the lines of the horizon placed at different levels. This explains why the house in Fig. 442 offers a typical eye-level perspective; the country house (Fig. 441) appears somewhat small, as it is seen from above ground level; and the church, seen from below, gives a sort of monumental impression.

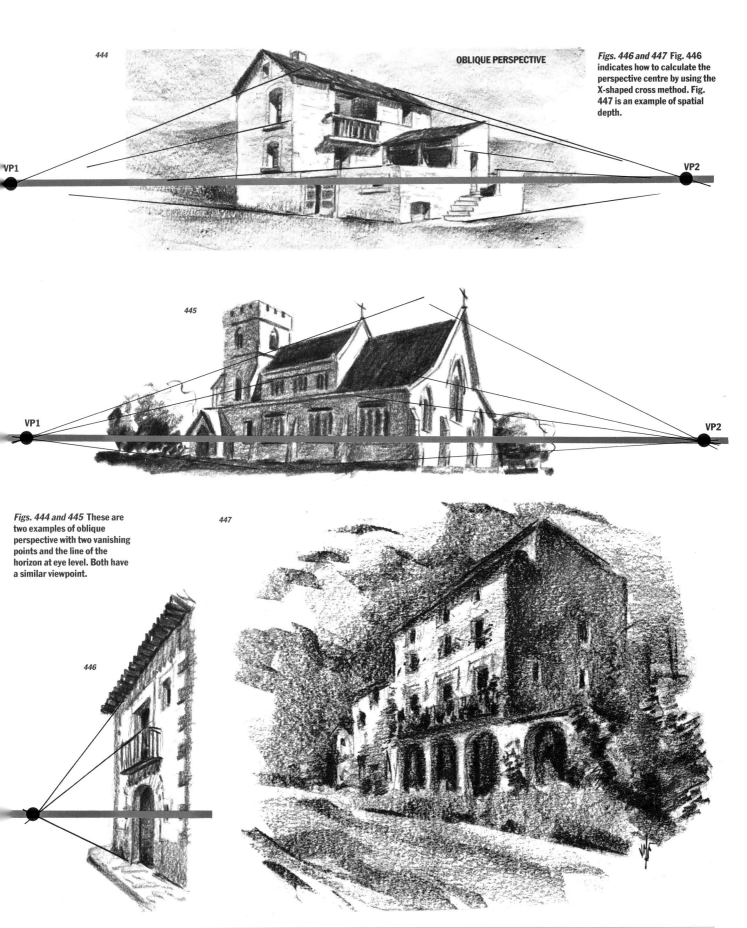

444

OBLIQUE PERSPECTIVE

Figs. 446 and 447 Fig. 446 indicates how to calculate the perspective centre by using the X-shaped cross method. Fig. 447 is an example of spatial depth.

VP1

VP2

445

VP1

VP2

Figs. 444 and 445 These are two examples of oblique perspective with two vanishing points and the line of the horizon at eye level. Both have a similar viewpoint.

447

446

Cézanne's formula

Shortly before he died, Paul Cézanne wrote a series of letters to the painter Emile Bernard, who was a passionate admirer of Cézanne's art. They had met two years before, in 1904, and Cézanne became Bernard's tutor. They painted together for a while and later corresponded with each other. This series of letters is an important written proof of Cézanne's methods and theories, the most famous of which states that the basic shapes can be seen in every item of nature. On 15 April 1904, Cézanne told Bernard:

Let me say again what I have already told you: deal with nature through cubes, spheres and cylinders, everything in the right perspective.

This idea had already been observed by Rubens when he wrote, 'The basic structure of the human figure can be reduced to cubes, circles, and triangles.' But Cézanne took this concept further to include all forms, rather than just

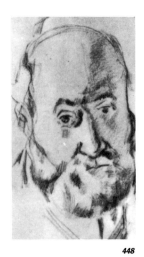

448

Fig. 448 Cézanne. *Self-portrait*. Pencil. Art Institute of Chicago. Cézanne said that in nature, everything is modelled according to three fundamental forms: the cube, the cylinder, and the sphere.

the human figure. His ideas had a profound impact on Matisse, Braque, and Picasso, and contributed to the birth of Cubism.

If you analyse the structure of objects near you, or if you look at a house, a car, or a flower pot, for example, you will notice that they are composed of one of the basic geometric figures. Thus, if you are able to draw a sphere, a cube, or a cylinder, you should be able to draw everything.

On page 100, under the heading 'Wash techniques', you were asked to build a cylinder, a cube, a pyramid, and a rectangular prism. For this exercise, you need a sphere, which could be a small white ball (if the ball is of a different colour you can paint it with white spray paint). Try drawing these shapes from the models in various sizes and positions, in parallel and oblique perspective, and seen from different angles. This is a very useful first step, from which you can progress to more advanced aspects of drawing.

449

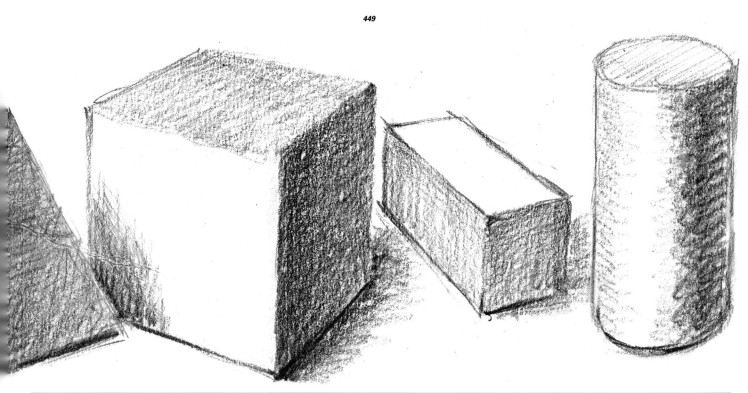

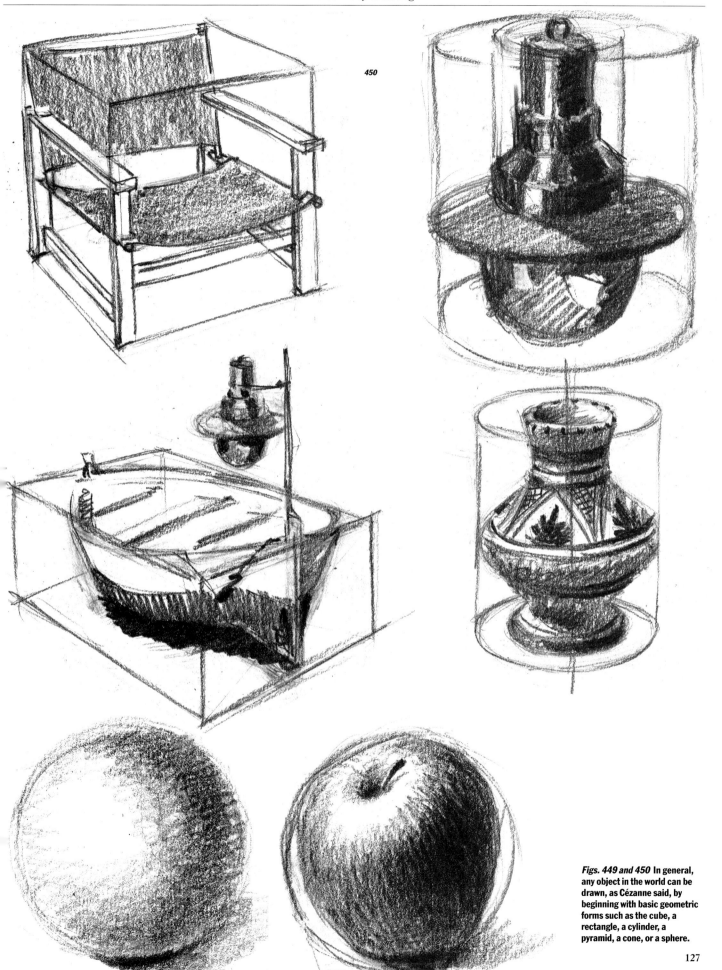

450

Figs. 449 and 450 In general, any object in the world can be drawn, as Cézanne said, by beginning with basic geometric forms such as the cube, a rectangle, a cylinder, a pyramid, a cone, or a sphere.

Boxing up, structure, sketch

How do we begin a drawing? Some people begin a drawing with one of the two basic forms of perspective; many draw a square or a rectangle or a sketch of the model. But only a few go straight to the specific, individual shapes. However, they all must consider the relation of the height of a model to its width and the problem of dimensions and proportions. They must draw or at least imagine a *box*, a square or a rectangle, a cube or a prism, where they can introduce the model. In other words, *boxing-up* the image is the first thing we do when drawing. We shall distinguish first between two groups of subjects or models:

1. Models whose structure may be reduced to one basic three-dimensional shape.
2. Models whose structure may only be reduced to flat geometric shapes.

In the first group, we should include all the bodies whose shape is given by a cube or its derivatives such as prisms, cylinders, cones, pyramids, or spheres. As for the second group, we should include in it all the objects that do not share the above-mentioned feature, such as the human figure, animals, plants, flowers.

The cube

Learning to draw a cube in the right perspective will help you draw many different objects, from a piece of furniture to a skyscraper. Look at the example on the following page, which shows the drawing of a church carried out step by step, using a cube as the basis for the drawing.

Fig. 454 I start by drawing the two verticals (A and B), corresponding to the two parallel lines that define the tower of the church. Previously, I have calculated the proportional length or height of both lines, as well as the distance between them. I now draw in the horizon line; then, I calculate and draw by eye the inclination of the oblique lines that go to the vanishing points 1 and 2. The former is outside of the drawing paper's edge, so I draw the vertical C. I divide both C and A into equal parts and then I build a guide-pattern – always by eye – according to the way it was done on page 123.

Fig. 455 I calculate the dimensions and proportions of the two parts of the church. I compare width and height, and I draw the structure of the model in perspective.

451

Fig. 451 Some artists begin with perspective lines to draw a basic form of the model.

452

Fig. 452 Other artists start a work by drawing a square, a rectangle, or a sketch of the subject's outline.

453

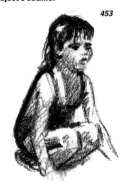

Fig. 453 A few artists venture to begin by drawing in the specific contours of the model, which states the shape in fine detail.

Fig. 456 I begin the actual drawing of the church filling in the shadows at the same time. The guide-pattern helps me now to locate in perspective the rooftop of the steeple and the wide windows. Notice how the calculation of the perspective centre has been made, in order to place the church's cross, and the top (or vertex) of the roof.

Figs. 457 and 458 There is only one question left: the distribution in perspective of the windows along the side of the lower building, which could be solved by dividing the spaces in depth (see page 121). However, I have calculated this by eye with the help of the reference given by the actual model. The rest is a matter of adjusting light and shade, drawing in complementary elements such as trees or hills.

The glass cube

Whenever you draw a basic shape in perspective, particularly a cube or a rectangular prism, it is best to draw the interior lines of the structure, as if it were made of glass. This will allow you to control proportions and structure errors, such as the ones you can see in cube A, made evident by the glass cube B. Cube A is not really a cube but a prism. This is made evident by the interior side C, which is completely out of proportion. The convergence of some vanishing lines is incorrect. The vertical D does not coincide with the vertex of the angle E, and so on.

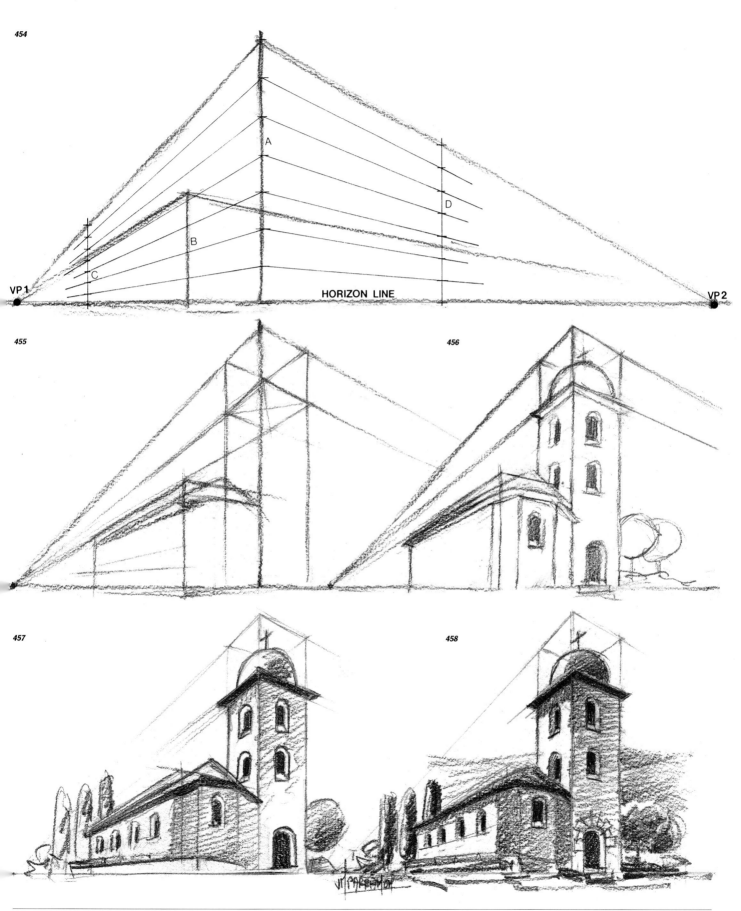

454

A

D

B

C

VP 1

HORIZON LINE

VP 2

455

456

457

458

Boxing up, structure, sketch

Flat geometrical box

The model is now a German shepherd (Fig. 460 A). We have no basic cube or perspective here. However, every model, no matter how complex, can be boxed up within a square or rectangle. We must calculate the full height of the model in relation to its width. Frequently you will find that the main body of a particular subject has other ancillary shapes that extend out of this main body (Fig. 460 B). If such is the case, the boxing up should enclose the main body and should omit the ancillary shapes (Fig. 460 C).

Tight box and countermould

The next step demonstrates the transition from the flat geometrical square or rectangle to a tighter type of box (Fig. 460 D), by drawing a structure closely related to the shape of the model. Draw it in a rough way, disregarding small details. The drawing will be a set of curved and broken lines. Be aware of the 'negative space' (Fig. 460 E). Try to see definite shapes, which act as a sort of mould to help adjust the shape of the model.

Boxing up with shadows

The edges of shadows are also a good reference as boxing-up lines, especially for models with sharp contrasts. Light and shade effects are often essential elements in a drawing. It is important to learn to draw areas of light and shade, disregarding small details, and to know how to modify or intensify the shadows.

When boxing up with lead pencil, use a soft pencil and be sure your strokes are very light so that you can modify them with a rubber. Use paper that is good enough to withstand moderate erasure and enable redrawing on the sketch, because it requires a great deal of practice to get the rendering exactly as you want it on the first try.

Boxing up requires drawing with slight, steady strokes and drawing quickly but carefully. It means keeping in mind dimensions and proportions, constantly comparing distances, finding reference points, and imagining lines to locate levels, contours, and shapes. 'Boxing up means keeping an eye on everything,' Ingres told his pupils, 'so that the drawing can be shown at any moment with the final character which will grow more and more refined.'

Fig. 459 A, B Sometimes, within the initial fitting process, there are subjects where the box or total structure of a subject (A) can be reduced and limited to the major masses, eliminating the secondary shapes (B).

Fig. 460 Visual process of fitting in a geometric or flat box. The model is seen in **A** and **B**. I start the sketch with a rectangular box, which exactly fits the height and width of the model. Then, inside this box (**C**), I draw a scheme of the dog's outline, taking as points of reference: the nose, which is placed at a third of the height of the box (*a*); the point of the right ear and the tip of the tongue (imaginary line *b*); the point *c*, which goes to the vertex of the angle formed by the ear and the top of the head (*d*). **D.** Imagine an inclined line *a-d*, where I draw the profile of the nose; then, another horizontal line under the nose, together with shape *e*, will allow me to draw the profile of the upper jowl. Now I draw the eye, checking that it is placed in the centre of the rectangular box. Then, I trace lines *f* and *g*, which correspond to the profile of the forehead and the right ear. I finish drawing the other eye and the black spot on the nose. **E.** Now, it is time to check, by studying the negative space *h* of the drawing. In them, we should see definite shapes which act as a countermould of the outline. **F.** Draw in the lines that limit the dark and medium-value areas, for they are also a valuable reference to constructing the drawing. **G.** General checking of proportions and dimensions, by erasing if necessary, and finally, by resolving values. **H** and **I.** Assessment of the correct amount of contrast.

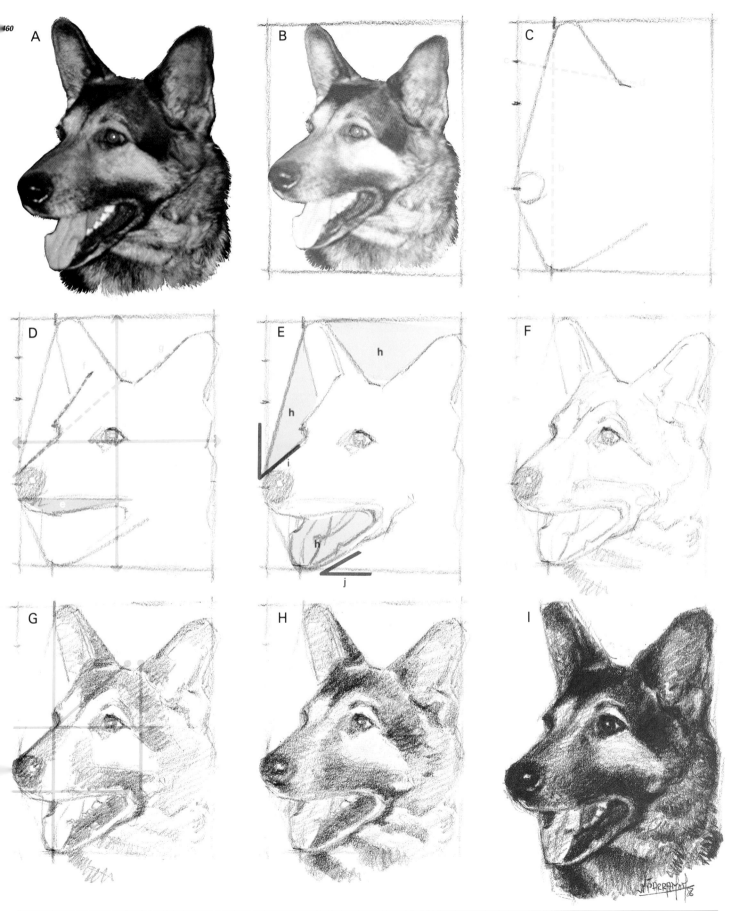

Light and shadow

The art historian Heinrich Wölfflin, after comparing drawings and paintings by Dürer, Aldegrever and Bronzino with works by Rembrandt, van Dyck and Velázquez, stated that in the Baroque period the art of drawing changed in style. It stopped being the art of lines and contours, and became a pictorial art where we see the mass instead of just the lines, and where we ignore contours, and appreciate the beauty of the model and the meaning of the picture through dark and light. In other words, this means that, if you are drawing with tones, values, grisailles and gradations you are, in effect, 'painting'. This is the basic principle behind the concept of 'drawing-painting'. There are three main factors that allow the artist to express his ideas through light:

The direction of the light
The amount of light
The quality of the light

The five most commonly used directions of light, which apply equally to drawing and painting, are:

1. *Front light:* illuminates the model from the front, casting virtually no shadow. It is not very appropriate for learning how to draw; without the effects of light and shade the model lacks definition and volume (Fig. 461).
2. *Front-lateral light:* falls on the subject at an angle of 45°. this is the direction that best explains shapes and volumes (Fig. 462).
3. *Lateral light:* falls from one side, throwing the other side into shadow, which dramatizes the subject. It is used for general figure studies and sometimes in portraits as well (Fig. 463).
4. *Back-light or semi-back-light:* comes from behind and throws the planes the artist sees into deep shadow. It is frequently used in modern figurative painting (Fig. 464).
5. *Top light:* comes from a lamp above or a window high up on a wall. This direction is ideal for drawing and painting. It is a classical type of illumination (Fig. 465).
Besides the above kinds of lighting, you can also light a subject from below. Goya used this lighting for his work, *May 3rd, 1808.*
The second factor, *the amount of light*, has a great influence on contrast. A model which is

Figs. 461 to 465 Commonly used directions of light. Below, frontal light; second row, from left to right, front-lateral light, lateral light, back lighting, and top lighting.

461

462

463

464

465

466

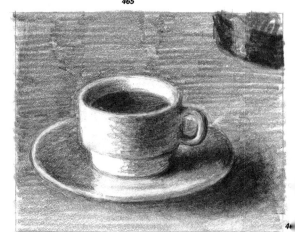

Figs. 466 and 467 The quality of the light influences the values and contrast found on the model. On the left, a model lit by direct light from an artificial light; on the right, the same image, under a diffused natural light, offers less contrast and definition.

illuminated with a weak light, such as a 25-watt bulb or a candle, casts very dark shadows, almost black. On the other hand, very powerful lighting, particularly if it is diffuse, diminishes the intensity of shadows and contrast.

The quality of light is determined by the type and placement of the light source and is closely related to the quantity. There are two types to consider:

1. *Direct light* from a bulb or the sun illuminates the model. Shadows appear precise and create sharp contrasts (Fig. 466).

2. *Diffused light* is the type of light seen on a cloudy day. It is also the type of light that reaches the model through a door or a window – including the above-mentioned top light. It produces soft shadows with blurred edges (Fig. 467).

Finally, we must consider the factors that condition the effects of light and shade:

1. *Light:* illuminated areas where the colour seen is that of the model itself.

2. *Brightness:* effect that is achieved by means of contrast. Remember that a white may appear whiter depending on how dark the surrounding tone is.

3. *Shade:* this is the part of the model that does not receive any light directly. We can distinguish there chiaroscuro, or lights and darks, and the reflected light.

4. *Reflected light:* this is the result of light on the shaded parts of the model. It always appears whenever there is a light-coloured object opposite the light, which may be a good set-up in some cases.

5. *Joroba:* a Spanish word meaning the darkest part of the shadows, between the reflections and the illuminated part.

6. *Bright-dark:* this is the area between the illuminated part and the shaded areas. It means the same as chiaroscuro.

7. *Cast shadow:* this is the shadow cast by the model.

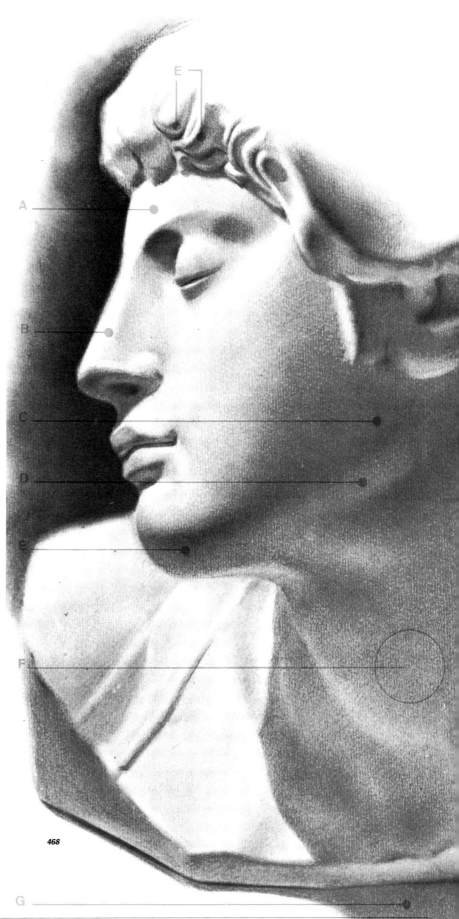

Fig. 468 Example of the effects of light and shade in a lead pencil drawing of a plaster cast. This drawing is a copy of *The Slave* by Michelangelo.

Value

Value, either in drawing or painting, refers to the degree of darkness or lightness we see on the model. Values are the same as tones. Thanks to values, we can suggest volume and depth in our drawing.

Value is a way of comparing. Its use implies the mental classification of tones and shades in order to render properly the darker, the lighter, and the intermediate. Here are a few rules to make this comparison easier:

1. *Observe the nature of light:* in real life, the shape of bodies is not determined by outlines. Bodies are not linear, as if they were made of wire. The shape of things is conveyed by a continuum of surfaces modelled by light.
In order to render the pictorial drawing the historian Wölfflin speaks of, we could begin a drawing directly with various shades of grey. This would create a lineless drawing in which limits and contours are defined by tones as you can see in the drawing on the right (Fig. 469). Notice the highlighted area from the chest and the hip down to the knees. Its configuration is described by a light tone in the background which defines the shape of the figure without lines.

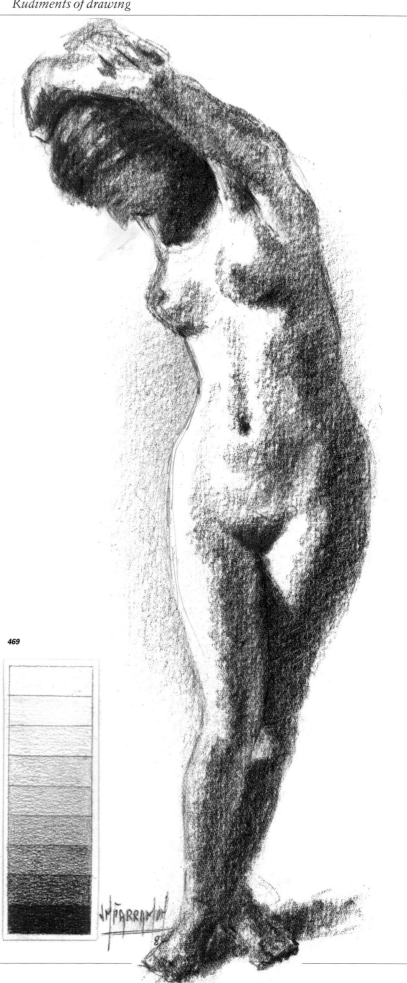

469

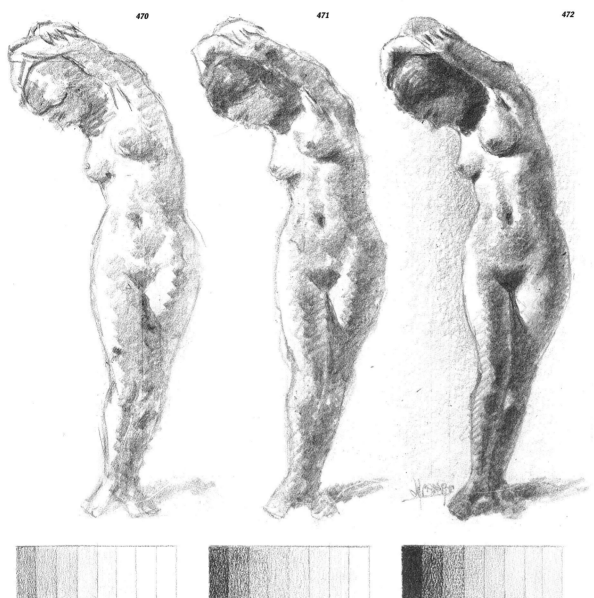

470

471

472

Fig. 469 A wide range of values, from an intense black to a light grey, enables the artist to suggest the volume of objects, which are never seen as line but as a composition of surfaces modified by light.

Figs. 470, 471 and 472 Note in this step-by-step study the process of building up values in a pencil drawing. Also note how all areas of the figure are worked on simultaneously and progressively.

2. *Use values progressively:* this is the next step after boxing up when you need to fill in the specific model's shape and lighting. But both factors have to be dealt with simultaneously and progressively, rather than stopping to finish completely this or that area.

It is a matter of studying and placing values correctly step by step: starting with a light range of greys (Fig. 470), proceeding to more intense tones (Fig. 471), progressing to dark greys and blacks within as wide a range as possible (Fig. 472).

3. *Squint to study an object.* Squinting enables you to see values more clearly. Objects become more defined and contrast is exaggerated, all of which makes the comparative values much easier to see.

The direction of strokes

In the chapter on light and shade in his book, *Treatise on Painting*, Leonardo da Vinci wrote, 'Compare the direction of lines; take into consideration which lines go in which direction and where they are stronger or more evident.' Pencilstrokes in drawing, or brushstrokes in painting, can be vertical, horizontal, slanted, wavy, or circular. Many artists of the past and present draw or paint following a 'logical' direction in their strokes, following the shape, structure, and texture of the model. Slanted strokes are the most widely used, particularly for quick sketches. Horizontal strokes might be used for the sea and sky, circular for the clouds, slanted or circular for the basic cylindrical shapes of the human body. However, there are remarkable exceptions to these directions of strokes. In many of his pastel drawings, in particular the female nudes, Edgar Degas resolved the whole drawing background, figure and minor details using only vertical strokes. Sometimes this direction is also used for landscapes. There is, however, a general rule which can be summarized as follows:
The direction of the stroke should follow or explain the form whenever possible.

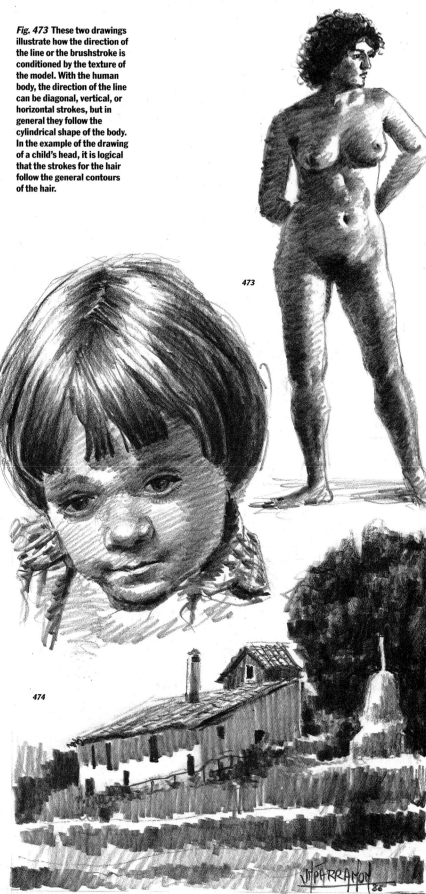

Fig. 473 These two drawings illustrate how the direction of the line or the brushstroke is conditioned by the texture of the model. With the human body, the direction of the line can be diagonal, vertical, or horizontal strokes, but in general they follow the cylindrical shape of the body. In the example of the drawing of a child's head, it is logical that the strokes for the hair follow the general contours of the hair.

473

474

Fig. 474 The general rule to 'envelop the form' with the direction of the line has a few exceptions, such as this one where most lines of the landscape are vertical.

Contrast

When we compare two or more tones or values in a drawing, we are seeing a new effect: contrast. It can be soft, if it is based on tones of similar intensity, whether they are all bright or all dark. Or it can be sharp, with a prevalence of light tones versus dark tones and hardly any intermediate tones. But a drawing can also contain a wide range of tones, deep black, dark grey, medium grey and so on, up to pure white.

Contrast, together with values and the direction of light, is an important method of artistic expression. In his work *The System of the Arts*, the philosopher Friedrich Hegel wrote: 'The character of objects depends mainly on the way they are illuminated. The theme of a picture is deeply related to the way it is illuminated.'

Now, moving on to practical examples: a child's face will express his age, complexion, and character much better in a drawing with soft contrast. Ingres advised his pupils: 'Women's portraits must not be very dark. They should be as light as possible.'

Fig. 475 The law of simultaneous contrasts states that *white will look even whiter the darker the tone that surrounds it. And grey will be more intense the lighter the tone that surrounds it.* For example, the shaded areas in the left-hand figure appear to be a more intense grey on a white background than the shaded areas in the right-hand figure. The black background gives us the optical illusion of a lighter grey, because of the law of simultaneous contrasts.

475

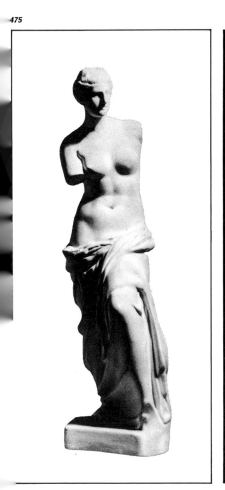
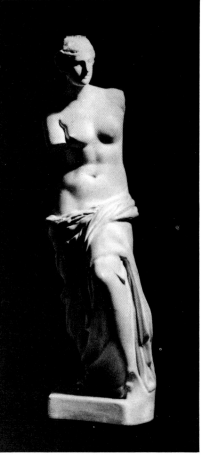

The contrast of tones provides us with some physiological phenomena very important for the artist's work. One of them, the *law of simultaneous contrasts*, can be expressed in this way:

1. *White looks whiter as the dark tone surrounding it is increased in depth.*
2. *A grey tone appears more intense as the light tone surrounding it is lightened.*

You can check this optical effect right now. Place in front of you a sheet of white paper and a sheet of black paper. Put in the centre on the black sheet a small square of white paper, about three centimetres square. You will see that the white of the small square appears whiter than the white sheet of paper because of the effect of simultaneous contrast. If you draw a grey shape on a white background, the latter will look lighter than the former.

From a practical point of view, the law of simultaneous contrasts means that in order to draw the brightness of a glass or the glitter of a metallic object, the shimmer of light on the sea, or any glossy surface, it is necessary to darken the surrounding tones. It also means that by darkening a tone which is juxtaposed with another, the latter becomes lighter, and a stronger contrast between these two tones is achieved.

Artists often use the white of the paper to enhance the effect of a shimmer or a gleam. They may render the white surfaces and shapes of the model, such as the white of a dress or a snowy landscape with an off-white or light grey. It is worth remembering the following theory:

No object is absolutely white.

The poet, philosopher, painter, and playwright Leon Battista Alberti wrote in 1436: 'Remember that you should never paint a surface so white that it cannot be made much whiter. The painter does not have a white white enough to reproduce the brightness of a sword. Thus, even if you are painting snow-white clothes, stop before you reach the whitest tone.'

Contrast and atmosphere

Imagine you are going to draw a still life. You choose your model, determine the composition, study the illumination but ... be careful! This moment is particularly important. You can create a deeper or a softer contrast depending on the direction, amount, and quality of light. You can illuminate the background or leave it dark. You can take into consideration Leonardo's advice, 'The background should be dark where the subject is illuminated and should be light where the subject is in shadow.' Then, when you are already drawing or painting, you can darken or lighten certain areas and spots creating contrasts to explain shapes more clearly. Velázquez, El Greco, Delacroix, Cézanne, and many other great masters created contrasts to enhance shapes.

Atmosphere

Atmosphere means air and space and suggests the third dimension: depth. Between the place you are sitting and the nearest wall there is space, and in this space there is atmosphere. We must be aware of this atmosphere to simulate it in our drawings, although it does not convey itself to us clearly or palpably.

As a typical example of atmosphere, see the drawing opposite made early in the morning at the fishermen's wharf in Barcelona (Fig. 478).

The day was a bit cloudy and the sun was not at its hightest point in the sky yet, so there was a sort of mist acting as a veil between the shapes and the viewer. This helps gauge the distance between one object and another. In the foreground there is an old boat and another one half-sunk, outlined in bright, humid colours, emphasizing the contrast between light and dark. The clear water moves there with glassy reflections and a metallic sheen. Further away, there is a group of three or four boats whose shapes are less visible, as if we are looking through coloured glass. There are no definite outlines or sharp contrasts here. Finally, blurred in the distance, we see the mist, the atmosphere, some tints whose silhouettes barely hint at a ship, and some buildings and smoke stacks.

This example helps to summarize the factors governing the sensation of atmosphere:

1. *Bright contrast occurs in close objects and decreases as the distance increases.*
2. *Colours fade and become greyer as the distance increases.*
3. *Marked brilliance occurs at the nearest points in contrast to those further away.*

To quote again from Hegel's *The System of the Arts*, where he relates the concepts of atmosphere and contrast, 'People usually

Fig. 476 According to Leonardo da Vinci, the background surrounding a figure should offer darkness where the area is illuminated and lightness where the area is shaded. This observation is evident in Gustave Courbet's portrait of Théophile Gautier. Here, Courbet darkens the background near the highlighted area of the face, but lightens the background tone adjacent to the dark hair.

Fig. 477 Vincent van Gogh, *Study of Trees*. Charcoal pencil and white chalk on paper. Kroeller-Mueller Museum. The subject of this drawing is the arabesque created by the shape of the trunks and branches of the trees. Van Gogh drew this scene with intense greys and blacks on a light, almost white background, an effect which creates extraordinary contrast.

476

477

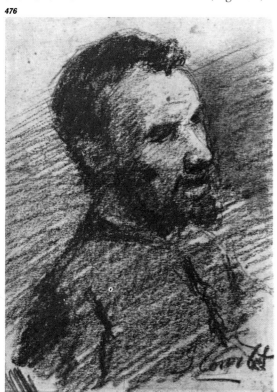

think that the foreground is the lightest and the background is the darkest. But the truth is that the foreground is the darkest and, at the same time, the brightest. That is, the contrast of light and shade in the foreground is more intense, and at the same time, the outlines become more definite. The more distant objects are, the lighter and greyer their colour is and the less determined their shadows are because the opposition of light and shade gradually disappears.'

But what are we supposed to do when all the objects are in the foreground? How should we draw the atmosphere of a still life, a portrait, or a group of figures? All those models are three-dimensional, so we need to represent the space between them. Of course, the atmosphere is not visible, as in a misty land-scape. But we have another option: blurring the outline of the furthest objects, even if their relative distance is very small. Remember that when we look at an object less than two metres away we spontaneously focus on that point and blur the rest of the objects in front of and behind it, just as a camera does. In a still life we will draw the objects in the foreground more precisely, and the ones in the background less precisely. Objects are alive since they have colour and reflect the light, and light vibrates. On the other hand our vision is not entirely steady. These factors indicate that, in a sense, a good drawing is somewhat ethereal. Even when drawing a portrait, we often stress almost intuitively the sharpness of the eyes, and we tend to soften our line when we draw the contour of the head or the ear, in an attempt to create the sensation that the head is not flat. In other words, we create the illusion of depth.

Fig. 478 This scene of a harbour is an example of using dark-light contrast in the foreground area, and colour in the background area.

Fig. 479 and 480 As seen in this portrait, when the model is observed close up, the perception of depth can be suggested by 'putting out of focus', or rendering very softly those areas that are farthest away. In a portrait the suggestion of atmosphere or depth is enhanced by juxtaposing highly resolved, detailed areas against softly rendered, diffused areas.

The human figure

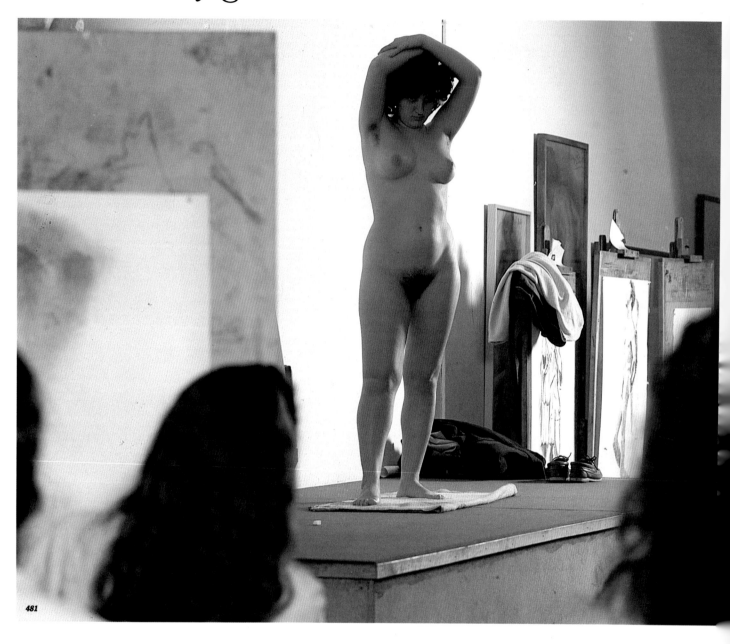

481

Fig. 481 This is a scene from a life drawing class at the School of Fine Arts in Barcelona. The classroom had about thirty students and two models. The students' area was lit by fluorescent lighting and the models were lit by a powerful floodlight which gave a backlighting effect.

Fine Arts School, Barcelona. Life drawing class. The classroom is quite large. There are more than thirty pupils drawing, more girls than boys, and two or three adults. There are two models: near one of the walls, on a platform, there is a naked man proportioned according to Velázquez's models in *Vulcan's Forge*, on the other side of the room, there is a woman as young as Renoir's bathers. It is daylight, but the curtains are closed, and the students work by artificial light, fluorescent light for the students and tungsten floodlights for the models. Everyone is paying great attention. The only sound that can be heard is that of the charcoal against the paper. The

atmosphere is so intense, there is almost a mystical feeling in the room.

In cities all over the world, in public or private schools, in societies or academies, there are classes in life drawing. There are professional models who go to an artist's studio to pose for a few hours. Studying and practising from nature is essential. The human figure is an ideal model.

About the middle of the last century, there was a painter in Paris named Troyon. He was a master of drawing *en plein air*, or outdoors. The young Impressionists used to visit him and listen to his advice. Claude Monet, in a letter of 19 May 1859 to the artist Eugène

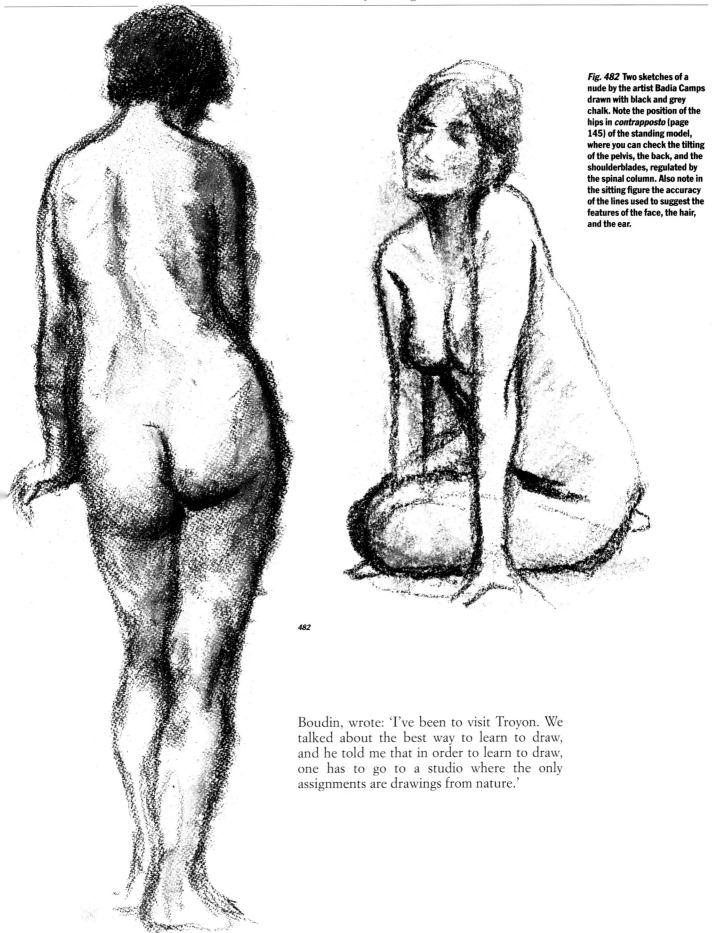

Fig. 482 Two sketches of a nude by the artist Badia Camps drawn with black and grey chalk. Note the position of the hips in *contrapposto* (page 145) of the standing model, where you can check the tilting of the pelvis, the back, and the shoulderblades, regulated by the spinal column. Also note in the sitting figure the accuracy of the lines used to suggest the features of the face, the hair, and the ear.

482

Boudin, wrote: 'I've been to visit Troyon. We talked about the best way to learn to draw, and he told me that in order to learn to draw, one has to go to a studio where the only assignments are drawings from nature.'

The canon of the human figure

There is a perfect formula, called a canon, for boxing up and proportioning the human figure, using the height of the head as the basic measurement. The first canon was established by the ancient Greek sculptor Polyclitus in the 5th century B.C. The basic measurement used by Polyclitus was the width of a hand, which was later transformed during the Renaissance into the height of the head. Polyclitus's canon was equivalent to seven and a half heads.

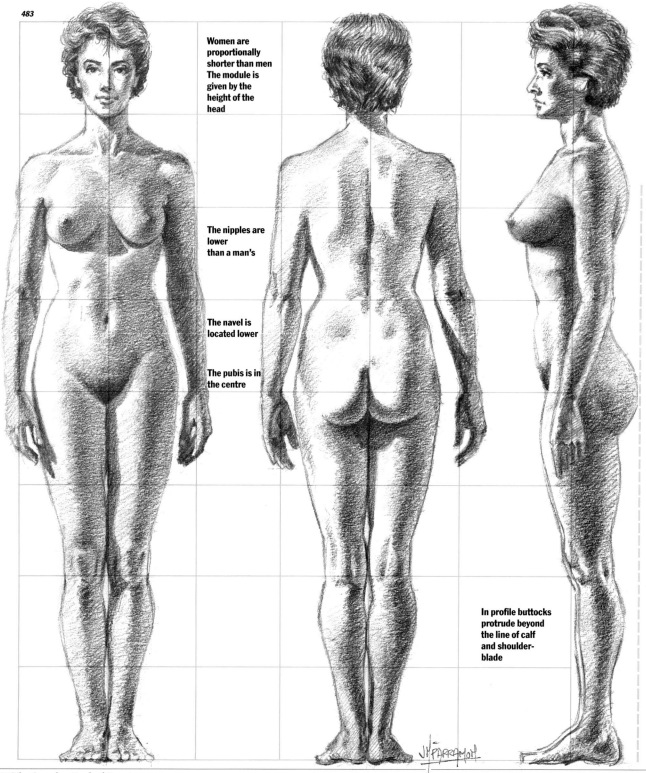

483

Women are proportionally shorter than men The module is given by the height of the head

The nipples are lower than a man's

The navel is located lower

The pubis is in the centre

In profile buttocks protrude beyond the line of calf and shoulder-blade

During the Renaissance, this canon was studied by several artists, including Leonardo and Dürer. However, though some artists held that Polyclitus was right, others established canons of eight or eight and a half heads. Leonardo insisted it had to be ten. Eventually, by the beginning of this century, it was determined that:

The canon for the ideal figure is eight heads high by two heads wide.

This refers to *ideal height*. The *normal height* of a figure is, as Polyclitus said, seven and a half heads, and the height of the so-called heroic figure, such as Moses, Tarzan, or Superman, is eight and a half heads. As far as I know, no artist draws figures to the canon or uses it systematically as if it were squared paper, but all good professionals know about it, and when it comes to drawing, either from life or the imagination, you must remember these dimensions and proportions (Figs. 483, 484):

1. *The proportion of the body seen from the front is eight heads high and two heads wide.*
2. *The level of the shoulders is one third of the way down module no. 2.*
3. *The nipples are on the line of module no. 2.*
4. *The distance between the nipples is one module (one head).*
5. *The navel is a little below module no. 3.*
6. *The elbows are at waist-level.*
7. *The pubis is in the centre of the body.*
8. *The knee is just within module no. 6.*
9. *In the male figure in profile, the calf protrudes beyond the vertical line of the buttocks and shoulderblade.*

The female figure differs from the male at the following points:

1. *The female figure is shorter than the male by about 4 inches (10 cm).*
2. *The shoulders are proportionally narrower.*
3. *The breasts and nipples are slightly lower.*
4. *The waist is somewhat narrower.*
5. *The hips are proportionally broader.*
6. *In profile the buttocks protrude beyond the vertical line of the shoulderblade and the calf.*

Whenever you draw a figure from nature, remember these dimensions. Then there's no way you can be wrong.

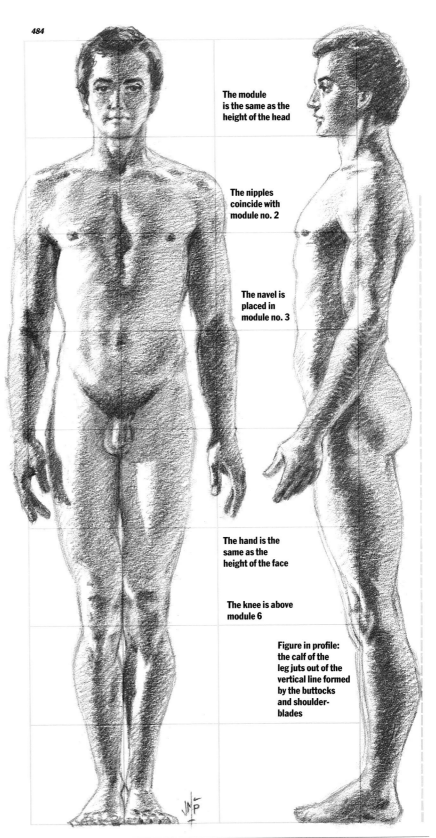

484

The module is the same as the height of the head

The nipples coincide with module no. 2

The navel is placed in module no. 3

The hand is the same as the height of the face

The knee is above module 6

Figure in profile: the calf of the leg juts out of the vertical line formed by the buttocks and shoulder-blades

Anatomy: structure of the human figure

Polyclitus and Praxiteles sculpted human figures just by observing the model and interpreting from nature, without being schooled in anatomy. But Michelangelo and all the Renaissance artists showed the necessity of a deeper knowledge in artistic anatomy. Ingres said, 'To express the surfaces of the human body we must first know its structure.'

Artistic anatomy has been the subject of many books and treatises, and is too large a topic to discuss here completely. Perhaps your interest in drawing will lead you to acquire a good book on artistic anatomy. However, we shall discuss here one very common pose in figure drawing, which is understood better when one has a knowledge of artistic anatomy.

485

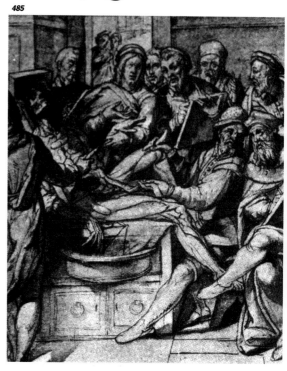

Fig. 485 *A Lesson in Anatomy.* **Anonymous engraving. Louvre, Paris. Using perspective and anatomy as a basis for drawing began during the Renaissance. Both Leonardo and Michelangelo dissected corpses, which at the time was considered a sacrilege and was forbidden by law.**

Figs. 486 and 487 A knowledge of artistic anatomy is necessary in order to make good drawings of the human figure. To learn anatomy, you should study the bones, muscles and tendons of the human body.

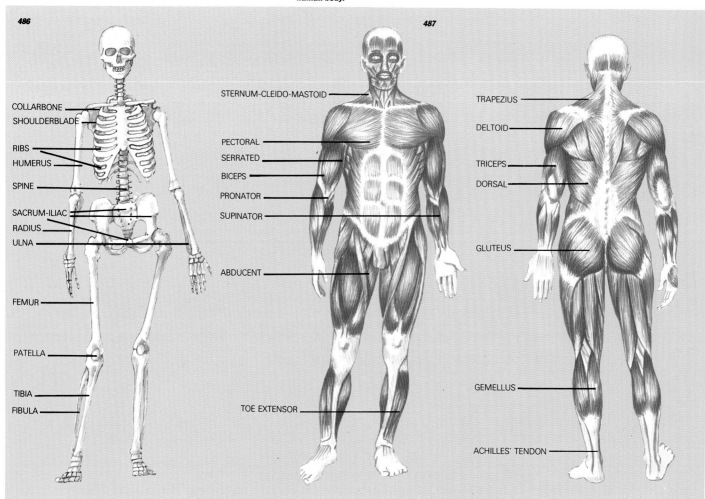

486

COLLARBONE
SHOULDERBLADE
RIBS
HUMERUS
SPINE
SACRUM-ILIAC
RADIUS
ULNA
FEMUR
PATELLA
TIBIA
FIBULA

487

STERNUM-CLEIDO-MASTOID
PECTORAL
SERRATED
BICEPS
PRONATOR
SUPINATOR
ABDUCENT
TOE EXTENSOR

TRAPEZIUS
DELTOID
TRICEPS
DORSAL
GLUTEUS
GEMELLUS
ACHILLES' TENDON

The contrapposto

When the model puts the weight of his or her body on one leg and at the same time relaxes the other, we have what was called, during the Renaissance, *contrapposto*. We shall define it as the hip position, though anatomists prefer the term *ischiatic position*, because the *ischia* (the lower edge of the pelvic bones) shifts from one side to the other when the body rests on one leg or on the other. This position also influences the chest and the collar bone, which shift to the other side, inclining the shoulders and twisting the spine (Figs. 488, B and C). Notice in the diagram below in Fig. 489, the prominence of the iliac crest of the pelvis (a); the soft 'valley' produced by the lack of bones near the surface (b); and another prominence produced by the greater trochanter of the femur (c).

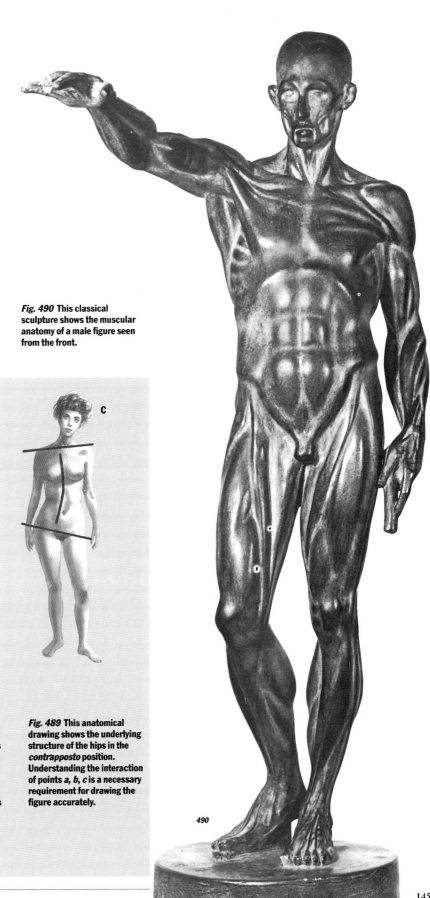

Fig. 490 This classical sculpture shows the muscular anatomy of a male figure seen from the front.

488

A B C

489

a

b

c

Fig. 488 Contrapposto This term describes a typical pose for a standing model, who rests by leaning the weight of the body on one leg, at the same time slightly bending and relaxing the other leg. It is in this position that the pelvis tilts towards one side while the chest and the shoulders tilt towards the other side, and the spinal column twists accordingly.

Fig. 489 This anatomical drawing shows the underlying structure of the hips in the *contrapposto* position. Understanding the interaction of points *a*, *b*, *c* is a necessary requirement for drawing the figure accurately.

490

The nude

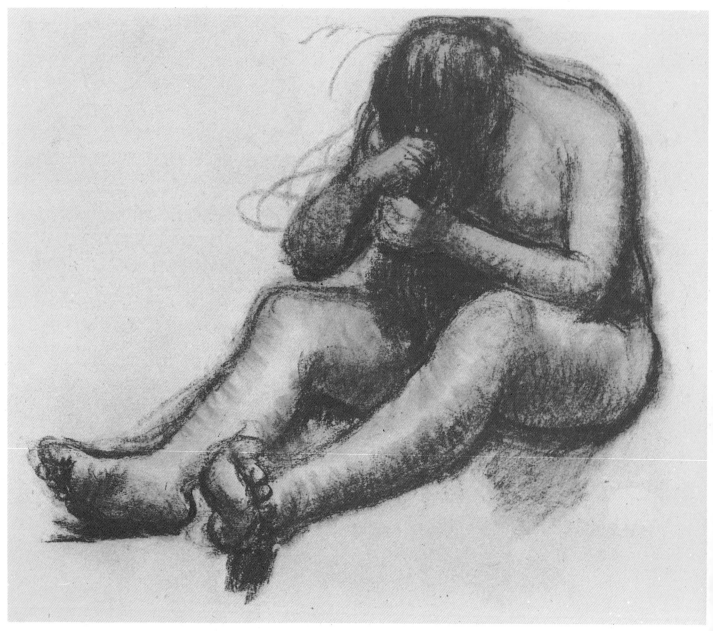

491

Figs. 491 and 492 Francesc Serra. *Nude.* Conté crayon on cream paper. (Right) Francesc Serra. *Nude.* Gouache and sepia chalk on cream paper. Both drawings were drawn from life in the artist's studio. In the drawing on this page, note the direction of the line and the top lighting. In the drawing on the opposite page, the artist considered the perspective of the background and drew it with a partial backlighting scheme. In both drawings there is a keen sense of underlying structure, based on an accurate calculation of proportions, a knowledge of light, and a surety in the direction of the line.

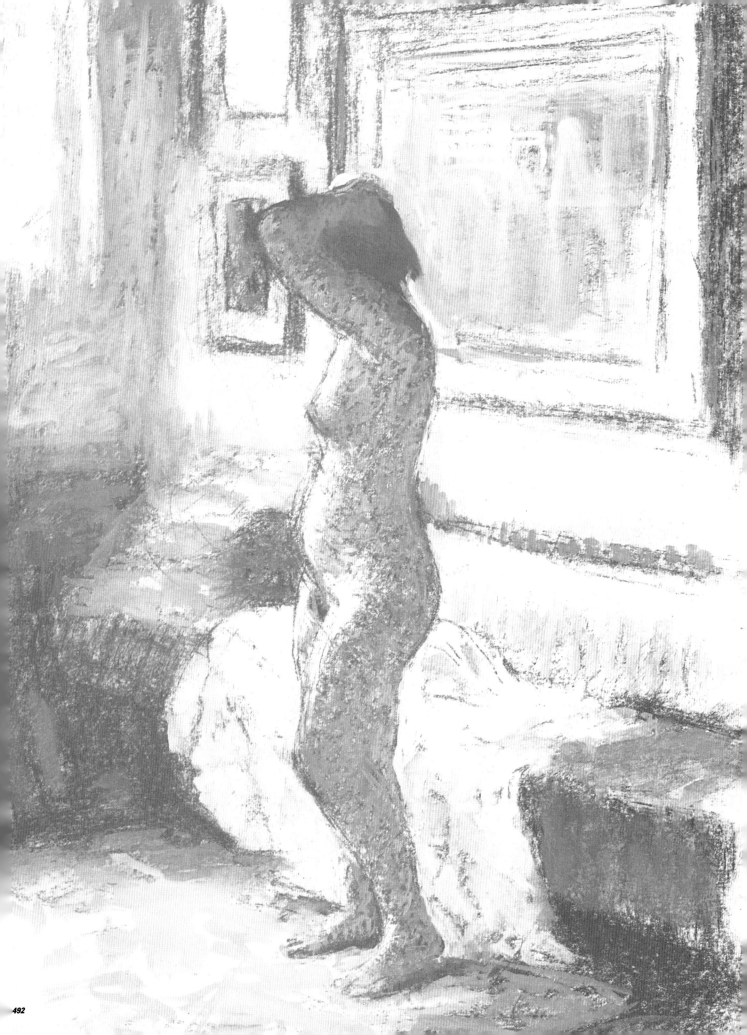

The clothed figure

Try this exercise: draw several fabrics of different kinds, draped in different positions – on a table, on a chair, or hung on a wall. This exercise will help you solve two major problems: volume and modelling. It will allow you to study the appearance or texture of fabric and to practise the shaping of folds and wrinkles which you can apply later when drawing a clothed figure. 'Clothes must adapt to the body and never look void inside' (Leonardo). For this exercise you can work with artificial light and choose light-coloured fabrics of different textures, such as a cotton sheet, a thick woollen blanket, or a dress of shimmering satin or silk. You should draw on a large piece of paper with charcoal, black chalk, or sanguine. Try to fill in the areas very rapidly, darken them, create whites with the rubber – in a word, paint.

Once you have started drawing clothed models, I advise you to practise the problem of folds and wrinkles. Draw quick sketches from nature. Try to represent the wrinkles of a jacket sleeve, made of thin fabric, with only a few lines.

Try to understand through drawing how fabrics behave in relation to the body and its movements. Find the point where clothes are more prominent and observe the shaping of creases and wrinkles. Finally, consider the possibility of clothing the figures yourself before drawing them clothed, that is, sketch the nude first with a few strokes, then 'dress' the model. This will encourage you to think about the folds and wrinkles as they result from the shape and position of the body.

Fig. 493 The study of fabrics is a good exercise which has been practised by all masters of drawing for its applications to the clothed figure.

Fig. 494 A thin material such as this shirt (A) will have more folds than a thick material such as this coat (B).

Fig. 495 Try sketching a dressed figure, and include the complex creases and folds of one sleeve. For example, A can be drawn by summarizing the folds and B by grasping the nature of the creases.

Fig. 496 It's a good idea to draw the clothed body, so that you can understand the behaviour of cloth in relation to the movements of the body.

497

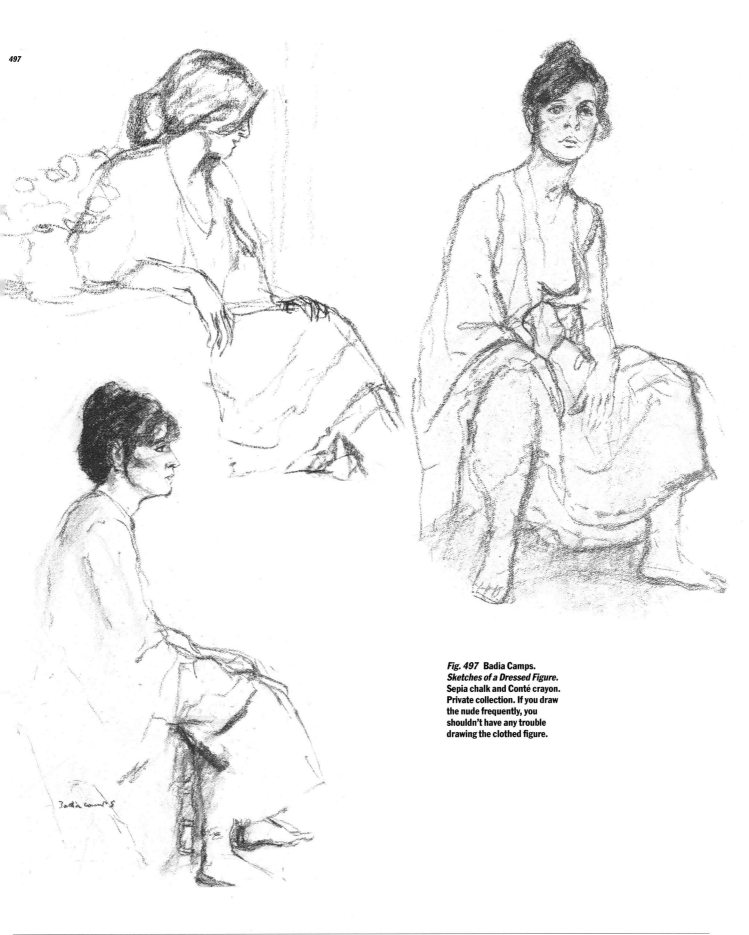

Fig. 497 Badia Camps.
Sketches of a Dressed Figure.
Sepia chalk and Conté crayon.
Private collection. If you draw
the nude frequently, you
shouldn't have any trouble
drawing the clothed figure.

The canon of the human head

In the Quattrocento, Cennino Cennini wrote in his work *Il Libro dell'Arte*, 'I'll give you the exact proportions of the man.' Incidentally he added: 'I'll leave those of the woman, since they are not exact multiples of one another.' As if women were different beings! Later on, studying male perfection he added, 'The face is divided into three parts, the forehead, the nose, and the area between the nose and the chin.'

Cennini established a canon very similar to that for the body, but applied it to the face. As you can see in the drawings below, this canon refers to the height of the head, from the upper outline (without the hair) down to the chin. Observe in Fig. 499 that the canon of an adult head seen frontally (a child's canon is different), is three-and-a-half modules high and two-and-a-half modules wide, the height of the forehead being the module used. (Check these and the following features of the frontal canon in Figs. 499, 500, 501. Notice in these figures too, that the eyebrows, the nose, and the mouth are placed on the vertical centre of the canon, whereas the eyes coincide with the horizontal centre.) Study the placement of the facial elements on the following horizontal lines of the canon:

A) *The upper outline of the skull (leaving out the hair)*
B) *The beginning of the hair*
C) *The placement of the eyebrows*
D) *The placement of the eyes*
E) *The lower part of the nose*
F) *The outline of the lower lip*
G) *The lower outline of the chin*

Notice, too, the height and situation of the ears which coincide with the placement of the eyebrows and the lower part of the nose (modules C-E). Finally, see the difference between the canon of an adult head and that of a child in the box on the following page, Figs. 504 and 505. This canon is particularly helpful for drawing and painting heads and portraits. Of course, it cannot be rightly applied to all heads and faces because everyone has his or her own unique features. However, there are dimensions and proportions that can be applied in a general way. For instance, the fact that the distance between the two eyes is exactly that of another eye; or that the height and situation of the ears coincide with the distance from the eyebrows to the lower part of the nose; or that the three modules *forehead, nose, nose-chin* are three basic dimensions to be taken into account when starting to draw a head.

Figs. 498 to 501 These illustrations show us the canon that enables us to draw the proportions of a human head, either male or female. Note in Fig. 498 (A, B, C) the construction of the canon through a simple geometrical calculation that will enable you to draw a head seen from the front. Study the alignment of the different parts of the head in both a front and side view. In Figs. 499 to 501, *A* indicates the top of the head; *B* is the hairline; *C* is the eyebrows; *D* is the eyes; *E* is the lower part of the nose; *F* is the edge of the lower lip; *G* is the bottom of the chin.

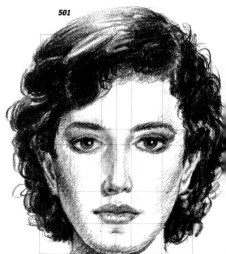

498

499 500 501

502

503

Figs. 504 and 505 Head proportions for young children correspond to a different canon than the one used for an adult. A child's forehead is wider; the eyebrows – and not the eyes – coincide with the midpoint of the height of the head; between the eyes is a longer distance than the single-eye distance found in adults; the ears are proportionally larger, and the features are typically shorter and rounder.

506

504

505

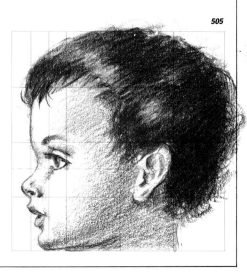

Figs. 502, 503 and 506 These drawings were made by Francesc Serra in pencil and blue pastel. Note the difference in the facial proportions between the adults at the top and the child's face below.

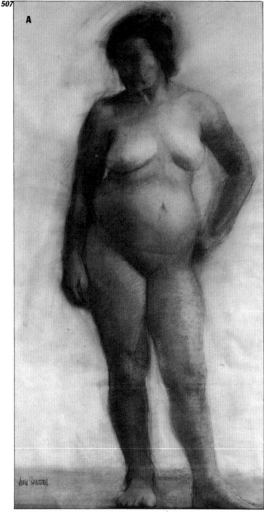

507

A

Fig. 507 As an example of artistic drawing and its expressive possibilities, here are some drawing examples made in the School of Fine Arts in Barcelona in Professor Francesc Crespo's class by his pupils: Joan Sabater (A), María Perelló (B), José Juan Agüera (C), and Raimon Vayreda (opposite page). Permission to reproduce these drawings has been granted by the School of Fine Arts in Barcelona.

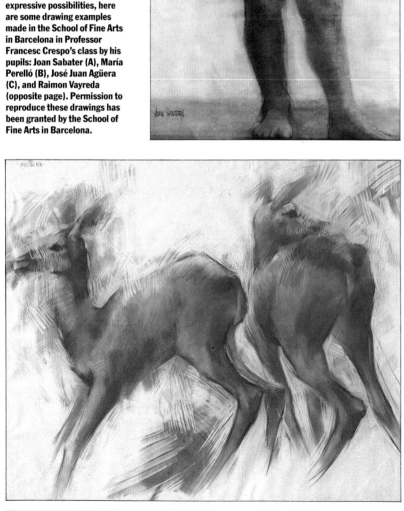

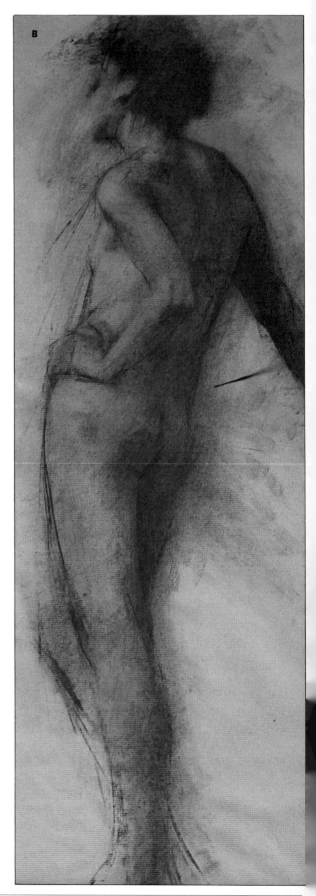

B

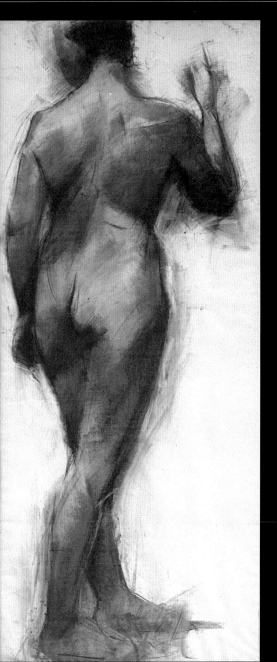

The art of drawing

'What makes a face beautiful

The portrait

The two portraits that illustrate these pages are by Francesc Serra, a famous Spanish painter and draftsman who died in 1976. Francesc Serra was a good friend of mine; we published two books together. He was a master of painting oil figures, and an exceptional draftsman in various other media as well. These portraits were carried out with Koh-i-noor HB and 2B pencils, on glossy drawing paper. He used a 100-watt tungsten floodlight about two metres away from the model. He would spend between five and seven hours on portraits like these, in one- or one-and-a-half-hour sessions.

Francesc Serra specialized in portraits for a while. 'I stopped drawing them,' he told me, 'because I had too many assignments and I didn't have enough time to paint! ... Besides, portrait painting is a conditioned type of art: for the artist, the likeness is important, but the drawing as a work of art in itself is even more important. For the person portrayed, it is the likeness above all that counts. The subject expects to see his or her image improved. In the end, you are not free; you have to keep the customer satisfied!'

Serra's idea coincides with the opinion of the sculptor Rodin: 'Because of a strange and fatal law, the person who wants a portrait goes against the talent of the artist he (himself) has chosen.' But the history of art is not altogether in accordance with this principle. One of Velázquez's best works is the portrait of Pope Innocent X, which is admired every day by hundreds of people at the Gallery Doria in Rome. Nobody remembers if Innocent looked like his portrait, but everyone agrees the picture is a work of art. This is the case with many portraits, including Serra's works.

One of the most famous artists in the field of painting and drawing was Jean-Auguste-Dominique Ingres. He left us a series of 'pieces of advice for several pupils' which are a superb lesson on portrait painting. Here you have the most relevant items:

● *Likeness depends on physiognomy; if you exaggerate the features, you'll come closer to capturing the way a person looks.*
● *The body does not have to follow the movement of the head.*
● *Before you begin, get to know your model.*
● *Remember, eyes are constantly moving; don't draw them as if they were static.*
● *Avoid an excess of reflections, which might break the sense of mass.*

509

The first session of a portrait must be devoted to the study of the pose, the lighting, and the likeness by making several preliminary sketches. The model must be comfortable, clothed naturally, with his or her hair naturally brushed. The model should look at the artist and keep his or her eyes at the height of the artist's eyes.

There are certain fairly standardized measurements for portraits: for a head or half body, a sheet of about 35 × 45 cm (14 × 18 in) is used; for the whole body, a sheet of about 50 × 70 cm (20 × 28 in). The size of the head itself should be about 12 to 15 cm (5 to 7 in); in half body, about 10 to 12 cm (4 to 5 in); in the whole body, 7 to 9 cm (2½ to 3 in). Notice that the illustration on the opposite page shows us the classic system: a carefully finished head with light and shade effects with the body sketched in a linear style.

Fig. 509 This portrait in pencil by Francesc Serra contrasts the precise modelling of the head and hands with the linear, sketchy quality of the body. This device also attracts our attention to the model's pose and attitude, which has been studied and emphasized by the artist.

Fig. 510 In this splendid portrait done in lead pencil, artist Francesc Serra has enhanced the magnificent modelling of the head, and indicated the body with just a few confident lines. (This is an example of the classical style of contrasting head and body.) Note in the areas of the shirt collar, the jacket lapel, the sleeve, and the hand, the use of lines blended with a stump, which is characteristic of Francesc Serra's style.

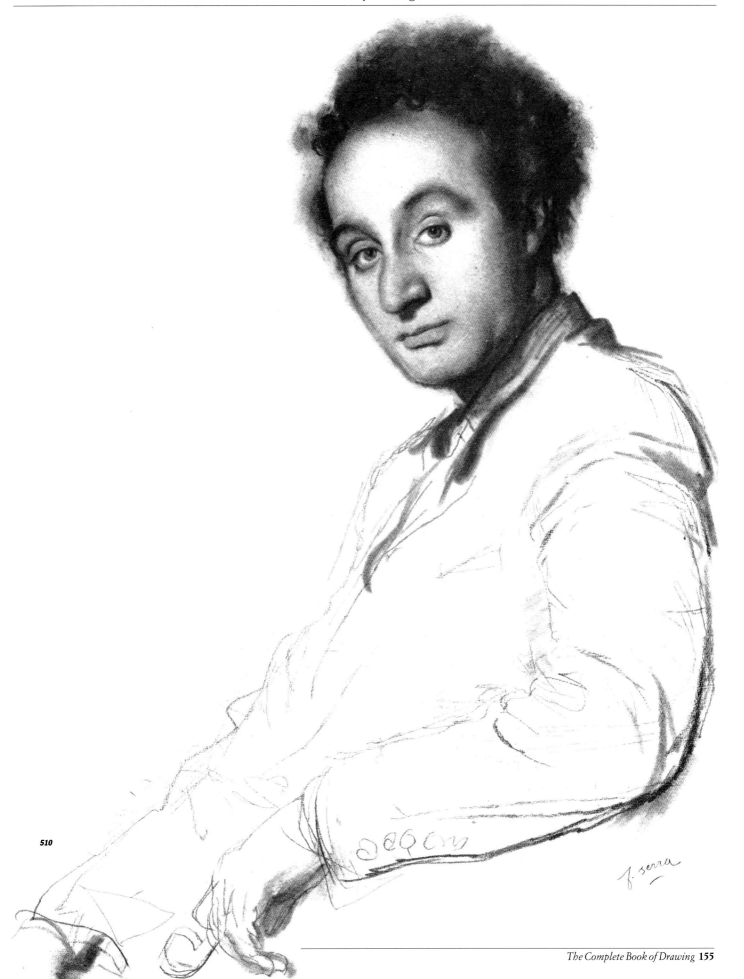

510

The sketch

A pencil and a piece of paper are all you need for studying, learning and improving the art of drawing. The paper should be a pad of sheets a bit smaller than this book. The sheets should be bound or stuck together so that you get a stiff surface without using a board. This will allow you to draw anywhere. Use a soft pencil, a 4B or an even softer one, or consider the possibility of using an *all-lead* pencil. A black felt-tipped pen or a set of three or four pens – black, grey, ochre, and sienna, for instance – would be enough. This range of colours allows you to sketch with a slight hint of colour.

Subjects can be found everywhere. Remember that Renoir made light of needing subjects or themes: he could make do with a pair of buttocks! All kinds of subjects are valid: trees, seascapes, boats, and a million more. At home, in the street, on a train, in a waiting room, in a hotel. Try spending a morning at the zoo or on a farm sketching animals. As Renoir said, 'We can do all right with a pair of hens, three ducks, a rabbit, a cat, and a dog.'

Besides being fun, sketches are the best exercise to improve your artistic capability. As van Gogh used to tell his brother, Théo: 'Drawing sketches is like planting seeds in order to get pictures later.' Good drawings or paintings are sometimes much better when they are 'short'. Shortness implies security and spontaneity. When painting a picture, people tend to be scared about the final result. This fear may disappear if you paint as if you were sketching, with the same philosophy, characterized by ease, spontaneity, and freedom.

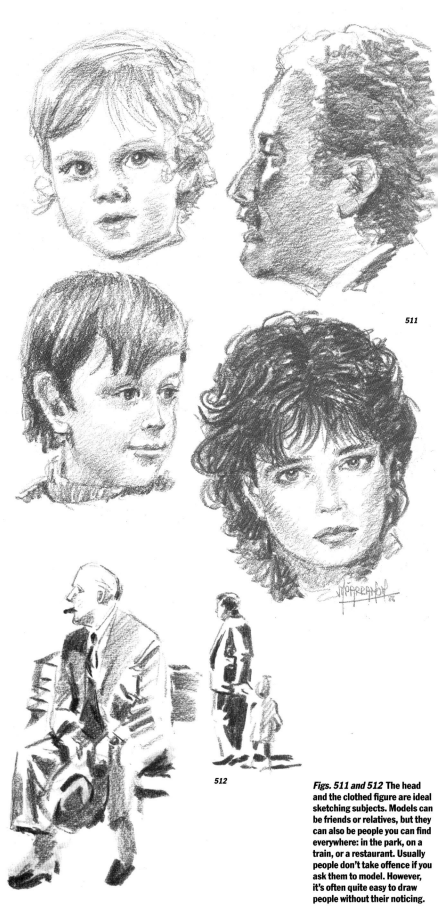

511

512

Figs. 511 and 512 The head and the clothed figure are ideal sketching subjects. Models can be friends or relatives, but they can also be people you can find everywhere: in the park, on a train, or a restaurant. Usually people don't take offence if you ask them to model. However, it's often quite easy to draw people without their noticing.

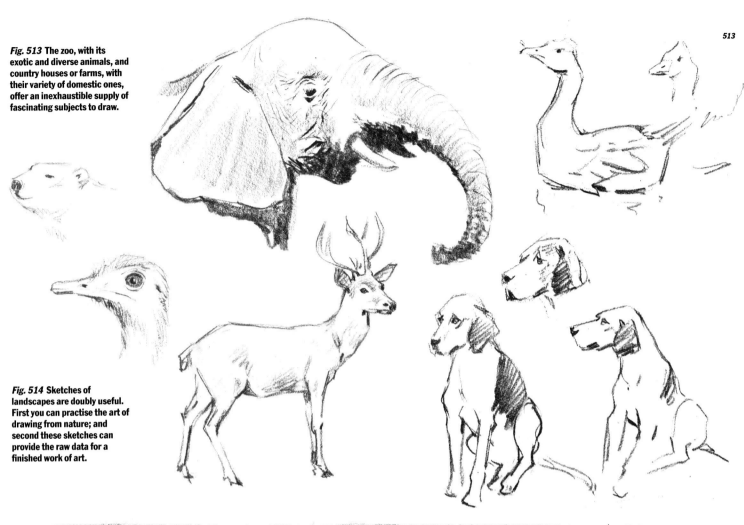

Fig. 513 The zoo, with its exotic and diverse animals, and country houses or farms, with their variety of domestic ones, offer an inexhaustible supply of fascinating subjects to draw.

513

Fig. 514 Sketches of landscapes are doubly useful. First you can practise the art of drawing from nature; and second these sketches can provide the raw data for a finished work of art.

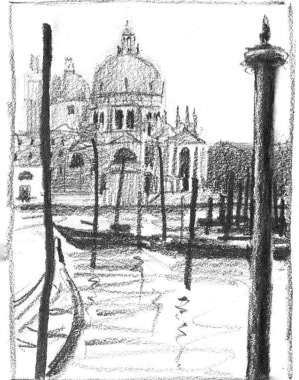

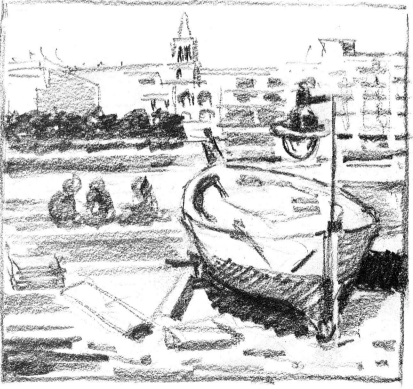

514

The sketch

Francesc Serra shows us six figure sketches here made with pastel and Conté crayon on light cream-coloured paper. These sketches were made from nature with quick poses of up to fifteen minutes each. 'Every two or three days, between one picture and the next,' Serra told me, 'I draw three or four sketches like these, just to keep in good shape.' In order to achieve excellent pictures, it is helpful to try this exercise as often as possible.

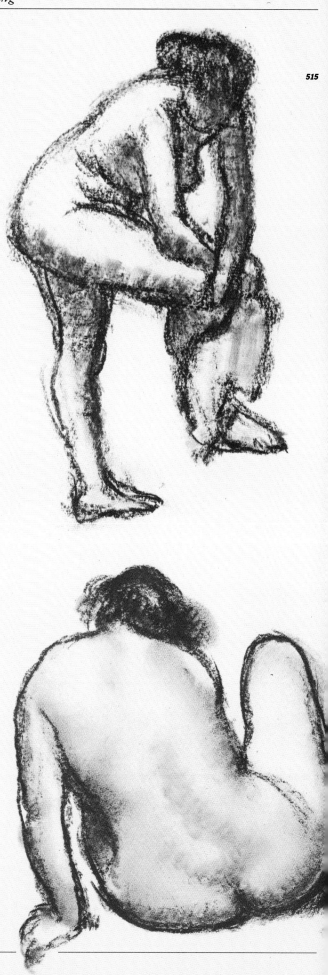

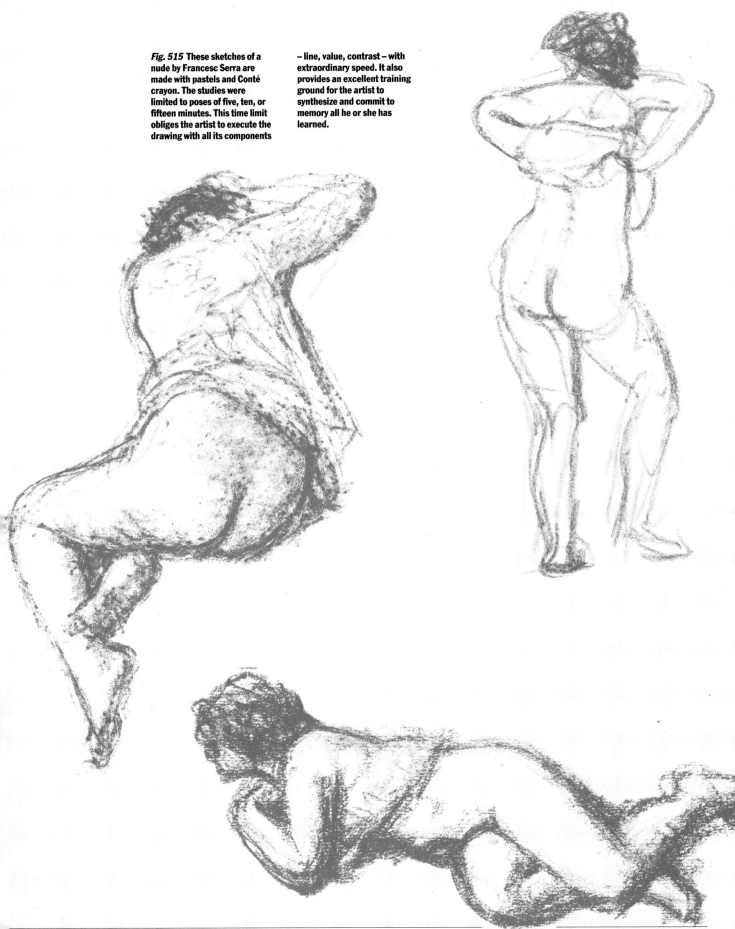

Fig. 515 These sketches of a nude by Francesc Serra are made with pastels and Conté crayon. The studies were limited to poses of five, ten, or fifteen minutes. This time limit obliges the artist to execute the drawing with all its components – line, value, contrast – with extraordinary speed. It also provides an excellent training ground for the artist to synthesize and commit to memory all he or she has learned.

The draft

Helmut Ruheman, chief restorer of the London National Gallery and author of *The Restoration of Paintings*, wrote, 'I was in Paris working with Maurice Denis for two years. I'll never forget some pieces of advice he gave me. Before starting a picture, draw a quick draft, postcard size. Then sketch the basic composition and the colours, and under no circumstances are you to abandon this small and fresh idea.'

In the beginning, the main purpose of drawing was to sketch and plan paintings. Many good pictures started as postcard-size drafts. Rubens, for instance, started like that – as can be seen in galleries and museums – with one or two and sometimes three wash sketches with two or more colours, then with one or two oil sketches, which eventually were sent to his workshop (where he worked with van Dyck and Jordaens) to be completed.

The artist Badia Camps shows us here the sketches of an oil painting beginning with a small draft and a more complete drawing. Both of them were made with dark sepia chalk, and a touch of colour made also with chalks, to get the final painting. Notice the changes in position, viewpoint, shapes in general, and objects on the table in particular. All this is characteristic of a study carried out with several drafts.

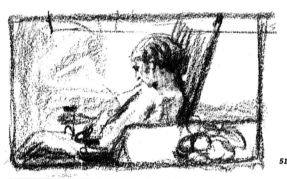

516

Figs. 516 and 517 The artist Badia Camps shows us here the process he followed to achieve this oil sketch he did for the painting on the opposite page. 'Sometimes,' Camps says, 'the idea for a painting starts from a little note such as this drawing.' This sketch, ever so small, offers the advantage of allowing you to realize an idea in a minimum span of time – say two or three minutes – by transferring to the paper a synthesis of what you have in mind. Later, this process becomes more laborious, when such radical changes as changing the position of the model are needed for the painting to be resolved (Fig. 517).

517

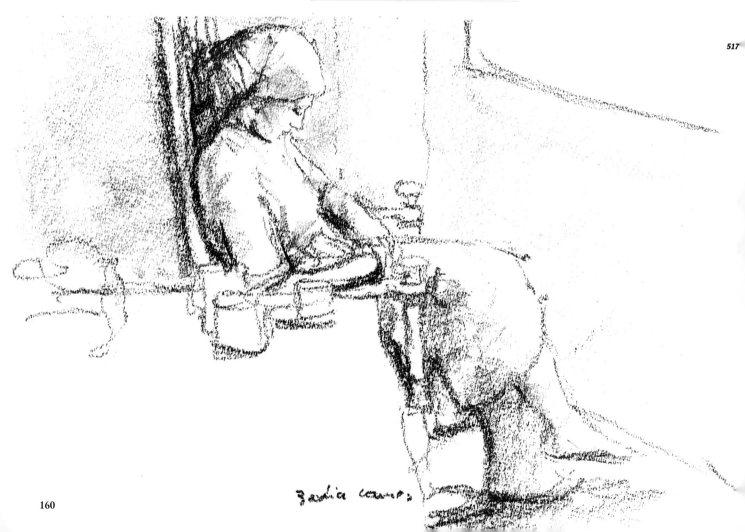

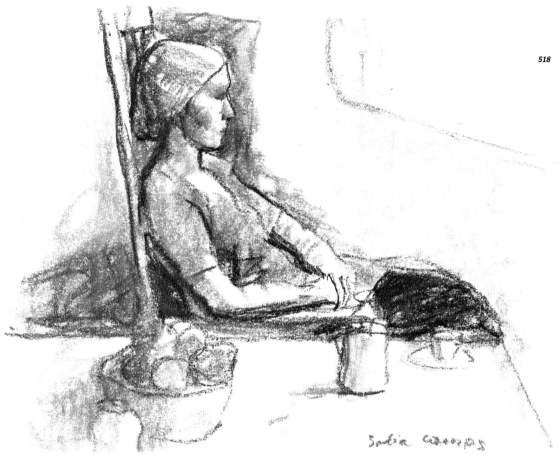

518

Fig. 518 (This reproduction of Badia's drawing is only slightly smaller than the actual drawing.) 'Afterwards,' continues Camps, 'you begin the study with gradations of tone and colour contrast. I usually make a sketch such as this using pastel on a sheet of white paper about 18 x 24 cm (7 x 9¹/₂ in). Then, I usually leave it until the next day, trying to resolve the rest of the study and perhaps the intended finished piece.'

Fig. 519 '... Finally, I make a sketch in oil on cardboard. Then, working with the model, I try to capture in this final sketch all the ideas and concepts stored up from the previous sketches. Two or three days later, I will start the definitive painting.' Thus, Badia Camps has shown us here the way to paint a picture successfully, using the same procedure followed by all professional painters.

519

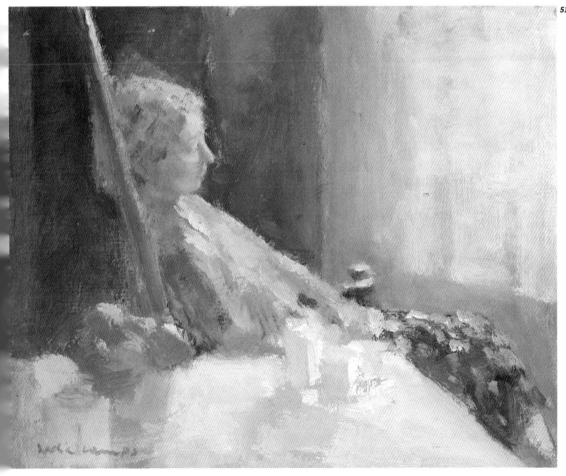

Subject, interpretation

Until late in the 19th century, one of the main aspects of a picture was the *subject*. Sir Joshua Reynolds, one of the most important British painters, wrote in one of his speeches as president and founder of the Royal Academy: 'Judging which subjects are suitable for painting and which are not requires great knowledge.' In 1847, at the Salon de Paris, the gold medal was awarded to Thomas Couture for his picture *The Romans of the Decadence*. Visitors became enthusiastic about this picture because of its story and plot. The young artists of that time used to say, 'People do not go to see paintings, but subjects.' Young artists began to paint in the open air in the Fontainebleau woods. They were referred to, in a pejorative way, as the Barbizon School. Their paintings and subjects did not please the public. The Count of Nieuwerke said, 'This is democrats' art, those people who don't change their clothes.' Those people were Rousseau, Corot, Millet, Tomière, Courbet. Alongside them came Manet, Monet, Pissarro, Degas, Renoir, Sisley, and Guillaumin, among others. They painted impressions, everyday scenes, common figures, small pictures. They rejected the scenery of the subject and looked for motifs; or rather, they did not look for them – 'I don't seek, I find,' declared Picasso. They found crowded streets, buses and cars, ballet dancers, bathers on the riverbank, moments at the circus. Sisley painted floods; Degas, horse races; Guillaumin was one of the first painters of the countryside. Lieberman, a prominent German Impressionist, said, 'Painting a rose or a virgin means the same to me.' The subject was no longer something transcendental. A subject as ordinary as an old pair of shoes or a chair (van Gogh), a bicycle (John Singer Sargent), the roof of a block of flats (Picasso) scandalized both public and critics. Yet they are commonplace subjects nowadays and appear on walls as masterpieces. Therefore, do not worry too much about your subjects. They are everywhere. You will find one just by turning your head. Cézanne wrote in a letter to his son, 'Here, by the riverbank, subjects are endless. The same point of view from different angles invites you to draw studies so varied that I think I could work for months sitting in the same place and just inclining myself to the left or to the right.'
The idea of that riverbank can be applied everywhere, but if you are unable to *see* it yet, do visit museums and exhibitions; buy books with good reproductions, study and associate painted people and places with people and places you know in order to depict them. You will notice – and this is the amateur's golden rule – that a successful subject depends on the interpretation: the setting, composition, structure, background, shape, language; 'exaggerating, improving, diminishing, changing shapes; that is, interpreting' (André Lhote). Interpretation according to what one sees inside himself or herself – that is what a picture is.
'*The subject is yourself, your impressions and your emotions as regards nature.*'

Eugène Delacroix

520

Fig. 520 Motifs or subjects for art can be found anywhere, sometimes just by turning your head. For instance, all the objects in this still-life drawing – the pencils, brushes, paint jars – are here in my studio on my auxiliary table.

521A

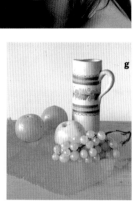

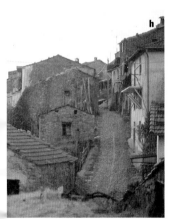

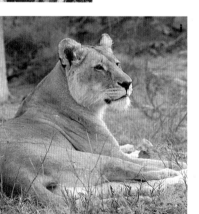

521B

Fig. 521 A As Cézanne said to his son: 'Motifs, or subjects, are endless.' To really be able to *see* this diversity of subjects, there is nothing better than visiting museums and exhibitions, or reading art books with good reproductions, studying and assimilating the subjects painted by other artists. Another good way to educate this faculty of seeing and choosing a motif to paint is through photography, where you will have to solve problems such as viewpoint selection and the correct framing. Note in the photographs on this page examples of motifs or subjects to draw. Among them, you will find:

a. Landscapes in general are always appropriate to draw or paint.
b. An urban landscape. You can choose an old city street or a modern one.
c. The human head is ideal for studies and portraits.
d. The human figure outdoors is an ideal subject for sketching.
e. Harbour scenes are an inexhaustible subject, perfect for drawing or painting.
f. Flowers, either singly or a whole bouquet, are especially beautiful subjects to draw. They also give you more time to observe them than do human subjects.
g. A still life offers the advantage of enabling you to study its composition in your own studio.
h. The time-worn streets of ancient villages make very picturesque subjects.
i. Zoo animals, so plentiful and varied, make excellent subjects.

Fig. 521 B Once you have chosen the subject you must study which is the best setting by changing the viewpoint in order to obtain a different foreground, a main subject more or less distant, etc.

On the art of composition

A young painter named Louis le Bail had the opportunity of watching Cézanne compose one of his still lifes. Le Bail wrote the following impressions: 'He started by taking the tablecloth and putting it on the table. He crumpled it a little bit. Afterwards, he placed the pears and the peaches. He put them on a dish on the tablecloth, next to a jug. He opposed some colours to others, making complementary colours vibrate: greens and reds, the yellow of peaches and the blue of shadows. He raised and inclined the pieces of fruit by putting different kinds of coins under them. He used to do this with great enthusiasm and dedication.' Paul Cézanne was a real master in the art of composition. What rules did he apply? None. There are no specific rules in the art of composing. It is a question of creation, of intelligence; and, as the philosopher Jean Guitton says, 'intelligence is something that can't be taught, but we can show the right direction to look at in order to see intelligence appear'.

The art historian Wölfflin states that 'a picture is in debt to other pictures much more than it is to the artist's observation of nature'. Therefore, in the first place you should get information: see good pictures by good artists and study their composition. Ingres said, 'Beautiful shapes are those in which small details do not question the great masses.' This idea may be complemented with Delacroix's advice: 'Pay constant attention to the mass, to the image that caught your attention.' All this is related to one of the few rules in the art of composition, stated by Plato in ancient Greece:

Composing consists of finding and reproducing variety within a unit.

Variety occurs in shape, in colour, in the position of the elements represented, creating a diversity of shapes and colours that catches the onlooker's attention and makes him interested. But make sure this variety is not so great that it puzzles the onlooker and distracts his attention. In other words, organize this variety harmoniously so that it becomes complementary, and establishes a unity throughout the work.

522

Fig. 522 Poor. This composition is too unified and the placement of the fruit is monotonous and inexpressive; it does not arouse our interest. Note that the attached diagram graphically illustrates the static quality of the composition.

523

Fig. 523 Poor. Here we have an excess diversity of objects. The scattered quality attracts our attention to the objects separately; the composition can't be contemplated as a whole.

524

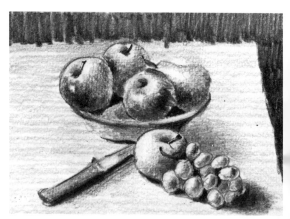

Fig. 524 Poor. Here again we see an excessive unity. As you can see in the diagram, the composition offers far too many geometric coincidences that contradict the natural diversity of things.

525

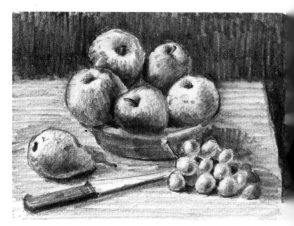

Fig. 525 Good. This composition is a good example of unity within diversity. The unifying factor is the arrangement of the whole, while the diversifying factor is found in the varied positions and arrangements of the objects in the picture.

The Law of the Golden Section

526

Fig. 526 This landscape is an example of how the Golden Section can be applied to achieve the best composition. Let's place the Golden Point in the block formed by the four buildings and the church belfry. You can see that in A the centre of the main motif is acceptable, but somewhat monotonous. In B the main motif is displaced towards one side, excessively off-centre, to the detriment of a good composition. Finally, in C, the block of the four buildings and the belfry is placed in an optimum situation according to the Golden Section, thus achieving an aesthetically perfect position in the composition.

We know that in the first century B.C. the Roman architect Vitruvius wrote *De architectura*, which he dedicated to Emperor Augustus. Vitruvius was an expert in painting – he directed the techniques used for the Pompeii wall paintings – and, like Plato, he was a theorist of art. While he was working at Pompeii, he studied the organization of shapes and space and wondered about the best place to locate the main subject, the most important element on the wall painting (or picture or drawing).

The easiest way, though hardly original, was, and still is, to put the main element in the centre of the picture. In order to break the excess of symmetry and unity, the centre could be taken to one side, but to what extent? Vitruvius found the solution and established the famous *Golden Section* or *Golden Rule*.

'For an area divided into unequal sections to be agreeable and aesthetic, there should be the same relationship between the larger section and the whole as between the smaller and larger sections.'

527

The Law of the Golden Section

Let's imagine a segment whose total length is 5 centimetres.

2 cm	3 cm

If we divide this area into two sections of 2 and 3 centimetres, we will see that, according to the Law of the Golden Section, an approximate proportional relationship exists between the smaller portion (2 cm) and the larger one (3 cm) as between

almost equals 3:2, which when reduced to a decimal fraction gives approximately the same result: around 1·6. Vitruvius found this numerical relationship in *'extreme and mean ratio'*, establishing that:
The arithmetical expression of the 'Golden Section' is equal to 1.618.
Practically speaking, whenever you want to find the Golden Section, multiply the total length of the space by

GOLDEN
POINT

the larger section and the entire length (5 cm). Thus 5:3

the factor 0.618. Look at the following examples.

Composition

528

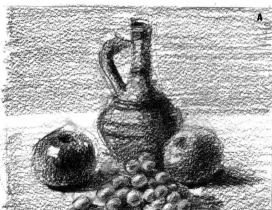

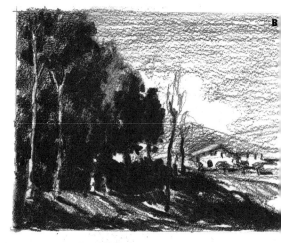

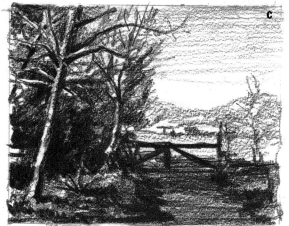

Fig. 528 Delacroix's advice, 'Pay constant attention to the mass, to the image that caught your attention,' is in fact a basic principle of the art of composing, whose practical applications could be summed up by: *Try to associate the form of the picture as a whole with a geometric scheme.* Many people feel geometric forms or schemes are the most aesthetically pleasing; these people prefer them to the more organic, looser forms of nature, such as a leaf. The art of composing through geometric forms started in the Renaissance with the triangular scheme (A). Then in the Baroque period artists used a diagonal scheme (B), known as the Rembrandt Formula. But, as far back as human history goes, and particularly since the Baroque period, the geometric forms have dictated, consciously or unconsciously, the composition of a picture. Note in the diagrams (C, D, E, F, G) above some of these common schemes and their application to the composition of subjects or motifs to paint or draw.

The third dimension

529A

529B

529A

530

529B

530

531

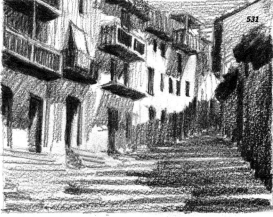

531

532

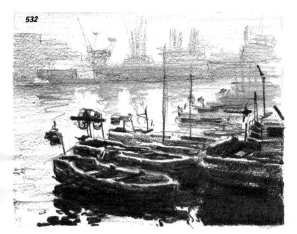

532

Fig. 529 A and B The first of these drawings shows us the sketch of a landscape with a church as the main motif. In the second drawing, a tree has been added to the foreground; this creates a sense of depth, because the relatively large size of the tree and its placement in the foreground imply a certain distance between the two.

Fig. 530 Here, depth is emphasized by superimposing successive planes, known as *coulisses*, meaning the lateral, or horizontal, layers of classical scenery.

Fig. 531 Perspective is one of the most common and effective methods used to represent depth.

Fig. 532 The sensation of space is often conveyed by using high contrast in the foreground and gradually fading to more diffused edges in the furthest reaches of the background.

Representing depth or the third dimension. We draw or paint on a surface with two dimensions: height and width. However, the models we draw or paint have three dimensions: height, width, and depth. To represent all three dimensions, the artist must suggest the relative space between foreground, middle ground and background. However, there are other factors that help to emphasize a sense of depth. They are shown on this page.

Foreshortening

Foreshortening is the word used by artists when they wish to depict a body placed obliquely or perpendicularly to our level of vision. Look at these examples and think of all the artists throughout history who have devoted hours and hours to the study of fore-shortening, generally as the preliminary step to a larger work.

In all foreshortening there is what I call the *two-dimensional barrier*. Look at these two hands I drew foreshortened. A sculptor would model these hands with complete realism, making them corporeal, giving them volume. That's because a sculptor works in three dimensions: height, width, and depth. But we only work in two dimensions: height and width. The third dimension, depth, has to be represented by playing with light and shade effects to create the illusion of volume.

This is no easy task. We are accustomed to seeing bodies in three dimensions. There is a psycho-physical diagram in our brain, which instinctively places some parts of a body at a middle distance in relation to others, which appear in the foreground. Here, too, there is a rule to follow:

We must reduce to two dimensions what we see in three.

Observe three basic factors to achieve that purpose:

1. *See the model without its third dimension.* In other words, see it as a flat object, without relief or foreshortening, or depth. This requires a change in attitude.

2. *Draw objects from nature with low relief.* Begin by drawing faces in profile; go on gradually to three-quarter views (semi-profile) and last, have a try with full-face drawings, with the problem of the nose seen foreshortened.

3. *Try to see the model as shapes or masses.* When you are drawing the nose on a face seen frontally, try to see it as a flat area composed of various values – 'Here I have this shape and this intensity, next to it another shape a bit larger, and a light point, a bright area...' – as if it were a sheet of paper showing only two dimensions.

Fig. 533 Michelangelo. *The Holy Family.* Uffizi, Florence. All the Renaissance artists showed a special preference for fore-shortening, partly, I suspect, because it was a way to show their skill as superb draftsmen. In this picture, note the fore-shortened left arm of the Virgin that is shown as a study in figure A.

Figs. 534 and 535 Here we can see the foreshortening of two hands, with the index finger pointing forward. To execute this drawing, I drew my own left hand while pointing at myself in a mirror. Why don't you try to draw this particular position? It's a good way to practise.

533

A

534

535

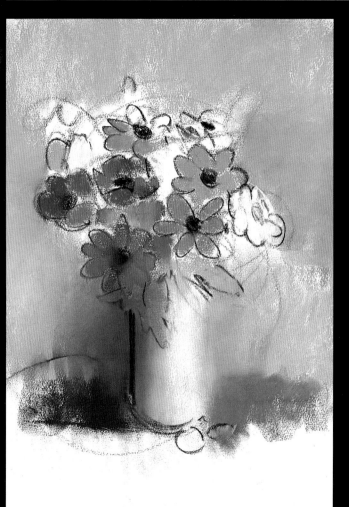

Drawing in

Drawing with ink and oil pastels

Try this practical exercise, to be drawn with a reed and Indian ink and oil pastels. You can do it comfortably at home, at any time, with a pair of trainers like these, or a pair of shoes or boots. I used medium-grain Grumbacher paper, an HB lead pencil to box up the drawing, a reed pen I made by cutting the end of the handle of a no. 2 brush (Fig. 541), and Rembrandt pastels.

Look at Fig. 542 for the colours used in this exercise, which you should be able to do after observing the images of this step-by-step process. However, I would recommend that you make some preliminary attempts at drawing greys by scrubbing a half-loaded reed against medium-grain paper before beginning this exercise.

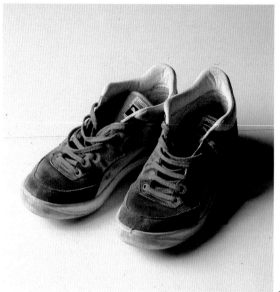

Fig. 537 Here is the model. It is better to draw this kind of shoe, where you have more than one colour, such as grey and white, or red and white. I have drawn these shoes in daylight, viewing them from above at an angle that I thought would be visually interesting.

537

540

538

539

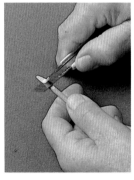

541

Figs. 538 and 539 At first glance, this model seems easy to draw: it can easily be boxed up; it has a simplified contour. However, it is a complex subject and will prove difficult enough to draw if you don't first simplify the contour lines and values.

Fig. 540 After the initial pencil sketch, the next step consists of making a linear drawing with the reed pen and Indian ink. Be careful! Avoid the problem of ink accumulating at the end of the pen; try to discharge any excess before you actually apply the ink to the pencil drawing.

Fig. 541 You can buy a reed pen in an art supply shop, but you can also make one by yourself, by trimming the handle of an old brush. Remember to make a vertical cut at the end so that the pen will retain the ink.

Fig. 542 These are the oil pastels that I used to make the drawing in Fig. 545.

542

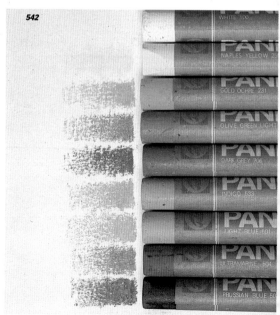

544

543

545

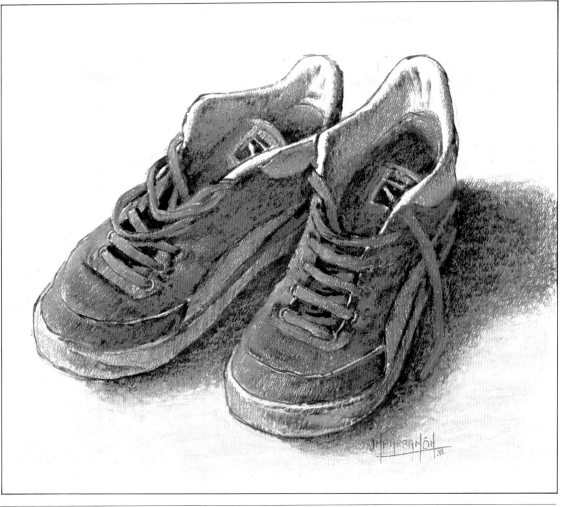

Fig. 543 Here we can see the finished reed pen drawing. It only needs to be completed with oil pastels. To achieve the correct modelling, I used a wide range of greys, which is the key to success. Notice that, next to the drawing, there is a piece of the same paper held next to it by a pin; this paper was used beforehand to unload the reed pen and test the intensity of the lines.

Fig. 544 To achieve correct tonal gradations and shades of grey, practise over and over again loading the reed pen with a small amount of ink, rubbing it hard against the grain of a scrap piece of the drawing paper. To succeed in this practice, you must use a pen that won't reject the ink, but success will also depend on your practical abilities and experience.

Fig. 545 When applied to ink drawings, oil pastels do not present any difficulty. The only thing to consider is that the oil pastels are opaque, so that they cover easily; and in this mixed media technique, it's important to see through to the lines of the reed pen. On the other hand, and thanks to the oil pastel's capacity to cover, the application of colour can enhance the look of the drawing.

Charcoal, Conté crayon, and white pastel

This drawing is by Francesc Crespo (Fig. 546), a friend of mine and an artist, professor and Doctor of Fine Arts and, until recently, vice-dean of the Fine Arts School of the University of Barcelona. He has won several drawing and painting prizes and has had more than twenty exhibitions in Spain and Italy. He draws and paints many subjects but preferably still lifes with pots and vases with flowers, and also nudes. 'The human figure is a compulsory subject for me,' says Crespo. 'I teach two days

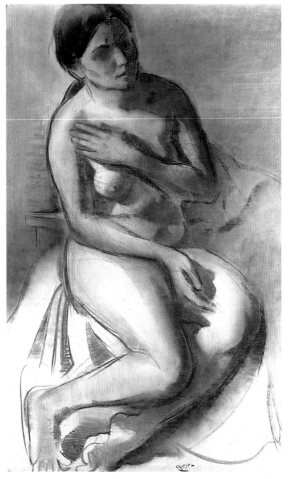

546

548

Fig. 546 This is Francesc Crespo, the artist who has drawn many of the illustrations for this book. Here, he is showing us how to draw, step by step, a female nude in charcoal and Conté crayon, highlighted with white chalk.

Figs. 547 and 548 Here we have two samples of Francesc Crespo's art, drawn in charcoal. Both drawings, the figure on the left and the still life below, are quite large, drawn on a sheet of paper 1 metre (40 in) wide.

547

a week at the Fine Arts School, and besides studying and preparing my classes, it's a subject I never get tired of.' (See Figs. 547, 548 for Professor Crespo's favourite subjects.) Crespo's studio is on a top floor with a terrace, two rooms, and a kitchen. It is a working studio, full of boards, folders, stretchers, frames ('I have a fortune in frames'), drawings and paintings completed or half done ('I always work on five or six paintings at once'), three easels, an auxiliary table with drawers and wheels to keep brushes and pencils at hand, a platform for the model in a corner, and a stereo.

The model arrives, goes into the kitchen, and undresses. Crespo turns on the record player. He already has a clear idea about the pose of the model so he starts drawing immediately, while the chorus of *Nabucco* by Verdi can be heard.

Crespo always draws or paints standing up. He does not box up. He goes directly to the

549

550

Figs. 549 and 550 On the left, the drawing in its final stage; on the right, the very first lines of the drawing.

Figs. 551 and 552 Crespo first draws in the basic structure of the model, laying in the various tonal values, plane by plane.

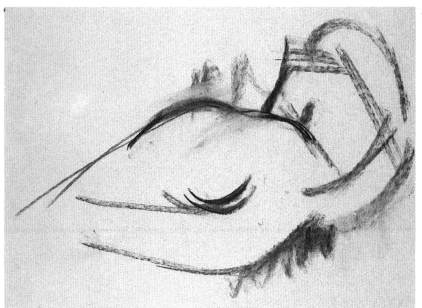

551

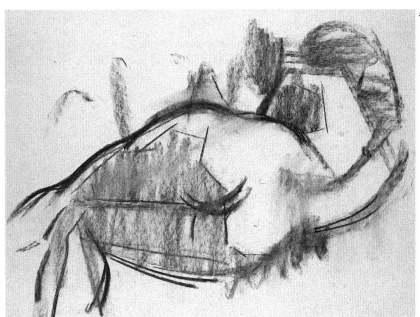

552

contours stage. He calculates by eye the total dimensions of the model. He uses charcoal. He marks, he fills in a corner, now to the left, now to the right ... He rehearses the stroke before he draws it, swinging his hand from the hip to the thigh. He moves his hand from one side to the other, and suddenly he draws a line, a strong line; he draws it again and stops. He compares model and drawing. He is absorbed in drawing with measured, calculated, intense, and secure strokes. His initial drawing shows a solid structure of lines and planes. Another feature of his way of drawing is that, when he renders areas in shade, he draws with the charcoal turned in a flat position. He draws and blends with a stump, draws and blends again. But he never completes the blending; it's as if he wanted to leave it half finished. 'Why?' I ask him. The answer is definitive. 'Because this way, I can keep the idea that all parts are subordinated to the whole work, and that all parts go on at the same time. Blending the shadow of this spine completely would mean that I give it a greater value than the rest of the picture.' Crespo begins colouring the drawing with Conté crayon. He draws with a piece approximately 3 cm wide, rubbing softly with the flat side, and using the system mentioned before: draw, blend, stop ... draw, blend. He prefers to use his fingers for blending, using stumps sparingly.

Now he draws with white pastel, enhancing lights. 'Why don't you use white chalk?' I ask. 'Pastels are softer, more ductile, and allow a greater speed when drawing and filling in areas.' He uses the white pastel as he did the charcoal and the Conté. He limits areas with strokes; as before, he does everything at once,

Charcoal, Conté crayon, and white pastel

painting everywhere without blending yet (Fig. 555).

He blends, draws, blends again (Fig. 557). 'We have to fix it now,' he says. 'A soft fixing, just to keep what we have done.' Then he stops for a few minutes – the fixative has to dry. He smokes a cigarette, washes his hands, talks casually. He is in no hurry.

When he goes back to the drawing, he approaches it with the same decisiveness he had before, but he slows gradually. He looks and compares more often now, and he draws less and less. Then he says, 'That's it,' and signs the drawing (Fig. 558).

Half an hour later, when the photographer has done his work and the model has left, Crespo suddenly says: 'Wait! wait!' He goes back to the drawing. 'That line of the shoulders ... that angle of the back you know ...' and he adds 'Don't take it yet. I want to see it this afternoon when I'm more calm, just in case something doesn't work. I don't like this way of working, always against the clock.'

This is Crespo.

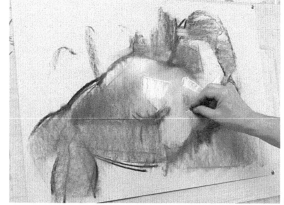

Fig. 553 Here, Crespo highlights the light areas using the pastel turned on its side. At this stage, he has not yet blended the white.

Fig. 554 The idea of subjecting the parts to the whole is manifested here by emphasizing the massing that makes up the form of the model.

553

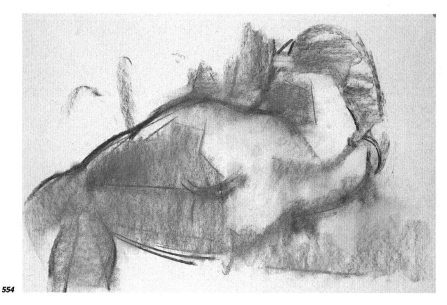

554

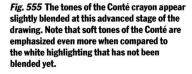

Fig. 555 The tones of the Conté crayon appear slightly blended at this advanced stage of the drawing. Note that soft tones of the Conté are emphasized even more when compared to the white highlighting that has not been blended yet.

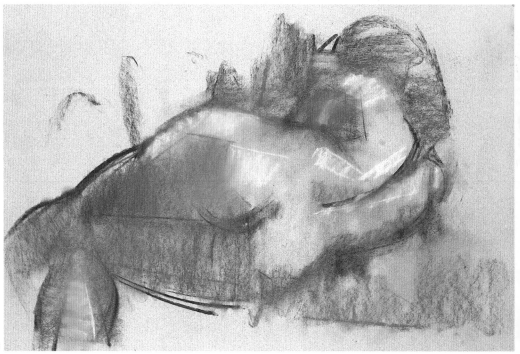

555

Fig. 556 Before beginning the next-to-last stage, Crespo sprays the drawing with fixative to safeguard the surface of the drawing.

Figs. 557 and 558 Crespo gives character to the drawing by working simultaneously on the modelling, contouring, and blending, and later adding the light and dark tones as well as colour. At the end Crespo has achieved a magnificent drawing with a perfectly rendered finish.

557

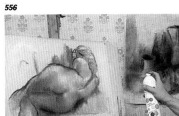

556

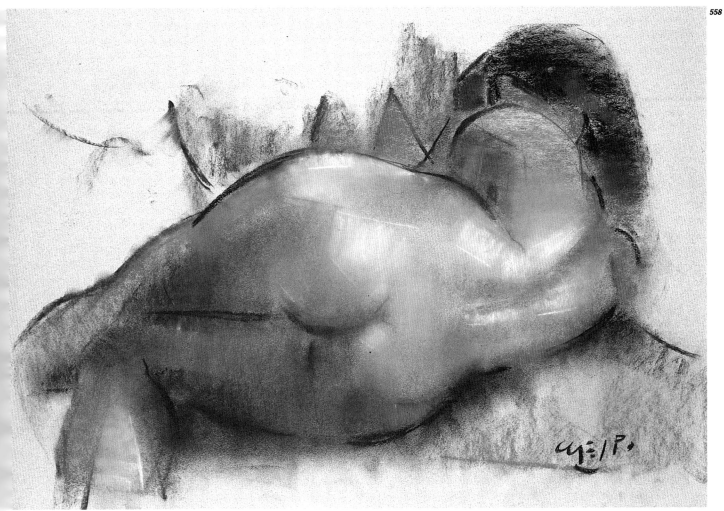

558

Drawing a nude with lead pencil

559

560

561

562

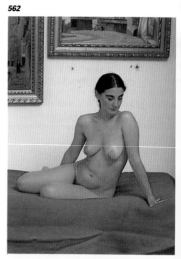

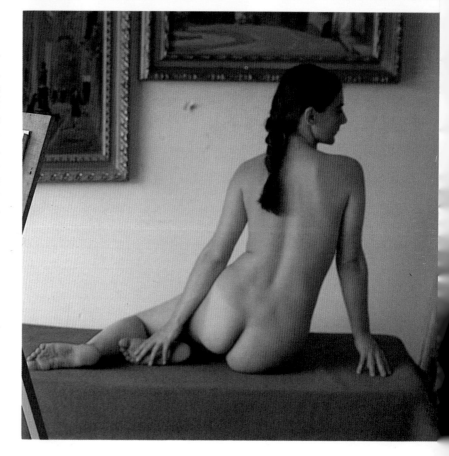

I mentioned some pages ago that the best way to learn to draw is to draw the nude human figure. Let me add now that if the study of the figure is made with lead pencil the pleasure of drawing from nature is much greater, because of the outstanding possibilities it has to blacken and make grey. We will see its potential drawing this model from nature. I asked her to adopt some poses, and I chose the one where her back is facing us (Fig. 563). I will use Arches glossy paper, a sheet of about 50 × 38 cm (20 × 15 in), with the diameter of the head 7 or 8 cm (2 or 3 in). I will use all-lead graphite pencils, 3B and 6B, though for the boxing up I will use an HB lead pencil, and a kneaded rubber. As you can see on these pages, the total proportion of the image is almost a square and the structure or basic shape of the model is triangular. The height of the head in relation to the height of the body can be deduced from the canon of the human figure, where, down to the level of the pubis, four heads can fit.

Using the pencil as a system of measurement and imagining vertical and horizontal reference lines, I draw the general structure of the model (Fig. 565). I redraw, erase, and compare until I get a linear drawing that is almost definitive. Then I start greying – without blending – yet trying to keep a certain regularity in my strokes in order to get a uniform blending later.

A warning: graphite is black, greasy, and dirty. You must try to avoid contact between your hands and the paper, and you should wash your hands frequently. Completing the drawing with the paper absolutely clean is expected from any good professional. Another require-

ment is to prevent perspiration from staining the drawing. Stains due to the perspiration of our hands are invisible at first. However, when there are greys – medium or light greys – the stains become darker than they first appeared and are practically impossible to erase.

In Fig. 571 you can see a half-completed *sfumato* which, as in a half-completed sketch, already hints at the finished drawing. Once this stage has been reached, you should keep in mind the following advice: *build up values*

Figs. 559 to 563 Here you can see the various poses of a professional model. A good model knows the classical positions and does them with an intuitive sense of which poses will make an interesting drawing.

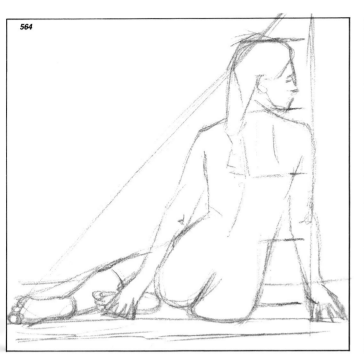

564

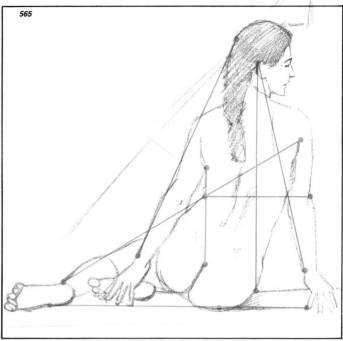

565

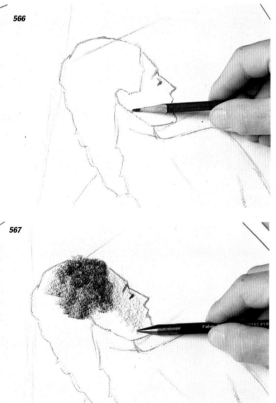

566

567

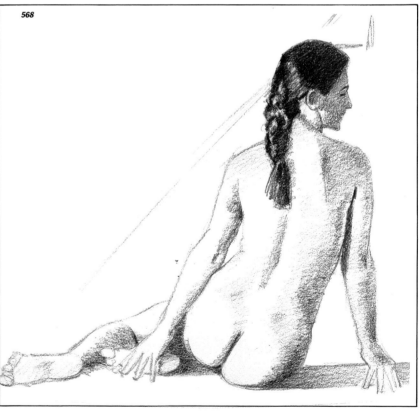

568

Fig. 564 Here, the position of the model allows me to box up a triangular shape; and the knowledge of the canon of the human figure enables me to calculate the size of the head in relation to the body.

Fig. 565 The basic structure of the pose is easily resolved with the above-mentioned box, but also by following traditional methods, such as measuring with a pencil, and using perspective reference points and lines.

Fig. 566 The initial stage of the drawing can be made with an HB lead pencil, which makes very light marks and will go unnoticed later when the tonal gradations are applied.

Fig. 567 Once you have completed the dark shaded areas, you should start using the 'all-lead' 3B pencil. By holding it at an angle, you can obtain thick lines that are useful for defining the middle-tone grey areas.

Fig. 568 The dark accents have been drawn in with a certain regularity, so that when they are blended later with a stump, these areas will have a uniform quality.

Drawing a nude with lead pencil

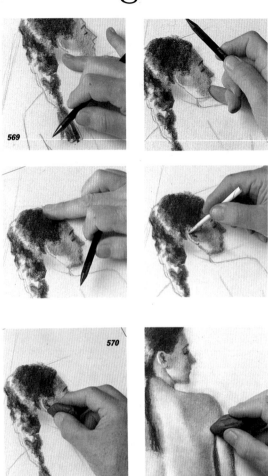

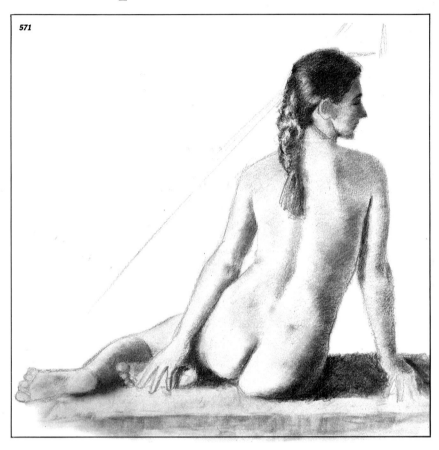

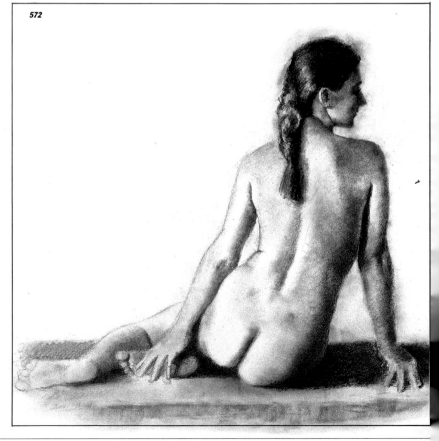

slowly and progressively, always comparing and being careful not to darken too much. Remember that intensifying is easy, whereas lightening is usually more difficult.

Remember that flesh colour must be translated into black and white. The most illuminated areas will appear a very light grey. This grey will only be 'broken' by the white of a shiny spot, a highlight on the model. Observe this in Figs. 572, 574.

Bodies are soft. Humans are not cold, metallic, or mechanical. Therefore our profiles, our contours, our changes from light to shade must be warm, vague, and soft. You can see this characteristic in the figures discussed above. In the final stages of a drawing, building value and modelling must be slow, calculated, and repetitive, especially repetitive in the sense that adding tone and blending

Fig. 569 Note the sequence used when blending an area with the fingers and a small stump.

Fig. 570 The kneaded rubber can adopt any shape, and this characteristic is what allows us to 'draw' with it. In this case, the rubber is responsible for drawing in the highlighted contour of the ear and highlighted areas of the back.

Fig. 571 Blending the areas that create light and shade is often a slow and exacting job, mainly because of the need to build up values.

573

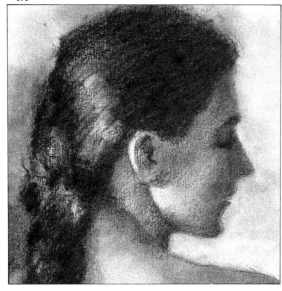

needs to be done carefully and slowly, comparing and controlling shapes that sometimes change because of the addition of a darker tone. Finally, there comes the moment when the final dark accents are added with the 6B all-lead pencil. It is at this final stage, when both values and modelling are completed, that the drawing is truly finished.

Fig. 572 Here, the drawing is near completion. A 6B pencil is used to intensify and develop all the range of tones, from the most intense black to an almost imperceptible grey.

Fig. 573 Above is a close-up of the head of the figure. Note the grey tones drawn over the blended areas, which give the drawing a more spontaneous and artistic finish.

Fig. 574 Drawings in lead graphite can be fixed with an aerosol fixative to preserve them indefinitely. However, before you take this last step, it's advisable to wait a few days, keeping the drawing out of sight, as Titian used to do; this way you'll see it fresh and then be able to make any last-minute corrections.

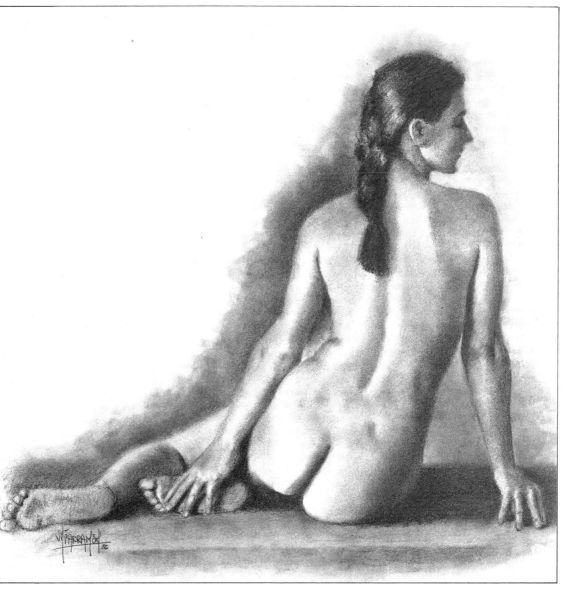

574

Portrait with coloured pencils

I begin this exercise by making three drafts. The first is to study the possibilities of the model posing with a book in her hands, reading. The idea does not work because it simply looks like a human figure reading; it is not a portrait (Fig. 576). I do a second draft. I paint the armchair the colour it really is, red. But that does not work either because this red is so deep that it forces me to strengthen the colours of the figure, and then it looks like a painting rather than a drawing (Fig. 577).

The third and last draft is the right one: it is clearly a portrait of a woman, it is a drawing, and it is clearly made with coloured pencils (Fig. 578).

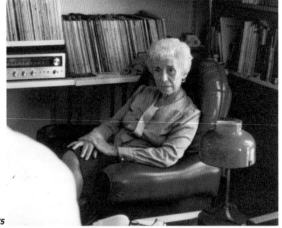

575

Fig. 575 This elderly woman, at home in her armchair, makes an excellent portrait subject.

Figs. 576, 577 and 578 The three sketches below are preliminary studies for the final portrait. In the first sketch, the pose is more appropriate for a sketch than for a portrait. In the second one, the intense red of the armchair necessitates a range of intense colours more compatible with painting than with drawing. The last sketch is the most appropriate; the muted tones are suitable for coloured pencils and the drawing reveals a sense of the woman's character.

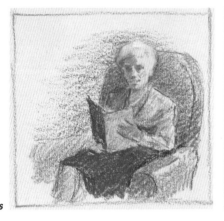

576

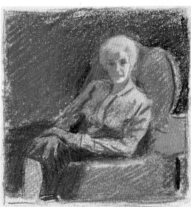

577

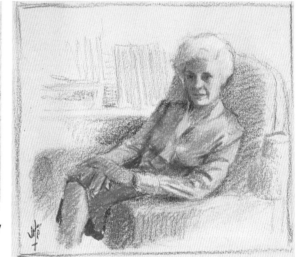

Fig. 579 The portrait begins by indicating the general dimensions of the woman's form.

I begin the portrait using an HB lead pencil, which is much less difficult to erase than coloured pencils. I draw in the oval of the model's face, calculating about 10 to 12 cm (4 to 5 in) high. Using that size, all the while calculating and comparing, the result is Fig. 579. Next I draw the features of the face. Ingres said that there is caricature in everything we see. We must try to see the most prominent features of this model, such as the narrow forehead, the white, silvery, springy hair. The dimensions of the canon of the head may be applied, but not on the forehead, because, in this case, the forehead is narrower. Yet the distance between eyebrow and nose, and nose and chin is the same as the canon. The basic concept that 'Between eye and eye, there is another eye' works in this case. In speaking of eyes, Ingres said, 'Draw the eyes while you are walking', meaning that the eyes must be drawn separately just as you would draw two eyes that don't belong to the same face. Once the sketch of the head is finished, I redraw the lines of the figure using a *Venetian red* pencil (Fig. 580).

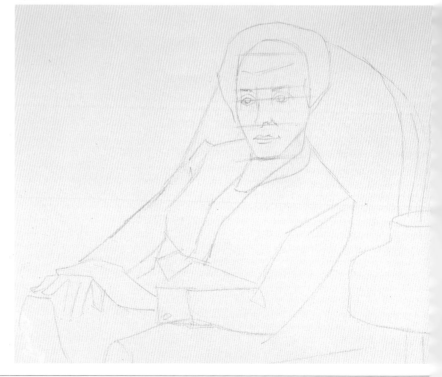

Fig. 580 This stage of the drawing takes into consideration the head and facial features of the model, the dimensions of which are based on the canon of the human head.

580

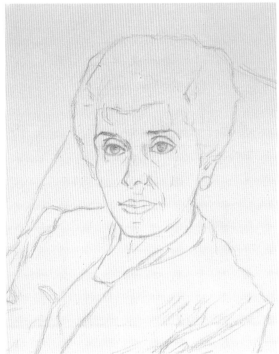

581

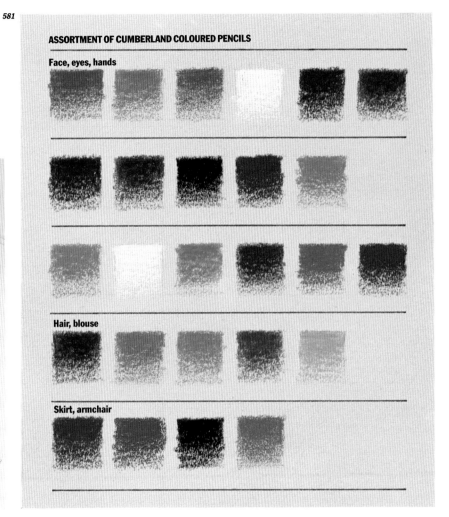

ASSORTMENT OF CUMBERLAND COLOURED PENCILS

Face, eyes, hands

Hair, blouse

Skirt, armchair

Now it is time to 'paint', but before this, take a look at the chart on this page showing the different colours available in coloured pencils (Fig. 581). I start on the face with a coat of *burnt sienna*, add a few touches of *magenta* and use *white* for the light on the face. Next I use *dark brown* for the eyebrows and *dark carmine* (almost *black*, as you can see in Fig. 582) to outline the eyelids, *ochre* for the irises, *black* for the pupils except the brightness which I paint *white*.

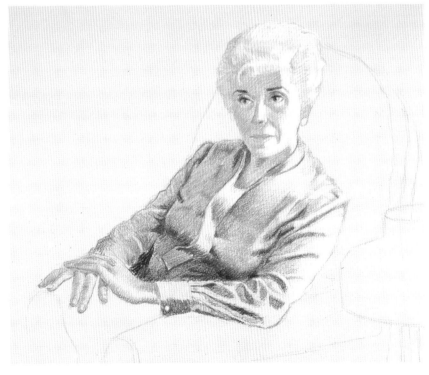

Fig. 582 As is characteristic of coloured pencils, the subject is drawn in gradually; values and colour are adjusted carefully as the drawing progresses.

582

Portrait with coloured pencils

I use *black* and *grey-blue* for the eyelids. Next, the hair: *ochre-sienna* for the left side and *white* for the lighted areas, a few strokes of *French grey* and *cobalt blue* for the massing of the hair. Then I use *burnt sienna* and a little *magenta* for the neck, draw the hands with *dark carmine*, and paint them with *sienna* and *magenta* (Fig. 582). There are two general areas of colour in the blouse, warm for the shaded areas and cold for the parts illuminated by daylight. I then use *olive green, dark grey-blue* and *dark carmine*, plus *burnt sienna, ochre*, and *bronze* and *silver grey* for the lights (still Fig. 582). Next comes the skirt, for which I use *dark grey-blue, Prussian blue*, and *black*. I intensify the colour of the hands and legs and try a background colour for the head using *carmine* for the armchair and a light shading of *cobalt blue* around the profile of head and shoulders (Fig. 583).

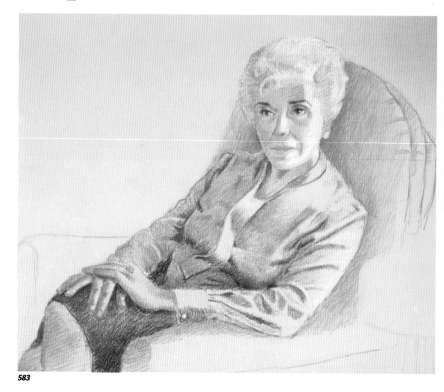

583

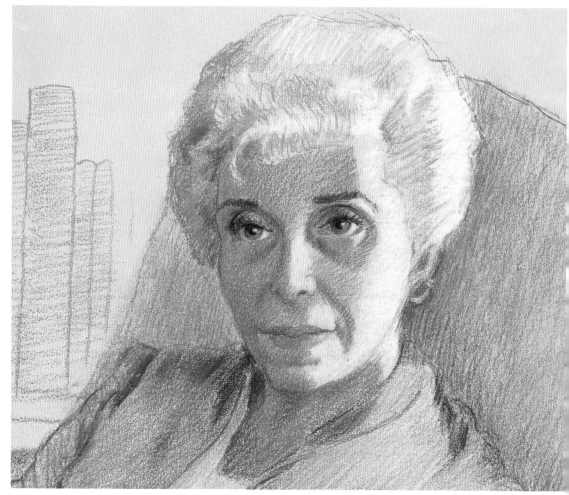

584

Figs. 583 and 584 In these two pictures, you can see how various areas of the subject progress from one stage to another, especially noticeable in the face and hair areas, which are often difficult. Note also the light and shade effects that make up such complex areas as the woman's dress and hands. The close-up of the head is enlarged here almost to the drawing's actual size. Note that this area is more refined and detailed than are other areas of the drawing.

585

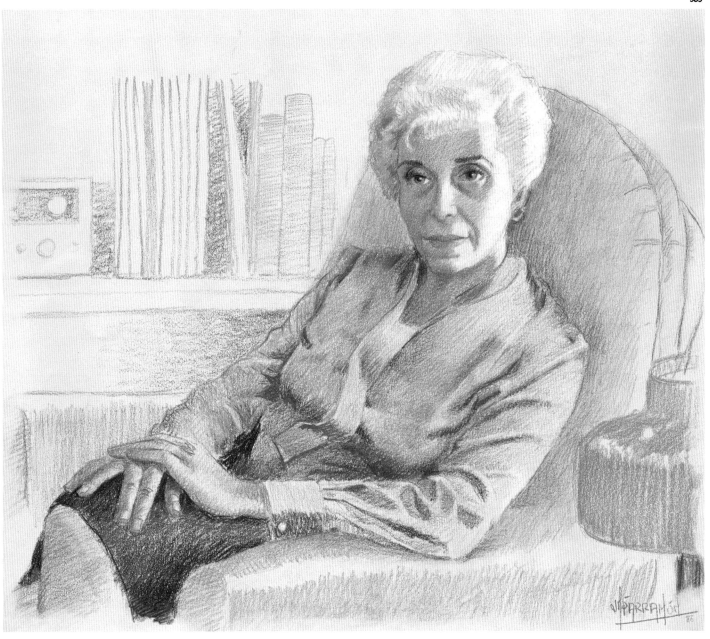

Notice how the red of the armchair makes the colours of the head look lighter, in confirmation of the *law of simultaneous contrasts* (see page 137, Figs. 475 A and B). In compensation I intensify the colours of the face and also finish up the hair.

The head contains all the colours used in the face (Fig. 583). I reduce the intensity of the background red to obtain a better general contrast. I end up drawing in the elements in the background (Fig. 584).

I finish the hair almost completely, working up its volume, enhancing brightness, and shaping the form. The eyes are finished using *ochre*, *Venetian red*, *dark brown*, and *black*. I do

additional work on the eyebrows and eyelids with *purple* and *grey*, and I add a slight touch of *grey* to the eyeballs, on the left side (Fig. 585). Tints of *purple-violet-carmine* are applied to the armchair, *green* for the lamp and *dark brown* for the books, records, and a part of the radio in the background. I paint the shadow under the bookcase a *dark grey-blue* and a *violet-blue*. But I don't sign yet. I will leave that until tomorrow. Then I will look at the finished drawing reflected in a mirror, which is a traditional method for discerning any possible errors because it provides a certain degree of objectivity.

Fig. 585 The final result is a fully realized portrait, where the model's person and personality are revealed through the medium of the coloured pencil.

Drawing-painting with pastels

We are again with Professor Francesc Crespo. Now Crespo will draw and paint a bouquet of wild flowers in a cylindrical white vase embellished with flowers and blue garlands (Fig. 593).

Crespo uses a white medium-grain Fabriano paper. He has a great number of pastel colours – more than 150 – which are placed on the auxiliary table on the left (Fig. 587). Cool colours are placed to the left and warm colours to the right. In between there is a space where Crespo leaves the colours he uses most often (Figs. 588, 589).

Francesc Crespo's pastel technique is the traditional one. First he boxes up the drawing with soft charcoal: in this regard, he says, 'As you know, boxing up with charcoal allows for easy erasing.' Then, he redraws and emphasizes profiles and contours with black pastel. He holds the black pastel stick as if it were a pencil. Eventually, he paints with pieces of pastel in a flat position and blends them with his fingers.

Where Crespo differs from other artists is in his way of boxing up and structuring the model.

586

587

588

590

591

592

Figs. 590, 591 and 592 Crespo paints with a large palette of pastel colours, working with bits and pieces which he breaks on purpose. When laying in lines of colour, Crespo holds the pastel as if it were a pencil; when filling in tonal areas, he holds the stick flat. He also alternates the strokes of colour with blending, which he always does with his fingers.

In a few moments, with a few steady strokes in the right place, he indicates the proportion and general structure, drawing in the model as if it were the easiest thing in the world. You can observe this facility in Fig. 594. Note also the cold tones and dense and mysterious shades of colour in the background (Fig. 595). As for the rest, Crespo's drawing does not seem very difficult. Seeing him work, one tends to think anybody could do it: he draws in the profiles of the leaves, the petals, and the flowers with black pastel; then he fills in these spaces with various colours.

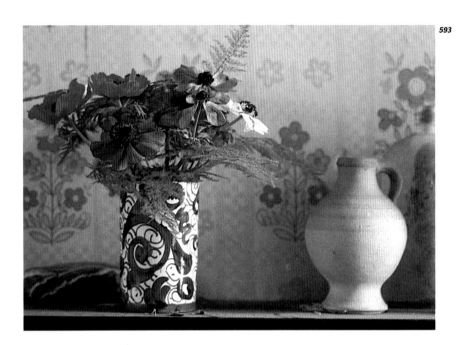

593

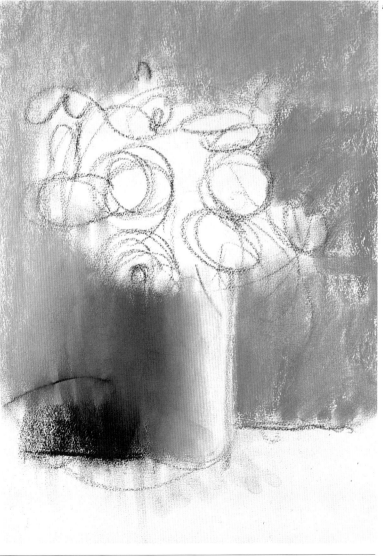

595

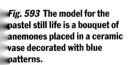
Fig. 593 The model for the pastel still life is a bouquet of anemones placed in a ceramic vase decorated with blue patterns.

Figs. 594, 595 In the pastel sketches above, you can see the extraordinary rapidity and confidence with which Francesc Crespo works. These drawings were made in less than five minutes.

Drawing-painting with pastels

He lays in the background of leaves behind the flowers, then draws in the blue flowers that embellish the vase. And that is all. But it is not as easy as it appears. Crespo's skill did not appear overnight. 'Of course,' he says as he goes on working, 'I've been drawing and painting for twenty years now!'

Try this demonstration for yourself, noting all the while how Crespo went about completing his drawing. Maybe, once you get started, you won't be able to give it up! This is what I hope for, as I conclude this book.

Fig. 596 Crespo begins by painting in the background with a middle tone, so that the flowers can be rendered with darks and lights. Artists typically start working in the largest area.

Fig. 597 Here, Crespo lays in a dark green behind the flowers. This dark area creates a dramatic contrast against the lighter tones of the flowers and general background.

Fig. 598 At this stage, the danger of lack of contrast is over. The flowers are highlighted and the whole offers a perfect harmony. 'Some people think', Crespo says, 'that to create a sense of spontaneity, it is necessary to leave small unpainted spaces and show the white of the paper.' This notion is not always true, however. Too much white space can attract too much of our attention – to the detriment of the painting as a whole.

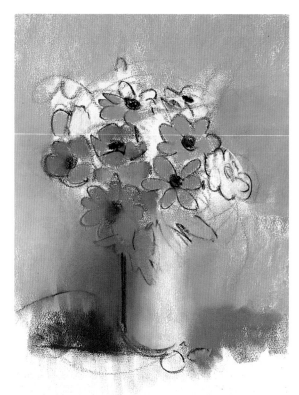

596

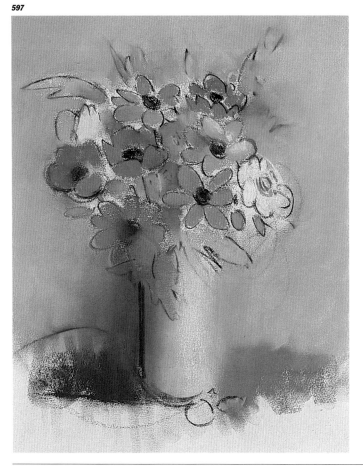

597

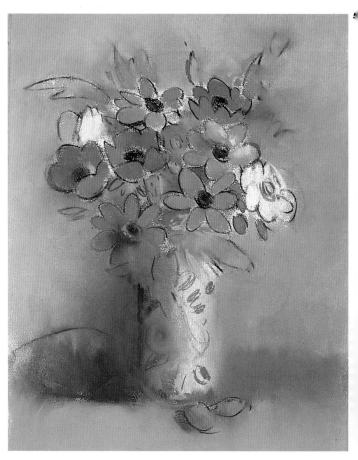

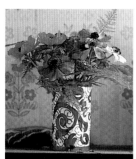

599

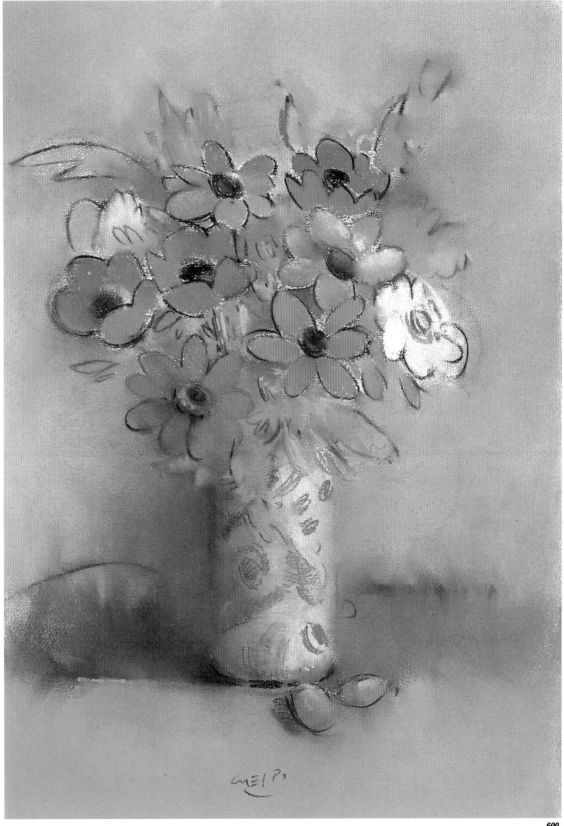

Fig. 600 Crespo has completed the drawing and there are no obvious white spaces left. The finished work is pleasant, simple, unpretentious – as are the anemones themselves, wild flowers that offer their beauty to whoever wants to look at them.

600

Glossary

A

Acrylic paints. Colours made basically of synthetic resins. They began to be used by artists during the 1960s. They are sold in tin tubes as fluid paste similar to oil colours. Acrylics are soluble in water while they are being applied but, once they are dry, they become indelible.

Alla prima. Italian expression which means 'all at the first time'. It refers to the technique of completing a painting in a single session, without any previous preparation.

B

Back lighting. Light that illuminates the model from behind or obliquely, creating the shading of the places seen by the artist.

Binary colours (secondary colours). These are purple, green, and orange. Each one is the result of mixing two primary colours.

Borders. A series of drawings, as a *fret*, that frame and surround another design.

Boxing up. Drawing the basic structure of models by using squares, rectangles, cubes, or rectangular prisms, called boxes.

Burin. A hand tool used for engraving, made of a steel shaft in a wooden handle.

C

Chalks (pastels). Small cylindrical or square bars of colour made of pigments and binding media. Natural chalk is similar to pastel, but more stable and with a harder line. They usually come in white, black, light and dark sienna, cobalt blue, and ultramarine blue. Pastels come in many colours.

Charcoal. A thin carbonized willow, linden, plum, or dogwood branch which is used to sketch.

Charcoal pencil. Compressed charcoal encased in wood, giving greater density and blackness than charcoal.

Chiaroscuro. Painting light within shadows to allow the forms of even very dark objects to show. Rembrandt was one of the great masters of chiaroscuro.

Colourism. A painting style that gives more importance to colour than tonal value, differentiating forms and volumes only by colour.

Complementary colours. Produced by mixing two of the three primary colours. The resulting colour is the complement of the third colour. For example, purple, mixed from red and blue, is the complement of yellow.

Contrapposto. Italian term used to designate that position of the body in which part of the body lies in the opposite direction from the rest of the figure.

D

Dry point. Engraving technique using a very hard steel rod with a point of steel, ruby, or diamond to draw directly on a copper plate.

E

'En plein air' painting. Painting outdoors, a way of escaping from academicism, perhaps because the Impressionists used this expression when they started painting outdoors in opposition to the 'official' way of painting learned in fine-art schools or academies. It also indicates the wish of the painter to convey to the onlooker the sense of being outdoors.

Etching. Engraving made on a metal plate covered with a resinous varnish, with a *burin.* Then the plate is bathed in an acid that corrodes the metal of the lines the burin has left without varnish. Once the rest of the varnish is eliminated, you ink the plate and imprint the proof.

Encaustics. Pictorial technique consisting of working directly on a wall using colours agglutinated with wax, which are later fixed with a candescent iron tool that makes them unalterable. This technique was used for small mummies' portraits in Egypt.

F

'Fêtes galantes' painting. Paintings that represent the festive and courtly

atmosphere of the French Rococo period. The most representative artist of this genre was the French painter Watteau.

Fixative. Any of several different substances applied to a drawing in order to preserve it against rubbing, the passage of time, excessive light, and dampness.

Foreshortening. Perspective applied to a single object, which gives the appearance of shortness to its nearer aspects.

Fret. Ornament made of short straight lines, often intersecting at right angles to form a continuous pattern, as in the swastika ornament of ancient Greek architecture.

G

Glaze. Transparent coat of paint, applied before or over another colour, that modifies the latter.

Glossy paper. Paper with an almost imperceptible grain, very appropriate for drawing in ink or in lead pencil.

Golden Section. The ancient law of proportion

to determine ideal placement of a line or point, aesthetically speaking, within a given space. If the space is represented by a line AB, point C should be placed so that CB:AC = AC:AB.

Gouache. A tempera paint similar to watercolour, but with a larger proportion of pigment and with added honey or gum arabic for opaqueness. Gouache is a thick, covering medium, allowing the artist to paint with light colours over darker colours. It dries with a matt pastel finish.

H

Hieratism. A style that's governed by strict rules sanctioned by religion, often used to describe Byzantine art. Monumentality, formality, and rigidity, as well as abstraction, characterize hieratic art.

I

Iconoclasm. Heresy of the 8th century that required the destruction of all the

painted or sculpted Christian images, since it forbade any figurative representation.

Iconography. Graphic representation of religious images and Christian allegories.

L

Lacquer. A coloured substance used in painting. It comes, originally, from a resin produced by some trees in China and Japan.

Lead pencil. A pencil made of cedarwood, with a lead composed of graphite and clay.

Lekythos. Funerary vases from Classical Greece.

Linseed oil. A solvent for oil paints usually mixed with turpentine and obtained from flax seeds.

M

Mannerism. Painting style from the end of the Renaissance (16th century), described by Vasari as schematic and based on intellectual preconceptions rather than direct

observation. Mannerist painting broke the classical rules to heighten drama and emotionalism.

Metalpoint. A lead, silver, or gold point used on a prepared surface to draw black lines slightly less intense than those made by lead pencil. It was commonly used during the Renaissance.

O

Ostracon. Any inscribed fragment of pottery or limestone.

P

Papyrus. Sheets made from a fibrous plant (Cyperus papyrus) in use in Egypt from the 4th century B.C. to the 5th century A.D., when it was replaced by parchment. The sheets were pasted together to form scrolls.

Parchment. Animal skin, generally of a ram or goat, treated so that it may be written upon. For centuries, parchment was considered to be the best material for

works of art, particularly for painting miniatures.

Perspective. The science of graphically representing the effects of distance. We may distinguish between linear perspective, which represents the third dimension (depth) through lines and forms; and aerial or oblique perspective, which represents depth using colour, shade, and contrast.

Pigment. Any dye which, when diluted in a liquid, provides colour for painting. Pigments are generally available as powders and may be of organic or inorganic origin.

Pointillism. Drawing or painting with lights and shades using only small dots and sometimes stumping, with a final result similar to a printed image.

Primary colours. Basic colours of the solar spectrum: red, yellow, and blue.

Priming. A coat of plaster and glue applied to a canvas, cardboard, or wooden board as preparation for an oil painting.

S

Sanguine. A small square chalk bar of a reddish sepia colour, similar to a pastel but harder and more compact. Sanguine is also a means of drawing by rubbing or using techniques similar to the ones for charcoals and pastels. Sanguines are also available in pencil form.

Secondary colours. See *Binary colours.*

Sfumato. Italian term for 'smoke', meaning Leonardo da Vinci's technique of blending from light to shade 'without lines or borders'.

Stretcher. A wooden frame on which canvas is mounted.

Stucco. Fine-grained hard plaster made of gypsum and ground marble, used for interiors and relief sculpture since Roman times.

Stump. A pencil-shaped tool with two points, made of spongy paper or chamois skin, used to grey or gradate lines made with charcoals, sanguines, charcoal pencils, chalks, or pastels.

Symmetry. Repetition of the elements of a composition on each side of a central point or axis.

T

Tertiary colours. A series of six *pigment colours* obtained by mixing primary and secondary colours in pairs.

V

Values. Gradations of tones between light and dark.

Vanishing point. In perspective, a single point on the horizon where every parallel line from any direction will converge.

W

Wash. Drawing made with Indian ink and water, or with one or two watercolours and water. The colours are usually black and sepia, or a dark sepia and a lighter sienna, etc. The paper, the brushes, and other tools, as well as the general techniques, are the same as in watercolour painting. Wash was used by most artists of the Renaissance and the Baroque.